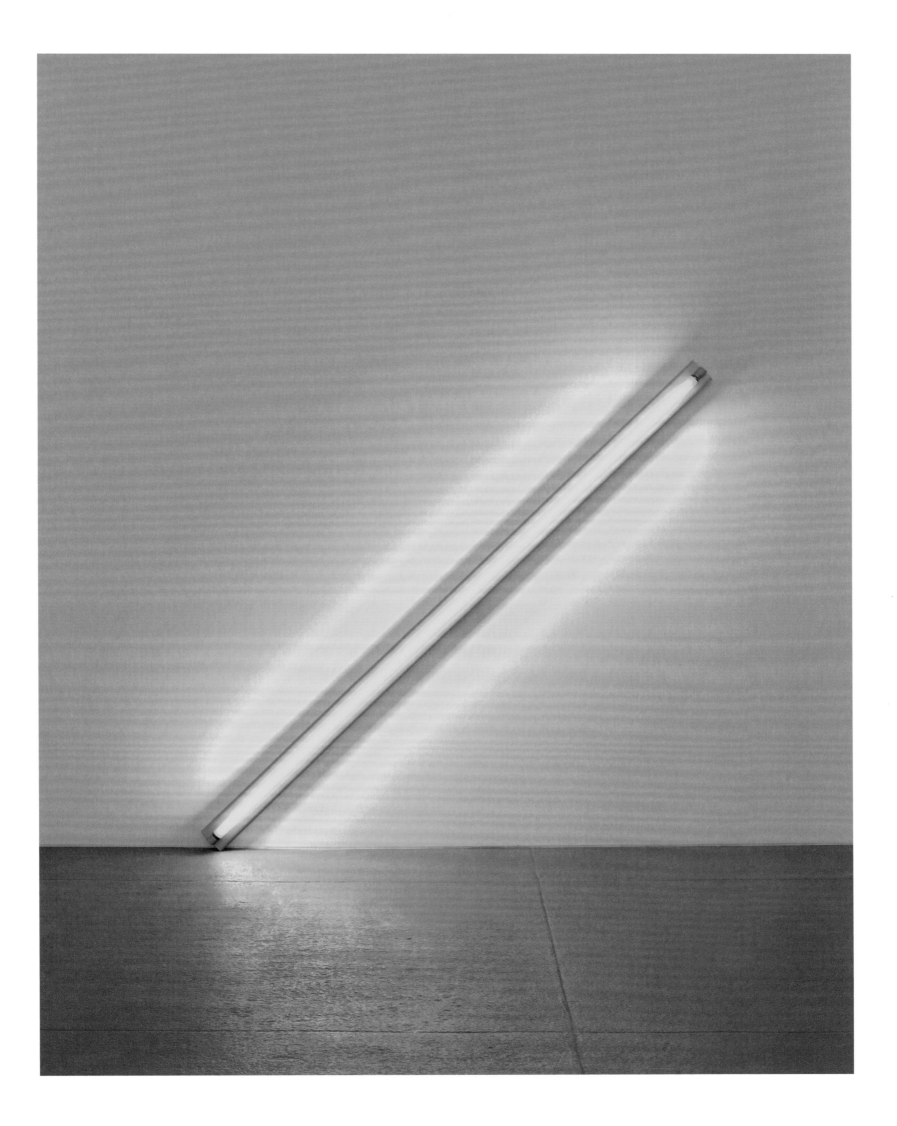

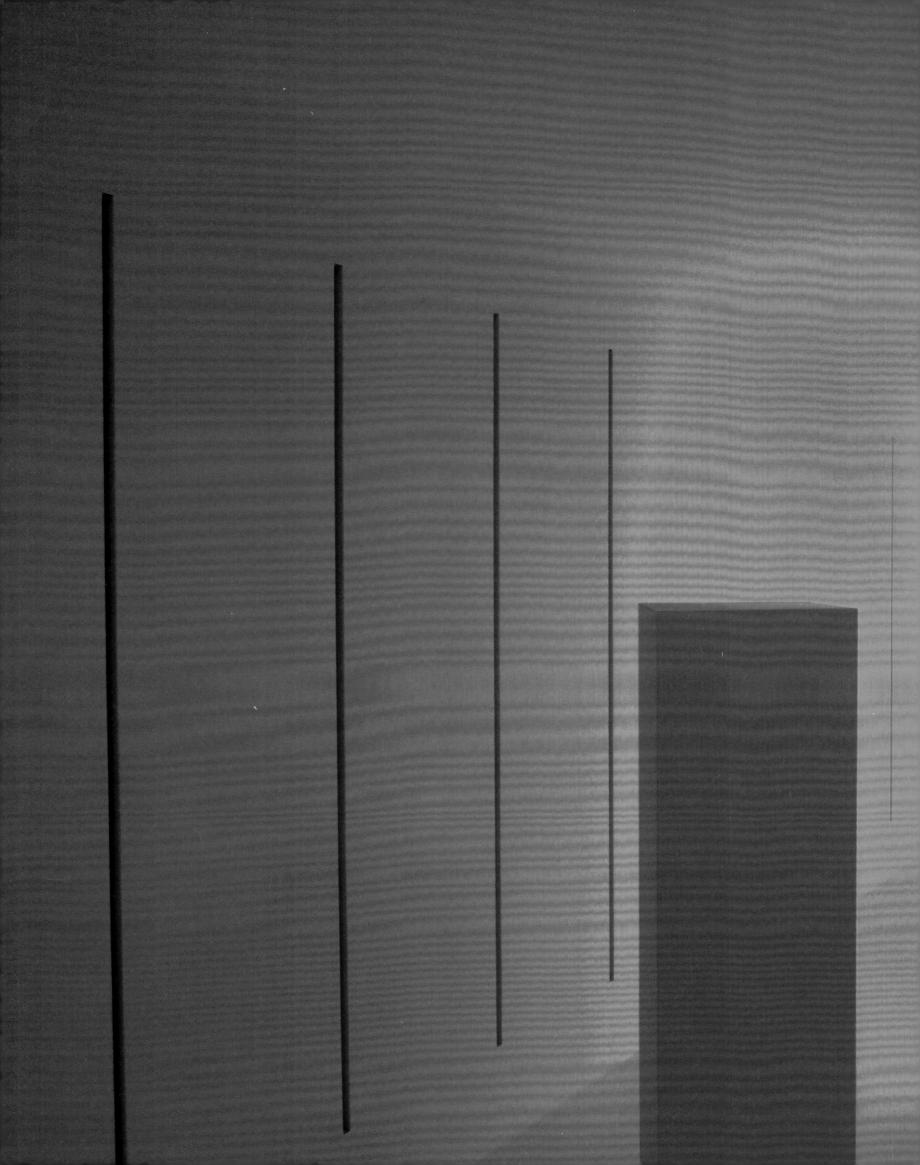

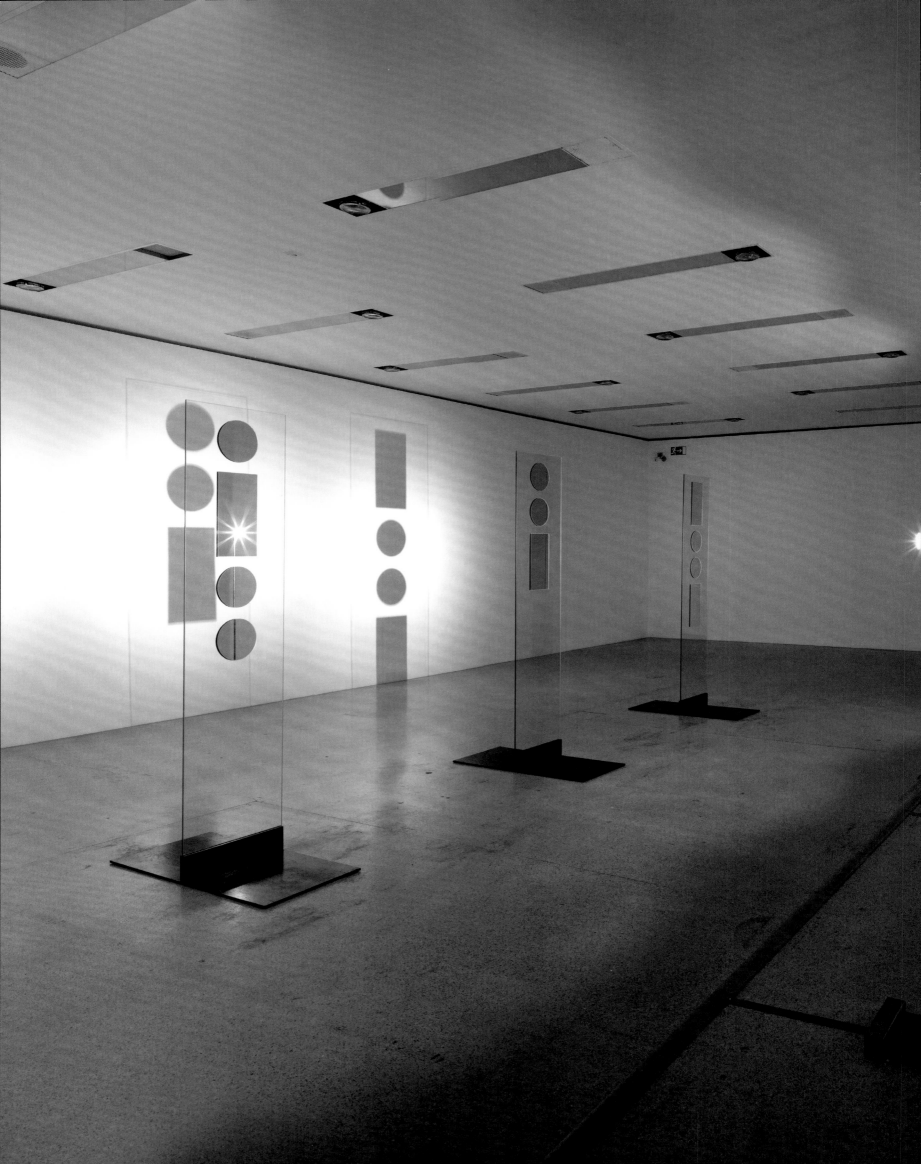

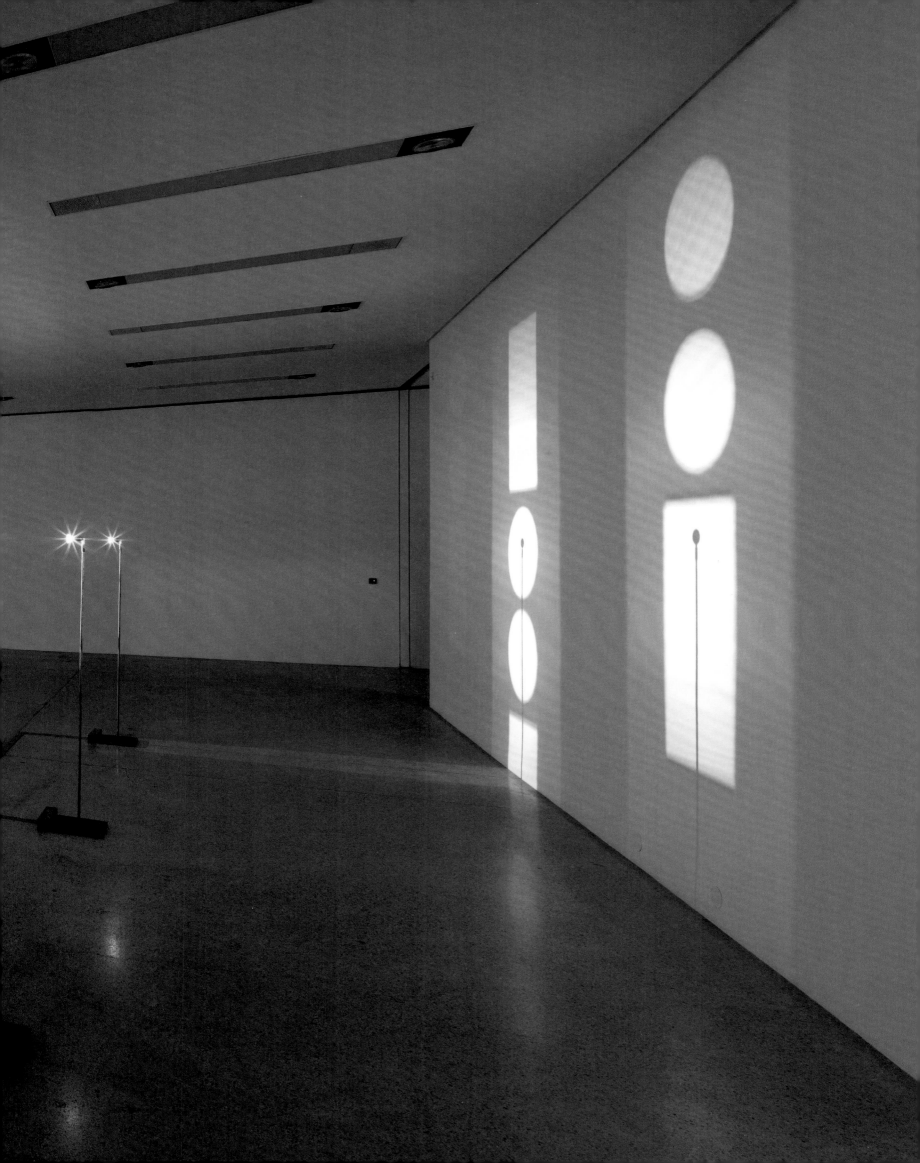

Published on the occasion
of the exhibition *Light Show*

Hayward Gallery, London
30 January – 28 April 2013

Curator: Dr Cliff Lauson
Assistant Curator: Charu Vallabhbhai
Curatorial Assistant: Rahila Haque

This exhibition has been made possible by the provision
of insurance through the Government Indemnity Scheme.
Hayward Gallery, London, would like to thank
HM Government for providing Government Indemnity
and the Department for Culture, Media and Sport and
Arts Council England for arranging the indemnity.

First Published by Hayward Publishing
Southbank Centre, Belvedere Road
London, SE1 8XX, UK
www.southbankcentre.co.uk

Art Publisher: Nadine Monem
Staff Editor: Faye Robson
Sales Manager: Deborah Power
Catalogue designed by Studio Frith.
Colour management by Dexter Pre-Media
Printed in Italy by Graphicom
Artists texts written by Helen Luckett (HL)
and Elizabeth Manchester (EM)

MIT Press books may be purchased at special quantity
discounts for business or sales promotional use.
For information, please email special_sales@mitpress.mit.edu
or write to Special Sales Department, The MIT Press,
55 Hayward Street, Cambridge, MA 02142.

This book was set in Ideal Sans by Studio Frith
and was printed and bound in Italy.

Library of Congress Control Number: 2012953627

ISBN: 978-0-262-01914-9

10 9 8 7 6 5 4 3 2 1

LIGHT SHOW

The MIT Press
Cambridge, Massachusetts

FOREWORD

The artists in *Light Show* use that most familiar yet intangible medium – artificial light – as the basis of their sculptures and installations. Bringing together a carefully considered selection of work from the past half century, this exhibition provides an incisive survey of pioneering and rarely seen installations made since the 1960s, including inventive and challenging works from recent years. Whether they make use of bespoke fixtures, off-the-shelf lighting or newly-developed technologies, the artists in this show have contributed to a profound experiment that continues to re-map the boundaries of contemporary sculpture while simultaneously provoking us to reflect on the qualities and limits of our perception.

Spanning several generations, the artists in *Light Show* represent a diverse array of practices. They explore interests that range from how we experience and psychologically respond to illumination and colour to more conceptual and political concerns. Almost all of their work, however, uses artificial light to create a sense of sculptural space that directly calls into play our individual perceptual responses. It invites us to scrutinise and, in some cases, to interact with, environments and projections in which we can unfold the complexity of our encounters with the myriad aspects of light. *Light Show* adds a cogent and exciting new chapter to the Hayward Gallery's previous exhibitions of light-based art, including the 1993 James Turrell survey, organised by my predecessor Susan Ferleger-Brades, and the Dan Flavin retrospective that the Hayward hosted in 2006.

An exhibition like this, which brings together works from public and private collections across North America and Europe, depends on the contributions and assistance of many individuals and institutions. For their generous support of *Light Show*, I wish to thank Abstract Select Ltd, Ulf G. Brunnstrom and Jiwon Lee, Paul Kasmin Gallery and Victoria Miro Gallery. I also wish to highlight the generosity of the lenders to this exhibition and to offer them our profound gratitude. In addition, I wish

to gratefully acknowledge the support provided by Studio Olafur Eliasson; Gering & López Gallery; Haunch of Venison; Sprüth Magers; Stiftung Museum Kunstpalast, Düsseldorf; and Zumtobel Lighting.

Hayward Gallery Curator Cliff Lauson deserves to be saluted for his shrewdness in shaping this exhibition, tackling the subject with an approach that is both innovative and scholarly. Assistant Curator Charu Vallabhbhai, with crucial help from Curatorial Assistant Rahila Haque, provided indispensable support in organising the show. This publication features original texts on the history of artists working with light, and we are grateful to art historian Anne Wagner, science writer Philip Ball and Cliff Lauson for their illuminating essays. Thanks also to Helen Luckett and Elizabeth Manchester for the artist texts that appear on pages 53 to 179. Hayward Publisher Nadine Monem exactingly supervised all aspects of this publication, ensuring it is a memorable companion to the exhibition. Finally, Frith Kerr and Ben Prescott of Studio Frith have earned our gratitude with their elegant design of this book.

In the Hayward Gallery team, I also wish to thank Operations Manager Ruth Pelopida and Senior Technician Gareth Hughes for capably meeting all the challenges of planning and installing the exhibition. Registrar Imogen Winter expertly handled transport matters; Interpretation Manager Helen Luckett wrote the exemplary texts for the exhibition guide and wall labels; and General Manager Sarah O'Reilly adroitly managed many of the larger organisational issues posed by this ambitious undertaking. In addition, this exhibition has benefitted from the support of Southbank Centre CEO Alan Bishop and Artistic Director Jude Kelly, as well as Southbank Centre's Board of Trustees, and Arts Council England. Finally, I wish to express our profound gratitude to all of the participating artists for making brilliant work that inspires us to see and think in new ways.

Ralph Rugoff, *Director, Hayward Gallery*

JAMES TURRELL, *SHANTA, RED*, 1968

LIGHT ART: AN IMMATERIAL MATERIAL

CLIFF LAUSON

For centuries, light has been a subject of fascination for artists, from medieval altarpieces to Impressionist painting to photography, literally 'writing with light'. The use of electric light in art is, however, a more recent phenomenon, emerging in the twentieth century. Artists using artificial light employ it as a material in and of itself, compelled by its luminous and intangible qualities.[1] Early episodes of light-based artwork were closely intertwined with the increasing availability of (and technological advances in) electric light: László Moholy-Nagy's *Light Prop for an Electric Stage* (1928–30), a motorised metal and glass machine for studying the interplay of light and shadow, and Lucio Fontana's series *Ambiente spaziale* (started in 1949), which incorporated large-scale curving neons or ultraviolet light, are two important examples of early precursors that made use of this unconventional medium.

1. For a comprehensive history of light-based artworks see Peter Weibel, 'The Development of Light Art' in Peter Weibel and Gregor Jansen (eds) *Light Art from Artificial Light: Light as a Medium in 20th and 21st Century Art*, exh. cat., ZKM Museum für Neue Kunst, Karlsruhe, 2006.

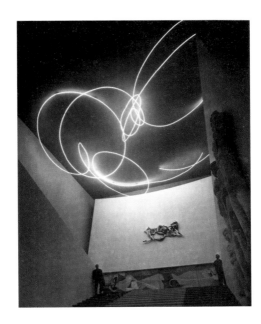

LUCIO FONTANA, *LUCE SPAZIALE*, 1951

2. Michael Auping, 'Stealth Architecture: The Rooms of Light and Space' in Robin Clark (ed.), *Phenomenal: California Light, Space, Surface*, exh. cat., Museum of Contemporary Art San Diego, University of California Press, Berkeley, CA, 2011, p.80. Environmental light art could also be seen to have its origins in nineteenth-century stage lighting; see Frank Popper, 'Introduction' in *Kunstlichtkunst*, exh. cat., van Abbemuseum, Eindhoven, 1966.

It was however the widespread broadening of the category of sculpture around the 1960s – 'the transition from "objecthood" to environment' – that saw artists fully maximising light's potential both as a sculptural medium and for altering the viewer's perception of space.[2] This shift was certainly related to the emphasis of much 1960s artwork on vision 'as embedded within the body and inextricably

bound up with a broader situating of the body within the physical environment', an encounter that art historian Alex Potts has since coined 'the phenomenological turn'.[3] Artists using light as a medium emerged internationally, often as a part of avant-garde movements; examples include Otto Piene's involvement with ZERO in Düsseldorf, François Morellet's with GRAV in Paris or Gianni Colombo's with Gruppo T in Milan. Contemporaneous artists such as Dan Flavin, Carlos Cruz-Diez, Joseph Kosuth, David Lamelas, Chryssa, Nam June Paik and Liliane Lijn also started to explore light's perceptual potential within their independent practices. In recognition of this mid-century zeitgeist, the first major retrospective exhibition to examine light in art, *KunstLichtKunst*, was held in 1966 at the Van Abbemuseum, Eindhoven.

The present exhibition, *Light Show*, brings together a selection of artworks made since the early 1960s that examine light's potential as a sculptural medium. Beyond simply including bulbs or light fixtures as material components, these works explicitly engage the spatial and sensory aspects of light, its aesthetics and its immateriality.[4] In exploring what light is and how we perceive it, they feature light as a medium, one that demands the highest levels of spatial awareness and visual acuity. The following is an exploration of how the artists included in *Light Show* examine light through slightly differing but overlapping approaches: as sculptural form, as perceptual phenomenon and as a medium invested with specific social and cultural meanings. These are not entirely separable categories, especially considering that the artists themselves have rarely adhered to a single aspect of light throughout their careers; they are instead points of entry in understanding how these diverse artworks share medium-based concerns.

Shaping Light

Unlike any other sculptural medium, light is constantly in motion, travelling in straight lines. 'Sculpting' with light therefore has much to do with directing and controlling its emanation. In response, artists have used different light sources and supports, each with distinctive aesthetic properties and spatial possibilities. The effect that light has on the surrounding gallery architecture becomes important, often forming a part of the artwork; some artworks actually take on the guise of built architecture. Overall, that the following artworks possess sculptural form is important – as 'objects' they still demand a sculptural encounter with the viewer, as something to be *looked at*, even if their forms exhibit varying degrees of solidity and ephemerality.

No artist was more pioneering or influential in his use of light, in particular the kind emitted from fluorescent tubes, than Dan Flavin. Over the course of three decades beginning in the 1960s, Flavin produced a myriad of works using only standard off-the-shelf fluorescent tubes in their ten available colours.[5] Despite these constraints, the results

3. Potts' term is indebted to French phenomenologist Maurice Merleau-Ponty's research into embodied vision. See Alex Potts, *The Sculptural Imagination: Figurative, Modernist, Minimalist*, Yale University Press, New Haven and London, 2000, p. 208.

4. With this particular historical trajectory in mind, many more artworks have been excluded from the exhibition than included. These include more 'discrete' or two-dimensional illuminated artworks, such as those by Keith Sonnier, as well as a plethora of works by artists who have used light as signage, a legacy that largely follows on from Joseph Kosuth's linguistic neons.

5. These included four different whites, as well as ultraviolet.

are remarkable: a seemingly infinite number of intensities and gradations of light achieved by mixing colours and configurations across three-dimensional space and in relation to architecture. By positioning his early artworks in relation to the gallery wall but in locations far from ideal for picture-hanging – at the corners and edges, occasionally touching the floor – the artist gave light a 'canvas' to engage with. His early work *the nominal three (to William of Ockham)* (1963, p. 87), was the first he modified to respond explicitly to architecture. After its original, pictorial display, the artist moved the work down to abut the floor, and made it adaptable to the space of display – spanning the whole wall from corner to corner.

From the outset, Flavin was aware that as a sculptural medium light 'somewhat betrayed its physical presence into approximate invisibility'.[6] By this he meant that the fittings, fixtures and tubes seemed to almost dissolve as supports for the medium of light, perhaps due to their ubiquity as fixtures and to their whiteness (so taking on colour in the same way as the gallery walls). Yet these supports, which are screwed or welded together into three-dimensional configurations, are crucial to how Flavin shaped light precisely. His first coloured corner square, *untitled (to the "innovator" of Wheeling Peachblow)* (1966–8, p. 89), projects a delicate balance of yellow and pink light into an area of the gallery usually abandoned to shadows. The square, which includes two outward-facing daylight-white tubes, doubles here as a frame for the corner, which in turn provides an area of sculptural depth for subtle effects of gradation to occur. Like most of Flavin's works, *untitled* involves a two-fold use of light: hard-edged linear forms that produce nuanced and diffuse effects.

6. Reprinted in Dan Flavin, ""...In Daylight or Cool White." An Autobiographical Sketch (1965)' in Michael Govan and Tiffany Bell (eds), *Dan Flavin: A Retrospective*, Dia Art Foundation and National Gallery of Art in association with Yale University Press, New York and Washington, DC, 2005, p. 191.

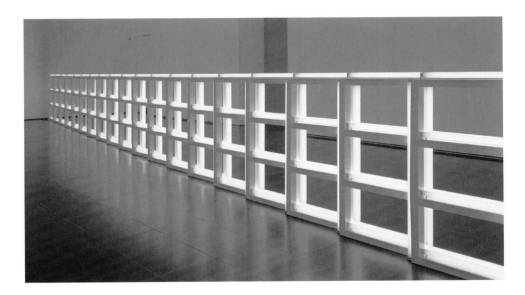

DAN FLAVIN, *UNTITLED (TO YOU, HEINER, WITH ADMIRATION AND AFFECTION)*, 1973

Around the same time that Flavin was making his first fluorescent light works, French artist François Morellet began working with illuminated neon. Compared to fluorescent tubes, neon affords more flexibility and customisation, in fact more than any other kind of light

source. This is perhaps why, after GRAV disbanded in 1968, Morellet continued using the material to explore his long-standing interest in geometric and elemental shapes.[7] A recent work called *Lamentable* (2006, p. 130), is typical of this sculptural abstraction. Designed as a large circle of arcing neon segments, the entire arrangement is suspended from the gallery ceiling, its connected pieces slumping under gravity. The resulting deconstructed figure becomes a large three-dimensional drawing, a translation of pictorial concerns into sculptural installation.

Since Flavin's and Morellet's pioneering artworks, artists have continued to deploy light in explicitly architectural ways, in some cases assuming the forms of recognisable structural elements. By using light in perhaps its most unnatural form – as a load-bearing feature – works by Brigitte Kowanz and by Cerith Wyn Evans each take on a surreal quality. Kowanz's *Light Steps* (1990/2013, p.117), is a series of ascending bars comprised of fluorescent tubes and their fittings. They appear to reach up from the gallery space toward the heavens (from where, in painting, light traditionally descends), yet retain such a minimalist aesthetic that they refuse a fully transcendent meaning. *Light Steps* was a key early work that set the tone for much of Kowanz's subsequent use of (primarily white) light to create sculptural forms that engage, shape and intervene in architecture.[8]

British artist Cerith Wyn Evans' recent installation *S=U=P=E=R= S=T=R=U=C=T=U=R=E ('Trace me back to some loud, shallow, chill, underlying motive's overspill…')* (2010, p. 176–7), takes the shape of columns of light as intangible and impossible architectural supports. The towering pillars are comprised of filament-strip lightbulbs arranged in cylinders, using only the bare minimum amount of structural support and wiring. The tungsten elements both emit light and radiate substantial heat, a reminder that visible light is merely a narrow section of the wider electromagnetic spectrum (see p. 44). Like many of Wyn Evans' other light-based artworks – including lamps, chandeliers, shutters and even a WWII searchlight that emits poems or passages of text via computer-controlled Morse code – the columns of *S=U=P=E=R=S=T=R=U=C=T=U=R=E* also pulse on and off. However, their cycles do not involve frenetic and abrupt flashes, but rather slow fades, a cadence that the artist has described as breathing. When off, the columns dissolve, leaving only transparent glass, mounts, wires and the relative emptiness of the darker (and cooler) gallery. Utilising near-obsolete lighting technology, Wyn Evans is able to create an architecture with a dynamic character that oscillates between oppressive physicality and near invisibility.

In an attempt to address the more immaterial aspects of light, artists Anthony McCall and Ann Veronica Janssens each use haze to make beams of light visible. The resulting 'sculpture' is visible but truly ephemeral, hovering in mid-air and allowing spectators to interact with and even interrupt it with their bodies. Reflecting and refracting off

7. The artists who formed *Groupe de Recherche d'Art Visuel* (GRAV), active from 1961 to 1968, were interested in investigating the perceptual phenomena induced in the spectator by their artworks, situations and environments.

8. Kowanz soon found that 'mirrors are instruments that allow me to work with light' and included them alongside light in most of her later works. Brigitte Kowanz and Barbara Willert, 'Brigitte Kowanz in Conversation with Barbara Willert' in *Think Outside the Box*, exh. cat., Museum Ritter, Waldenbuch, 2012, p. 30.

the countless microscopic particulates in the air, light seems to take on a tactile quality, an effect that McCall describes as 'solid light'. It was in New York in the 1970s that McCall pioneered the technique in his groundbreaking film *Line Describing a Cone* (1973, see p. 39, 121 for an in-depth discussion), a work that sits at the intersection of sculptural, pictorial and cinematic illumination.

Advancing the dynamic and near-tactile experience of McCall's earlier work, *You and I, Horizontal* (2005, pp. 122, 123) is part of a series of digitally animated projected-light works. The film features the interaction of three shifting mathematical forms: line, ellipse and travelling wave. The transition from one shape to the next is achieved by using a wipe, a cinematic convention usually used to indicate the passage of time or a change of location.[9] In McCall's film, however, the wipe plays out over minutes instead of seconds, creating a slow unfolding dance that allows viewers to examine the morphing sculptural form from all angles, whether by moving around it or by standing within the projection. From the latter vantage point, the viewer experiences an illuminated phenomenon entirely unique to McCall's work – enclosure within a hollow tunnel made of marbled white light.

Also created within a hazed room, Ann Veronica Janssens' *Rose* (2007, p. 109) grants light a similar visibility and tangibility as found in McCall's work. Instead of a digital projector, however, Janssens uses a circular configuration of theatrical spotlights directed at a central point to create a three-dimensional star. The overlapping beams of light make the heart of the star an especially bright point in space; the addition of pink filters colours the overall experience. As in her other works, comprised of rooms filled with even denser, obscuring haze, Janssens is interested in the way in which colour takes on a vibrancy and intensity under controlled conditions. *Rose* creates the perceptual effect of intense colour saturation via a delimited sculptural form. Its effect is almost soothing, bathing the viewer in pink 'starlight'.

As mentioned above, McCall uses the medium of film, whether celluloid or digital, to create constantly changing sculptural forms. Another way of shaping light dynamically is to exercise control over a multitude of lights, as American artist Leo Villareal has been doing since the late 1990s. Having studied computer graphics and programming in addition to art, Villareal designs and creates his own LED circuits, controllers and software. This allows him to create a scalable custom lighting technology that runs dynamic programmes in real time. A case in point is *Cylinder II* (2012, p. 166–7) a large sculpture, over 3.5 metres in height, and made up of concentric rings of LED strips, each containing hundreds of lights. The third in a series of what the artist calls 'volumetric explorations', the 19,600 lights together perform sequences of complex choreography across three dimensions. In a darkened gallery, the armatures seem to disappear, leaving only the clouds of light as they materialise, move, change shape and then dematerialise. Waves of

9. Further, the choreography of the two forms, their slow dance in space, could be read as something of an erotic interaction – as two figures, horizontally intertwined.

light travel in different directions along the cylindric form, while other bundles of light transform into a vortex of fireflies. With such a high degree of real-time control, light becomes a pliable medium in Villareal's work, in this way demonstrating an unparalleled ambition for the precision, speed and sheer quantity of illuminated sources.

Perceiving Light

If much of the sculptural and installation art of the 1960s depended upon the presence of the spectator in order to complete the work, this shifted the meaning of the artwork away from the object and toward the order of experience. As artist and writer Brian O'Doherty observed, the 1960s were 'concerned with eroding the traditional barricades set up between perceiver and perceived, between the object and the eye'.[10] Light art, in particular the kind that foregrounds perceptual phenomena, had a crucial role to play here. Many of these artworks are immersive and environmental installations that investigate how we perceive and negotiate the world around us. Many also depend upon established physiological principles in order to generate their effects. These artworks not only anticipate the presence of the spectator as a perceiving subject, but assume the mutability of his or her vision.

Working in and around Los Angeles during the 1960 and 70s, a number of artists comprising the Light and Space movement examined the relationship between materials and perception. Unlike the aforementioned European avant-garde groups, this was not a coherent movement, but instead a loose circle of contemporaries whose work demonstrated shared themes addressed through sculptural abstraction, and often involved experimentation with the reflections and refractions of light and new industrial materials.[11] Of these artists however, Doug Wheeler and James Turrell are the only two to have consistently used light itself as the primary means through which to create sensory environments.[12] They achieve this by carefully placing or concealing light fixtures in highly constructed spaces so that the phenomenal effects of light itself are emphasized.

Wheeler's transition from a canvas painter to an installation artist is apparent in his light encasement works of the late 1960s, made from neon installed behind a wall-mounted, vacuum-formed acrylic sheet. The light has a dissolving effect on the semi-opaque surface, causing it to blend into the supporting wall and even – via coved corners and vertices – into the surrounding room. Wheeler's frequent use of rare daylight ultraviolet neon heightens this effect by giving the white environment a further luminous glow. The artist has referred to the 'sensate experience' of his works in replacing the viewer's attention to the object with an awareness of the effects of light. So extraordinary was this sensation that John Coplans, curator of Wheeler's first solo exhibition, claimed, '[His] medium is not light or new materials or

10. Brian O'Doherty, *Inside the White Cube: The Ideology of the Gallery Space*, University of California Press, Berkeley, CA, 1999, p. 97.

11. Light and Space artists are identified by critics and art historians rather than by the artists themselves and usually include Larry Bell, Robert Irwin, Maria Nordman, Eric Orr, James Turrell and Doug Wheeler. Other artists sometimes included are Peter Alexander, Michael Asher, Ron Cooper, Mary Corse, Craig Kauffman, John McCracken, Bruce Nauman, Helen Pashgian, Hap Tivey, DeWain Valentine and Susan Kaiser Vogel.

12. It is worth noting that Maria Nordman continues to use the lack of light as a sensory environment, but resists association with the Light and Space movement.

13. John Coplans, *Doug Wheeler*, exh. leaflet, Pasadena Art Museum, CA, 1968, np.

14. James Turrell and Richard Andrews, '1982 Interview with James Turrell' in *James Turrell: Works 1967–1992*, exh. cat., Henry Art Gallery, Seattle, 1992, p. 37.

15. Turrell's *Bindu Shards* (2010, p. 160) is in fact a spherical light chamber that only a single viewer can enter at a time, via a gurney-like tray. See Dawna Schuld, 'Practically Nothing: Light, Space, and the Pragmatics of Phenomenology' in Robin Clark (ed.), *Phenomenal: California Light, Space, Surface*, Museum of Contemporary Art San Diego, University of California Press, Berkeley, CA, 2011, p. 111.

16. Some earlier installations had a more labyrinthine design and greater separation between the coloured zones, with a few, mostly outdoor, installations having transparent walls.

technology, but perception.'[13] Wheeler's larger installations such as *DW 68 VEN MCASD 11* (1968/2011) or *SAMI 75 DZNY 12* (1975/2012, pp. 172–3) exemplify this interest: they extend beyond the individual viewer's peripheral vision, their physical size immerses multiple viewers and their subtle lighting effects create the feeling of infinite space.

While Turrell's earlier works such as *Shanta, Red* (1968, p. 16) are shaped and/or coloured projections that explore the discrete sculptural aspects of light, he soon moved to a larger scale to make these effects wholly spatial – so that the viewer would 'look into [the work] rather than just at it', as the artist put it.[14] The *Wedgework* series (begun in 1969) is among the earliest to have this depth divided into what the artist calls the viewing space and the sensing space. In the former, the spectator is seated in a dark chamber, while the latter space beyond is filled with subtle light sliced through by intervening planes of angled light, forming wedges. This series of works critically incorporates the temporal dimension that is central to much of Turrell's practice – the full interplay of these multiple light elements slowly unfolds over the ten, fifteen, twenty minutes of immersion that the viewer's eyes require to adjust after entering. It is the dependency of the perception of light on duration that Turrell has refined over the years, particularly in his *Skyspaces* (1975 – present) – large chambers or stand-alone buildings that frame the sky through apertures, balancing the shifting natural light (to best effect at sunset) with computer-controlled interior lighting.

In some of the installations by Wheeler and Turrell, a single colour of evenly-diffused light can produce startling perceptual effects. Prolonged exposure to these environments not only causes the brain to recalibrate its 'white balance' (causing vision afterwards to be skewed toward the opposite colour), but also makes light seem atmospheric and colour almost tangible. The latter effect is an optical form of 'the ganzfeld', a state of disorientation caused by a confusion of the senses in response to continuous, uniform simulation. In removing visual anchors (by concealing doorways, corners, lighting fixtures, etc.), distance and spatial awareness are confounded, as if in a sensory deprivation chamber.[15] These monochromatic installations distil light, narrowing it to a single point of perception and amplifying the extreme nature of its effect.

Around the same time as Wheeler and Turrell were experimenting with light phenomena in California, Venezuelan artist Carlos Cruz-Diez was in Paris also exploring the properties of colour, only in a much broader way, across the full spectrum. Cruz-Diez's series of installations since 1965 called *Chromosaturations* (there have been 84 to date, see pp. 66–7, 69) immerse the spectator in rooms of coloured light. While each of the installations is unique, designed for a specific exhibition space, all share a basic format: a larger space is subdivided into three adjoining spaces, each of which is flooded by an intense red, green or blue light.[16] As the viewer spends time in each room and moves between

them, his or her eyes are continuously adjusting: to the dominant colour, to the additional colours created in the areas of overlapping light and to the unpredictable new colours produced as a result of the shifting optical experience. For Cruz-Diez, 'light, and its colours, create unstable situations that are constantly evolving and changing' and his environments provide immersive ways of exploring the 'situation' or 'event' of colour.[17] While the layout for each *Chromosaturation* installation is configured to suit each venue, the artist considers the physical space merely as an apparatus through which to produce perceptual phenomena.

A far more direct and immediate way of altering perception is to control the spectator's vision. American artist Nancy Holt's outdoor installations, including her famous *Sun Tunnels* (1973–6, p. 103) use holes and cylinders, some of which she calls 'locators', to narrow the spectator's field of vision and frame a particular view. One of only a few indoor installations by Holt, *Holes of Light* (1973, p. 99) brings these concerns into the gallery, drawing out the reciprocal relationship between sight and light. *Holes of Light* consists of a floor-to-ceiling partition that divides a large room, with a bright lamp on either side of it. What the artist describes as 'shapes of contained light' are created when one of the lamps shines through a series of holes in the partition, creating bright circles on the far wall.[18] Every minute or so the lamps alternate, causing the room to reverse light and dark sides; the spectator barely becomes accustomed to one spatial configuration before being subjected to the other. With a number of circles at eye-level, the relationship between sight and light becomes an equivalent and symmetrical one, articulated by the partition. And when multiple spectators populate the room, the corresponding relationship between perceiving and being perceived becomes strongly apparent.

The study of perception as both an individual and social phenomena is at the centre of Danish-Icelandic artist Olafur Eliasson's practice. His immersive installations probe the interactions between the viewer and sensory phenomena, and often have the feel of laboratory experiments incorporating the natural elements – fire, water, light, earth and air. His works, however, are intended to be catalysts for the moment and duration of experience, involving 'the combination of physically moving around them and looking at them at the same time, looking at the way they instrumentalise, or activate, the space'.[19] That this experience is contingent upon embodied vision is not only key to understanding how his works function, but is also essential to their completion: 'it's something that we produce, phenomenologically speaking, as we constitute the objects that we look at by looking at them'. By depending upon the presence of a perceiving spectator, Eliasson's works perhaps most clearly demonstrate the legacy of the 1960s concern with the 'situating of the body within the physical environment,' to return to Alex Potts' description.

17. Gloria Carnevali and Carlos Cruz-Diez, '"My Aesthetic [Is] the Effectiveness of the Evidence" Gloria Carnevali Interview with Carlos Cruz-Diez (1981)' in *Carlos Cruz-Diez: Color Happens*, exh. cat., Fundación Juan March, Madrid, 2009, p. 69.

18. The circles' penumbrae are also of interest to Holt as she inscribes them on the wall in pencil, creating a kind of afterimage when they are not illuminated. See Nancy Holt, 'Holes of Light, 1973' in Alena J. Williams (ed.), *Sightlines*, exh. cat., University of California Press, Berkeley, CA, 2011, pp. 242–3.

19. Olafur Eliasson and Jochen Volz, 'An Interview with Olafur Eliasson' in *Olafur Eliasson: Your Body of Work*, 17th International Contemporary Art Festival SESC _Videobrasil, São Paulo, 2012, pp. 413–4. Many of Eliasson's titles feature the word 'Your', emphasizing the ownership of the viewing experience.

20. See the over 140 artworks involving light in *Olafur Eliasson: Your Lighthouse. Works with Light 1991–2004*, exh. cat., Kunstmuseum Wolfsburg, Hatje Cantz Verlag, Ostfildern-Ruit, 2004.

A large proportion of Eliasson's work involves light in varying forms.[20] Of these, his series (since 1996) involving strobe lights and water demonstrate a unique optical effect through the use of specialist lamps and water in motion, generally falling. Earlier installations involve curtains of droplets or spray from a hose appearing to form solid walls or arcing coils of water respectively. In more recent works, such as *Model for a timeless garden* (2011, p. 77) water is given a more sculptural form through no less than 27 decorative fountains. When the rapid flicker of strobe light illuminates the fountains, the water droplets appear frozen in space, suspending our reference for duration (motion) and creating the paradoxical feeling of equally stilled and infinite time. The baroque water sculptures of *Model for a timeless garden* create something like a temporal bubble, extending the moment of perception, our time to revel in the garden.

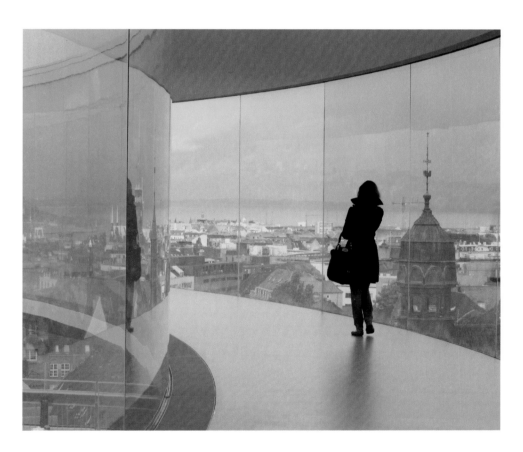

OLAFUR ELIASSON, *YOUR RAINBOW PANORAMA*, 2006–11

Addressing an altogether different physiological reflex related to vision, American artist Jim Campbell explores the subtleties of image recognition. From most angles his LED work *Exploded View (Commuters)* (2011, pp. 59, 60–1) appears to be a block of shimmering, decorative lights. But, when viewed straight on, the three-dimensional matrix aligns into two-dimensional perspective order and can be read as a screen on which moving shadows are recognised as walking human figures. Though high-tech, Campbell's work is actually low-resolution because he renders the film down until individual pixels correspond to single LEDs.[21] In fact, he is interested in achieving the *lowest* possible resolution in these works, the minimum threshold at which the viewer can discern

21. Like Villareal, Campbell engineers and programmes his own LED circuits.

moving shadows as figurative elements. This perceptual reflex is hard-wired into our eyes and brains, which have evolved to see objects in motion more easily than when they are at rest. As a kind of sculptural film, Campbell's work draws upon an instinctual trait, but it does so using advanced light technology.

Light References

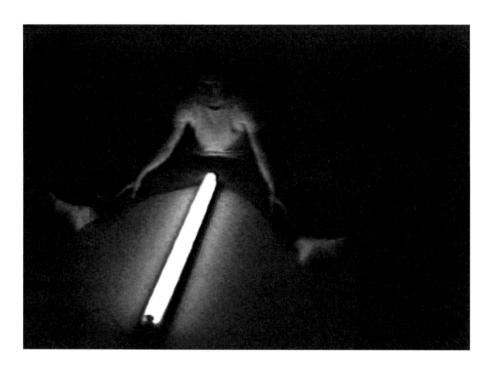

BRUCE NAUMAN, *MANIPULATING A FLUORESCENT TUBE*, 1969

As much as the artworks included in *Light Show* use light as a sculptural medium, light is also a medium in the sense that it carries information.[22] It is a medium to which specific cultural meanings and connotations attach, through direct or metaphorical references to specific kinds of light. Rather than explore the aesthetic (one is tempted to say Modernist) qualities of light, the following artworks are anchored in the social, the scientific and the literary. Some are also more self-consciously playful and witty – recalling that it was only six years after Flavin made his first diagonal fluorescent work that Bruce Nauman responded corporeally in his video *Manipulating a Fluorescent Tube* (1969), in which he poses with a tube, at one point literalising it as the artist's phallus between his legs. In this same spirit of awareness, Bill Culbert's *Bulb Box Reflection II* (1975, p. 71) condenses much of the zeitgeist and fascination with light art (including the artist's own) into a singular and enigmatic point of illumination – or non-illumination, depending on how the viewer perceives it.[23] The following artworks may be no less sensory or sculptural than those in the preceding sections, but it is their foregrounding of a specific subject matter that shapes our encounter with them.

Of a large number of artists referencing the light and language of advertising, the American artist Jenny Holzer has been the most

22. This quality is most obvious in lit signage and advertising, and the artworks that take on these forms, particularly since Joseph Kosuth's early neon works. Kowanz and Wyn Evans have both made light works that incorporate Morse code, another way of using light as a carrier of information.

23. Although the visual pun is only one aspect of Culbert's broader practice involving light as a medium and thematic, it is also present in the series of sculptural and photographic works that reveal a light bulb in the shadow of a short wine glass (see p. 73).

consistent and pervasive in the use of information-carrying LED signage. She first intervened in existing billboard and ticker signage in the late 1970s, and, since the mid-1990s, she has worked with the signs themselves as sculptural objects. At larger scales and in different shapes and forms, these custom-manufactured LED panels are sometimes designed and positioned in relation to existing architecture. *MONUMENT* (2008, p. 106) combines the prominence of a floor-to-ceiling column with a recent research project involving declassified US government documents related to the global 'war on terror'.[24] Reporting seemingly endless micro-narratives of both generalised and highly personal conflicts, this politically explicit work is both engrossing and at times horrifying. As the only source of illumination in the room, the work commands the surrounding space with multiple streams of running text; the space is plunged into dramatic darkness during long punctuations, but its multicoloured ambience is restored as information starts to flow again.

Even when presented as bespoke sculptures in the gallery, Holzer's LED signs carry the connotations of ubiquitous information signage. British artist David Batchelor's light-based works also exude the familiar illumination of the street, largely because they are found objects retrieved from the urban environment. Exemplary of the artist's broader interest in mass-produced and manufactured colour, his lightboxes – what he calls 'dirty readymades for shiny monochromes' – combine salvaged materials with sheets of opaque, translucent or transparent, coloured Perspex configured on industrial Dexion shelving units.[25] Without language or graphics to illuminate, they broadcast only their super-saturated colours. Moreover, when the lightbox works are positioned facing away from the viewer and toward the gallery wall, as they are in *Magic Hour* (2004/7, p. 52) the result is a halo of colour surrounding the monolithic sculptures. This auratic presence can be read as something of a visual pun considering the lowliness of the materials. However, according to Batchelor, colour too has a 'lowly place in the moral hierarchy of the universe', a social and historical condition he terms 'chromophobia'.[26]

Similarly quoting a specific form of outdoor light, Paris-based artist Philippe Parreno's light marquees preside over gallery doorways, importing a theatrical glitz and Las Vegas-style kitsch into otherwise serious locations. These flashing marquees can lead on to more modest artworks, by Parreno or by other artists, drawing attention to the threshold itself as theatrical passageway. The entertainment industry aesthetic of Parreno's marquee is shared by Chilean-born artist Iván Navarro's *Reality Show (Silver)* (2010, p. 133), a 'phone box' cabinet that the viewer is meant to enter. From the inside, one-way mirrors and lights induce a feeling of vertigo through illusions of height and depth; from the outside, spectators gain a voyeuristic view of the person experiencing the dizzying effects within.

24. These military transcripts were declassified and released under the Freedom of Information Act via the National Security Agency and the American Civil Liberties Union. They document formal investigations, violent incidents and autopsy reports; shift between third-person and first-person narrations; and are littered with censored names and struck text. These transcripts were first combined with *MONUMENT* in 2012.

25. David Batchelor and Clarrie Wallis, 'David Batchelor Interviewed by Clarrie Wallis, 07.11.03' in *Dirty Shiny*, exh. cat., Ikon Gallery, Birmingham, 2004, np.

26. David Batchelor, *Chromophobia*, Reaktion Books, Ltd, London, 2000, p. 25.

For Navarro, the combination of light and one-way mirrors in *Reality Show* became the basis for a series of lightboxes that create the illusion of space using light. These wall-mounted works quote the architectural footprints of skyscrapers such as the Empire State Building and the Jumeirah Emirates Towers. *Burden (Lotte World Tower)* (2011, p. 134) appears to retreat infinitely, recasting the building's towering height as receding distance. Unlike Parreno's thresholds or the environmental installations discussed above, Navarro's tunnels of light are virtual spaces that can be perceived but not entered. Further, onto the rear mirror of the lightboxes, Navarro inscribes words such as 'BURDEN', 'ABANDON' or 'DECAY', eroding the seemingly utopian aspects of these works and 'dirtying the purity of industrial forms', to borrow the artist's description.[27] Though not readymades, Navarro's works sit alongside Batchelor's in their examination of objects produced by a culture of late capitalism.

Far from the manufactured urban light referenced by Holzer, Parreno and Navarro, the practices of British artist Conrad Shawcross and Scottish artist Katie Paterson frequently refer to celestial light and its associated sciences. Many of Shawcross' light works, which take the shape of large spinning, twisting and rotating machines, refer to cosmology, quantum mechanics and harmonic ratios. For him, a moving light point expanding out from an origin is a metaphor for the Big Bang or a moving star; its movement 'can be a very obvious structural and visual metaphor to describe time'.[28] In the *Slow Arc Inside a Cube* series the speed at which the light moves is also critical: it has a 'sinusoidal profile' – accelerating toward the centre and decelerating as it moves outward – giving it the appearance of being subject to gravity, like an orbiting planetary body.

In *Slow Arc inside a Cube IV* (2009, p. 152–3) a cage surrounds a smaller, moving light source, casting a perspectival shadow on the gallery walls that tilts and veers in proportion to the movements of the mechanical arm. This series was developed during the artist's residency at the Science Museum, London, during which time he became inspired by Dorothy Hodgkin's use of crystal radiography to indirectly reveal the molecular structure of insulin. The shadows cast by the light source represent the methods of inference and indirect observation increasingly used in science to work beyond visibility, at both submicroscopic and cosmic extremes.[29] *Slow Arc* is a poetic and visually elegant form for representing aspects of complex scientific discoveries and theories.

Similarly research-based and equally poignant, Katie Paterson's work *Light bulb to Simulate Moonlight* (2008, pp. 145, 146) involves specially engineered incandescent bulbs that emit light of the same colour, temperature and intensity as moonlight. A single, lit bulb is suspended in a dark room, appearing to glow bluer and almost clearer than a normal bulb. It is indeed rare in effect, since almost all commercial bulbs are designed to mimic some form of (unmediated)

27. Justo Pastor Mellado and Iván Navarro, 'Politics of Provision' in *Iván Navarro: Threshold, 53rd Venice Biennale, Chilean Pavilion*, exh. cat., Edizioni Charta, Milan, 2009, p. 55. Navarro's previous works involving light are more explicitly political, addressing crime, dictatorship and homelessness.

28. Helen Sumpter and Conrad Shawcross, 'Interview with Conrad Shawcross' in *Chord by Conrad Shawcross*, exh. cat., Measure, London, 2009, p. 7. The gearing ratios of these machines define the paths that their lights trace out as harmonic tori, which can be seen in long-exposure photography of the works.

29. The works in the *Slow Arc* series also refer to Plato, through the use of simplified geometric structures (Platonic forms) and the shaping of perception using shadows (his 'Allegory of the Cave').

30. The number of bulbs is based on the average life of an incandescent bulb as 2,000 hours and the average life of a human in 2008 as 66 years. The bulbs were specially manufactured with OSRAM and each edition is accompanied by a logbook in which the start and end dates of each bulb are recorded.

daylight. Paterson's minimalistic display is given further resonance by the fact that each edition of the work contains 289 bulbs – an average lifetime's worth of moonlight.[30] The work literally and metaphorically measures out life in moonlight. Like many of Paterson's works that engage with geology, meteorology and astronomy, *Light bulb to Simulate Moonlight* humanises global or cosmic scientific concepts.

Taking a lighter attitude, British artist Ceal Floyer plays with the conventions of light as a medium, upending our expectations of how light inhabits our daily lives. Light has been the subject of frequent address in Floyer's conceptual practice, which turns on a series of self-reflexive conceits and linguistic puns. An early work, *Throw* (1997, p. 93) consists of a theatre spotlight projecting an image of a splat onto the floor; the title refers both to the casting down of an image and also the violent action required to make such a splodge. Though based upon a light effect, her work is not illusionistic, embodying instead a matter-of-factness, since the apparatus – a spotlight and gobo in the case of *Throw* – forms a visible part of the artwork. The medium of light proves to be slightly deceptive in Floyer's work, disrupting expectations and

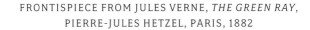

FRONTISPIECE FROM JULES VERNE, *THE GREEN RAY*,
PIERRE-JULES HETZEL, PARIS, 1882

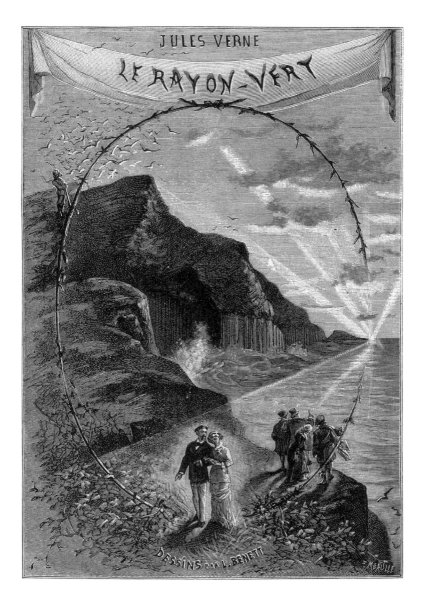

performing a kind of logical short-circuit that seems rather appropriate to its electrical source.

Equally literal in presentation, *Son et Lumière (Le rayon vert)* (1990, p. 84) by Fischli and Weiss is a small sculpture layered in illuminated meaning. The work's title refers to the popular outdoor light and music or sound shows that take place at night at historical or monumental locations; such extravaganzas are a far cry from the artists' rather modest display of a vintage camping light shining through a tumbling plastic cup on a turntable. This sculpture's special effects show is the small patterns cast on the wall and the repetitious 'clunk' of the plastic cup as it rounds each rotation. The work's secondary title refers to an even grander light phenomenon: the green ray, a very rare flash of coloured light observed through an extremely clear atmosphere when the sun dips below the horizon. Ciphered through both Jules Verne's book *The Green Ray* (1882) and Eric Rohmer's 1986 film of the same name, the work takes the concept as a romantic metaphor for longing and aspiration. *Son et Lumière* parodically miniaturises the hope that its viewer might just catch a glimmer of green on the gallery wall.

Conclusion: On and Off Art

As a relatively new medium, and one intertwined with the continuing history of invention, artificial light brings with it transient and material-based concerns. While some artists like Campbell and Villareal utilise cutting-edge materials, others like Wyn Evans, Culbert and Paterson look back to outmoded and increasingly obsolescent forms of illumination. In late 2012, the European Union directive banning the sale of incandescent bulbs came into force, forever changing how we regard these objects, both culturally and artistically. Like analogue photographs or 16mm films, the historical resonances evoked by artworks that use 'old-fashioned' lightbulbs are significantly amplified. While the replacement technologies exemplify the cultural tendency to work increasingly quickly, toward the speed of light, artworks exploring this immaterial material most often resist this pace, giving us time to slow down and consider its nature and effects.

As we have seen, since the 1960s artwork using light as a sculptural medium has generally emphasized the experiential nature of viewing and drawn particular attention to the nature of perception. These works have and continue to contribute significantly to the field of sculpture, not only facilitating the transition from object to environment, but also expanding upon its spatial and visual potentiality. The vast amount of ground covered by the artworks using light is a testament to the fact that artists are able to bend light in different directions, not only aesthetic and perceptual, but also thematic and topical. Perhaps less explicitly, artists have also turned to light for its potential to have a bearing on mood and emotion, to create wonder and a sense of awe.

VISION
MADE VISIBLE

ANNE WAGNER

This is an essay that aims to characterise the nature and intentions of light art over the course of the 100 years or so this genre has been in existence. The brush it uses is necessarily broad, given the scope of the topic, but even so, the effort seems worth making if it brings one central difference between early and contemporary light art into view. That difference, to anticipate the essay's conclusion, is a matter of effects and aims. These are inevitably diverse, yet most recent light works still seem to share the recognition that an audience possessed of vision is equipped with a faculty that is mutable and profoundly bodily, yet at the same time more than merely personal; it is also interpretive, situational, historical and cultural. These qualities, so artists have implicitly argued, can be made vivid, made visible, if light can be shown to have a poetics that can be put to active use.

An essential precondition of the human faculty of vision, light began to be understood, produced and controlled in whole new ways in the twentieth century. Technologies developed in the 1800s – gas and electricity – were the first to generate cheap and reliable sources of illumination, and thus helped to enable the use of light as both a vehicle of mass communication and an artistic medium, in each case with unprecedented results.[1] In earlier centuries, calculated effects of light and space had been crucial to the experience of religious buildings and public spectacles, but in the fine arts, light had served mostly as a formal and emotive vehicle, vivifying sculptural surfaces and providing the template for many of the most dramatic of painting's depicted effects. Light, and its antonym, darkness, created the art object's atmosphere, in every sense of that word. They summoned its central illusions, which so strikingly render the impression of time's passage and the sensation of physical depth.

The changes in this state of things began to arrive in the wake of World War I. They involved the idea that, in the face of the new visual powers and experiences that result from artificial illumination, human vision would inevitably be subject to change.[2] The issue, for at least some artists, has been how the enormous explosion of visual experiences and technologies would matter to their art, if at all. When they deployed light, they could not help but confront its relationship to time and vision;

1. Readers are referred to the invaluable exhibition catalogue, *Light Art from Artificial Light: Light as a Medium in 20th and 21st Century Art*, Peter Weibel and Gregor Jansen (eds), ZKM/ Museum für Neue Kunst, Karlsruhe, 2006, whose many contributors together survey the topic in its multiple dimensions.

2. Marshall McLuhan, first in *The Gutenberg Galaxy* (1962) and then in *Understanding Media* (1964), became the great theorist of these changes.

the diverse implications of their interconnection became a subject in itself. If the nineteenth century offered a 'New Painting', in the guise of Impressionism, in the twentieth century nothing less than a 'New Vision' seemed to come into view, in large part the product of the pedagogical and technological awareness championed at the Bauhaus, first in its Dessau studios, and then, following the school's forced closure, in the United States.

Soon after he joined the Bauhaus faculty in 1923, the Hungarian photographer László Moholy-Nagy (1895–1946) began to try to represent this New Vision – the phrase became his watchword – and to present its developmental logic since the invention of photography as a forsaking of pigment for the medium of light.[3]

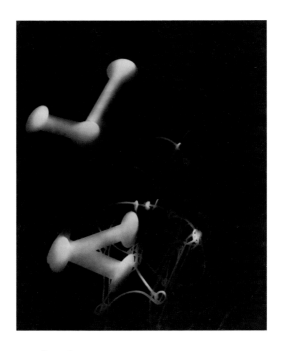

LÁSZLÓ MOHOLY-NAGY, *UNTITLED*, 1925

From representation to optical experience: the energies propelling this logic were not to be understood as merely subjective, the province of each individual spectator exercising the faculty of sight. On the contrary, Moholy-Nagy maintained that objective factors – the 'material qualities of the optical medium of expression' – determine visual experience. And when that optical medium is black-and-white photography, the logic of its light-sensitive process leads directly to its ability to stand in for light. If Moholy-Nagy's work takes up light's 'material qualities', it does so by capturing its powers of erasure and exposure, its affinity for edge and outline, its untrustworthy revelation of depth. This is a materiality dedicated to black and white as its default condition, marking out both visual and spatial extremes.

The artist first put these concepts to work in mechanically generated images he termed photograms.[4] To understand the procedure behind them – works such as that shown above were produced by illuminating objects positioned on or just above photosensitive paper – is to grasp how Moholy-Nagy mined the possibility of pushing chiaroscuro towards

3. 'From Pigment to Light' in Richard Kostelanetz (ed.), *Moholy-Nagy: An Anthology*, Da Capo Press, New York, 1970. Or, as the artist put it in the introduction to *Painting, Photography, Film* (MIT, Cambridge, MA, 1969, first published in 1925), 'Chiaroscuro in place of pigment'. 'The New Vision', Moholy-Nagy's coinage, was a term in general use to describe German photography of the period.

4. The word is a neologism derived from telegram, another coinage prompted by modern technology. The Oxford English Dictionary, q.v. 'telegram', locates its first usage in 1852, and points to the initial dispute among scholars over the failure to follow the Greek analogy suggested by *tele*; had it done so, such messages would have been named *telegraphemes*, as indeed they are in modern Greek. The photogram deploys what might be called a pre-photographic technique, in use since the discovery of the photosensitivity of chemically coated paper. While William Fox Talbot (1800–77) called the result a photogenic drawing, in the first decades of the twentieth century the name of the individual artist using it (the Schadograph for works made by Christian Schad, the Rayograph for those produced by Man Ray) was routinely deployed. Moholy-Nagy's is the first term for this technique to make clear its hybrid relationship to current technologies of communication.

emptiness, and defamiliarising the mundane objects afloat in its space. They were the first of his works to exemplify the New Vision: active, unsettling, they tied transparency to space, fragmentation, speed and disembodiment. If this way of seeing is new, it thrives on blindness as much as sight. And it led its inventor to experiment with projecting light and shadow in space.

Beginning in the early 1920s , Moholy-Nagy put his mind to devising a machine-powered display of moving artificial light. The apparatus that resulted – by now twice reconstructed, as befits its legendary status – is a quasi-sculptural construction fabricated from moveable planes of metal and glass. Its language is urban, architectural, as if to broadcast messages to and from a city on the move. And so it did. Spot lit, it was set into motion (its components were mounted on a set of turning axes) like a mechanical organ playing an updated fugue.[5] The effect is utterly theatrical, with spectators composing an 'audience' on which the light and shadows fall. Little wonder that Moholy-Nagy first presented it in Paris in 1930 bearing the title *Light Prop for an Electric Stage (Lichtrequisit einer elektrischen Bühne)*. Two years later, it became the centrepiece of the artist's first film, *A Light-Play Black White Grey (Ein Licht-spiel schwarz weiss grau)*, its initially modest staging of shadow now augmented by the injection of special effects.[6] The effect produced is dizzyingly antic, a splintering geometry of light and dark.

5 . The earlier replica (1970) is at the Van Abbemuseum, Eindhoven; the later one, which was manufactured for inclusion in a 2009 exhibition at Tate Modern, is now in the collection of the Harvard University Art Galleries.

6. These effects, which according to Oliver Botar included 'multiple exposures, negative sequences and doubling, as well as light modulating properties such as transparency and translucency', were clearly chosen to strengthen and supplement the 'natural' workings of the *Prop*. See Botar's 2008 review of several recent books on Moholy-Nagy's films, 'Films by Lázsló Moholy-Nagy', *Journal of the Society of Architectural Historians*, vol. 67, no. 3, November 2008, p.461.

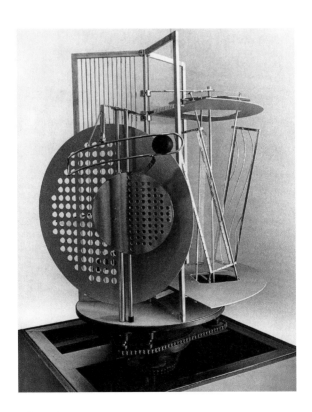

LÁSZLÓ MOHOLY-NAGY, *LIGHT-SPACE MODULATOR*, 1922–30 (RECONSTRUCTION OF 1970)

7. Botar attributes this information to the American scholar Linda Dalrymple Henderson. See *ibid.*, p.462, n. 7.

Later, in 1969, *Light Prop* was renamed *Light-Space Modulator*, and under this title its first replica was produced the following year.[7] The name change seems significant: it is as if an object that was initially quick to acknowledge its artificial, even theatrical, status was later asked

to assume another identity, as an agent of perceptual change. Yet it is considerably more plausible to assume that by then, with Moholy-Nagy dead for almost a quarter-century, his work was not a catalyst so much as a recovered memory, a forgotten prototype in which 1960s critics and historians could recognise a kindred aim.

Yet this intuition was only partly right. There is no doubt that Moholy-Nagy's experiments with artificial illumination remain landmarks, yet their effects inevitably seem restricted compared to those deployed by the diverse set of artists who followed. These occupy his 'electric stage' with a considerably wider range of aims and effects than he could or would have conveyed.

Thus our task demands making sense of that diversity, the sort of sense that, if it begins with basic demographics, moves on to other matters. For if it is crucial to note that artists using light today are both male and female; and that their national origins span several continents; and they range in age from the generation born in the 1920s to the cohort born in the 1980s, what is more important is that, though they too mine the effects of artificial illumination, their goals have changed. The aim is not so much to invent a 'new vision' consciously adapted to 'modern' experience, to speed and the city; nor do they see artificial light as a modern emblem, the sign and symptom of technological change.

One reason it still seems useful to remember Moholy-Nagy's practice is because it helps us to think about what is different, or might be different, today. Is it possible that the experience of time and light has changed since then? In interwar Europe, the transformative goals of 'New Vision' were to be actively, even passionately, embraced. Since then, ambivalence has wormed its way in. Artists seem to have become less prepared to put blind trust in technological vision or to find 'illumination' only in the otherworldly glow of the screens that surround us. These have emerged as our 'personal' devices, the technologies that, in the words of David Cronenberg, are the ones 'you take to bed with you'.[8]

The question here is not where these changes have come from, but whether a new set of principles concerning light and vision have come to govern light art since its return, so to speak, in the years since the 1960s. By the end of that decade not only had the *Light-Space Modulator* been remade for exhibition, but a series of exhibitions – shows staged in both US and European museums with titles like *Kunst Licht Kunst* (1966), *Light, Motion and Space* (1967) and *Light: Object and Image* (1968) – had begun the process of describing the new landscape, or lightscape, initiating a process that is still ongoing.[9] Nor is its end in sight, given the sheer proliferation of art using light in the last forty years or so, as opposed to the half-century before. Where there's light, there's heat, or so the saying goes. To it should be added a rider: where there's light, there is also vision and time. Since the 1960s, this trio has again emerged as a key concern of ambitious artists, with some of the reasons for its new centrality set down by the artist Nancy Holt in 1973. Her list,

8. The opening lines of David Cronenberg's film *Videodrome* (1983) are said by a man's voice coming from a television set: 'Civic TV; the one you take to bed with you.' Cronenberg both wrote and directed the film. Since it appeared, mobile phones and tablets have, of course, been added to the list.

9. The titles mentioned refer to shows held at the Stedelijk Van Abbemuseum, Eindhoven, the Walker Art Center, Minneapolis, MN, and the Whitney Museum of American Art, New York, respectively.

entitled *Vision,* was first published as a contribution to Lucy R. Lippard's 1973 catalogue, *c. 7,500.*[10]

10. The catalogue, one in the series of exhibitions now dubbed 'numbers shows', is part of the topic of Cornelia Butler et al., *From Conceptualism to Feminism: Lucy Lippard's Numbers Shows, 1969–74,* Afterall, London, 2012.

```
NANCY HOLT

Vision Fixed
Vision Concentrated
Vision Demarcated
Vision Located
Vision Concretized
Vision Re-focused
Vision Circumscribed

Vision reconnected with vision in a dual channel
Vision delimited and reflected in mirrors, glass
Vision designated by things as they exist in the world

Vision made visible
Vision made actual
Vision made definite

Vision within a circle
Vision within sight patterns set up in depth
Vision within the boundaries of sight
```

NANCY HOLT, *VISION*, FROM LUCY R. LIPPARD, *c.7,500*, 1973

This was a moment when the artist's list – half poem, half manifesto – was often presented as a work in itself. Like Richard Serra before her, Holt proved herself a master of the form. But while his subject was sculpture and all that can be done to make it ('to roll to crease to fold to store'), hers was vision – vision as it can be manipulated, and thus made the object of the artist's labour and thought.[11] Vision, she writes, is or has been 'fixed', 'concentrated', 'demarcated', 'located' and 'concretized', 're-focused' and 'circumscribed'. It is or has been 'reconnected', 'delimited', 'designated', 'made visible', 'made actual', 'made definite'. All these terms are governed by a shared implication that there is a yawning gap between the illumination offered by nature and that invented by man. Holt's notion of the latter sees it as being acted upon by some unnamed force or agent – the artist, perhaps, though this is never made clear. The closest Holt comes to identifying this catalyst is in speaking of 'vision designated by things as they exist in the world'; in retrospect this seems close enough.

11. Serra's handwritten list is now in the collection of the Museum of Modern Art, New York. Richard Serra, *Verb List,* 1967–8, graphite on paper, two sheets, each 25.4 x 20.3 cm. Gift of the artist in honour of Wynn Kramarsky.

To 'designate' vision is to make it visible, actual, concrete. Again, the adjectives are Holt's. But what seems striking in retrospect is how much purchase they seem to have on the shared purposes of light art, then and since. Consider, for example, the work of Dan Flavin, which from the outset staked a claim on an 'actually existing vision', to be summoned by the studied deployment of store-bought fixtures, and thus of store-bought light.[12] The artist's use of the variously soft and vibrant hues of fluorescent tubing – the commercially-available fixtures he bought off the shelf – insistently brought the experiential effects of various 'elsewheres' (the garage, the workshop, the warehouse) into the physical space of the gallery. Most often, the result is perceptually confounding. Our eyes begin to ache uncomfortably, and our ability to

12. This brief paragraph relies on material discussed at greater length in my essay 'Flavin's Limited Light' in J. Weiss (ed.), *Dan Flavin: New Light,* Yale University Press, New Haven and London, 2006, pp.108–32.

see is exposed as a function, first, of where we stand and move within the gallery; second, of how long we have stood there; and third, of what we have just seen in the moment before. It sometimes matters what we wear to look at a Flavin (say, we are wearing white when looking at an ultraviolet installation), and it always matters what we look at next. Flavin's works are utterly a function of artifice, so much so that, within their compass, time and light no longer work together; we are no longer able to read the one from the other, and vice versa. What's the point of telling time when the clock being looked to is an artificial sun?

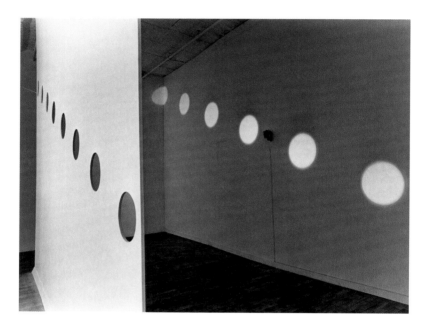

NANCY HOLT, *HOLES OF LIGHT*, 1973

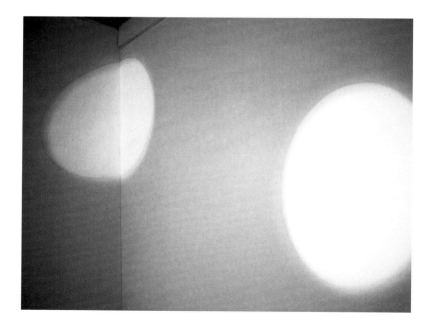

When Holt first drew up her 1973 list, she was undoubtedly thinking of Flavin's works. This seems inevitable, given their visibility at the time, not only as the focus of both regular gallery exhibitions and major museum presentations in the United States and abroad, but also given that their author played such a notoriously argumentative art-world role. Yet Holt was also clearly speaking from her growing sense of light as a

medium, and her efforts to realise what she termed the 'concretization of sight'. This is a concept that if it is explored most thoroughly in her *Holes of Light* (1973, opposite), and its accompanying documentation also shaped much of her art.

An installation that depends on artificial illumination, *Holes of Light* operates by channelling and thus shaping light's fall. Its method is simple: two brilliant quartz lamps are mounted on opposite walls of a gallery, which in turn has been divided by a temporary wall through which have been cut a diagonal line of eight circles. Each of these is ten inches in diameter, and each creates an orb of bright light that is double the size of its generating hole. Yet, because the room divider is shorter than the walls of the gallery, none of these light circles appears crisply defined. Although each is the product of a distinct light/dark alternation, ambient light erodes its curves. The 16 bright pools thus each take on an oddly hazy, elusively optical appearance that the artist has bordered with a pencil trace. It is as if the eponymous holes have been cut so as to measure light's immeasurability, and thus to undermine the precision of the work's own precisely-cut apertures. As a result, Holt's 'holes of light' become cloud-like; capable of softening, even obscuring, our sight.

The fact that the great majority of Holt's light works were produced out of doors gives *Holes of Light* its own particular role in her work. As an installation, it makes vision visible under what we might call laboratory conditions, a set of rules drawn up to test out phenomenological questions of light's incidence and play. Holt's outdoor works, by contrast, harness perceptual experience in aid of a different sort of vision – a vision consciously 'located' in a conceptually expansive cosmos large enough to measure planetary time. This is nowhere more vivid than in her brilliant *Sun Tunnels* (p. 103). Sited in the barren grandeur of the Great Basin Desert, Utah, the three-year project was completed in 1976. Like an enormous camera or a cosmic sundial, the sunlight caught in the work measured the annual activity of the heavens, both sun and stars.

It bears insisting that for an artist like Moholy-Nagy, the sun was not a concern. Like other artists of his generation, he would have concurred with the Futurist ambition telegraphed so concisely by the title of the 1913 opera *Victory over the Sun*.[13] Moholy-Nagy's ideal field of operations was urban and nocturnal; if light was to be confined to the interior, the artist preferred light shows, projections and film. Light and spectacle went together, and his goal was to find a way to mobilise their hyperbolic opticality for a spectator whose assigned role asked only that she look.

By contrast, to consider the range of light works produced since the 1960s is to see that the viewer's share is considerably expanded. She now moves, thinks, observes and remembers. She is often asked to understand light and its sources not only as having a history, but also as summoning the terms in which artificial light has been put to social use. When Philippe Parreno, for example, constructs (or reconstructs) a theatre marquee, whose time-bound typology he has been exploring

13. As a teacher at the Bauhaus, Moholy-Nagy knew both Kazimir Malevich and El Lissitsky, each of whom produced costume designs for the work.

since 2008, he uses it not only to enhance a real-life doorway, but also to recall the sense of splendid artifice that characterised the great movie palaces of a long-lost day. And when, in 1973, Anthony McCall adapted straightforward animation techniques to simulate the projection of a movie – the work that resulted was his foundational *Line Describing a Cone* (opposite) – he too addressed the deep-seated semantics of the cinema, transforming its signature projection into a slowly forming and deceptively tactile cone of light. And in this case, a work that began life as a structural analysis of film's fundamental components – the projector and its changing cone of light – has become in the course of its recent screenings a memorial to cinema's now-vanished past.

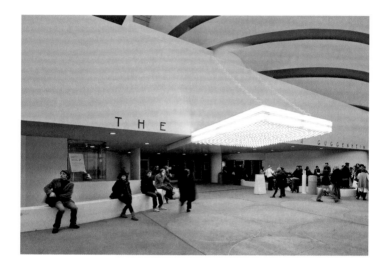

PHILIPPE PARRENO, *MARQUEE, GUGGENHEIM, NY,* 2008

One way to characterise the transformation represented by McCall and Parreno is in terms of what seems to be a growing recognition of the metaphoric capacities of light. Not only does it illumine, it also represents – and does so with often deceptive force. The long-established association between light and knowledge had already become unfixed by the 1920s: since that time, light has been revealed as an untrustworthy agent, capable of deceptions both large and small.

Among recent artists, it is perhaps Ceal Floyer who has specialised with greatest concentration on producing gestures that, despite their small scale, manage to communicate something of this experiential complexity. *Light Switch* (1992–9, p. 98) does nothing more emphatic than to use a standard carrousel projector and 35 mm slide to cast an unchanging light patch alongside a nearby door. It is only on approaching its steady brightness that the viewer can see that the slide represents the switch of the work's title. And, of course, it summons other 'switches' too, more conceptual in kind: above all, there is the linkage we are asked to make between the obvious source of the light and the considerably subtler implications of its projected image. It is as if the impossible tripping of this non-existent switch would dispel our accustomed understanding of how artificial light occupies our space. Is it too just an image, after all?

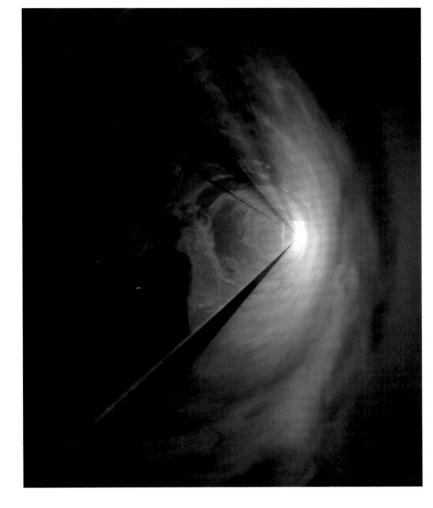

ANTHONY MCCALL, *LINE DESCRIBING A CONE*, 1973

To encounter *Throw* (1997, p. 93), another of Floyer's utterly minimal pieces, is to become acquainted with her rendering of two separate meanings that inhabit the title word. On the one hand, a light, like a voice, has 'throw' – which is to say that it projects according to its strength. On the other, if a speaker were to 'throw light' on an obscure subject, she would make it clear. By contrast, the light that comes from Floyer's *Throw* does neither. Instead, the work revels in its rendering of light as a splotch or splatter whose outline has cartoon-like force. The result is a pun conflating light, language and Modernist painting: we are back again with Jackson Pollock's splatters and pours, though now equipped with the contradictory effects of violence and humour that occur when the language of light is made concrete.

Perhaps here, in the seamless overlay of effects that are both immaterial and yet so sensually present, comes the complexity that light art before the 1960s did not seem to possess. These are the contradictions that animated Olafur Eliasson's *The weather project* (overleaf and p. 82), the unforgettably monumental, yet coldly illusory, sun that dominated the Tate Modern Turbine Hall from October to March 2003–4. The sheer scale and artifice of the work, though not literally cinematic, inevitably take us back to Moholy-Nagy's preoccupation with a cinematically urban spectacle, though only to insist that if Eliasson's spectacle should also be understood as urban, this quality is above all the effect of the enormous audience – more

than 2.3 million visitors – it attracted in the course of its run.[14] That, and the pre-coding of their beachside behaviours inside a space set aglow by a stone-cold sun. Throughout all of this, they saw themselves seeing – and thus sensing – because Eliasson's design had replaced the hall's workaday ceiling with a mirrored skin.

14. In his essay 'Tate Modern's Turbine Hall and the Unilever series', Wouter Davidts cites a Tate Modern press release made public immediately following the work's closure and giving the attendance figure of what remains a high for this particular space. See Christopher R. Marshall (ed.), *Sculpture and the Museum*, Ashgate, London, 2011, p. 213, n. 15.

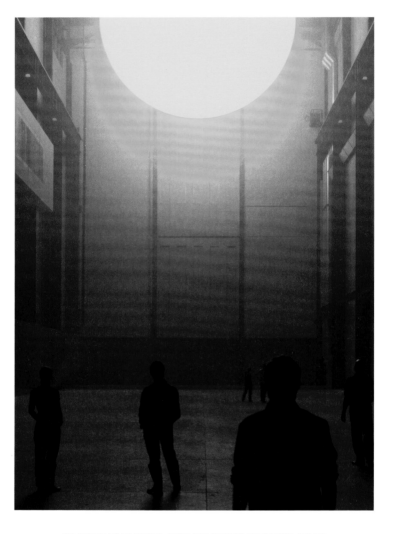

OLAFUR ELIASSON, *THE WEATHER PROJECT*, 2003

As technologically precise as it was socially compelling, *The weather project* is one of those outsized works that, despite (or because of) their obvious complexity and ambition, can serve as what might be called a 'representative' work. What it stands for is a newly analytical and newly social aspect of light work, initiated in the perceptual awareness urged on gallery-goers since the 1960s, and increasing ever since. If such pieces succeed in making vision visible, the result is viewers who are asked to develop an awareness of what it means to inhabit that role. We are asked, as Eliasson once put it, to 'see ourselves sensing', with his revision of Holt's concept pointing to the potential of self-conscious sight. This form of vision is spatial and sensual, and often occurs alongside other viewers whose presence we cannot ignore.[15] In achieving effects that are social and metaphorical, bodily and temporal, the light art of recent decades seems to have abandoned 'new' vision so as to represent something of the complexity that already inheres in human powers of sight.

15. For a discussion of Eliasson's notion of 'seeing yourself sensing', first presented in a brief text accompanying an exhibition of that title held at the Museum of Modern Art, New York, in 2001, see my essay 'Acconci and the Senses' in Juan A. Gaitán, Nicolaus Schafhausen, Monika Szewczyk (eds), *Cornerstones*, Sternberg Press, Berlin, 2012, pp. 116–31

FROM SYMBOL TO SUBSTANCE: THE TECHNOLOGIES OF LIGHT

PHILIP BALL

There has never been a time when the nature of light has not been at the leading edge of science, technology and art. We 'play' with it for so many reasons – to encode information, to bedazzle the senses, to probe the universe, to evoke the presence of the divine. These are not, as they might seem, separate issues, which is one reason why the scientific study and use of light comes laden with cultural and symbolic signification. At the same time, that same science – both fundamental and applied – has prescribed the boundaries of light as an artistic medium. As our ability to produce and manipulate light has evolved, artists have embraced the possibilities on offer, so that light art is, among other things, always a conversation with technology.

Sacred Light

The theological virtues of light pervaded its early scientific study. Early Christianity was imbued with a metaphysics of light stemming from the tradition of Neoplatonism, according to which radiance was a symbol of God's presence. When men spoke truth, they were 'lucid'; when they understood it, they were 'illuminated'. This reverence for light motivated the thirteenth-century proto-scientists Robert Grosseteste, Bishop of Lincoln, and his disciple Roger Bacon to study optics at the University of Oxford. 'Physical light is the best, the most delectable, the most beautiful of all the bodies that exist,' wrote Grosseteste.[1] That was not mere genuflection; Grosseteste was the first to propose that the rainbow's arc – an eternal source of wonder, a symbol of the Virgin and the post-diluvian renewal of life – results from the refraction of light by clouds. His hypothesis wasn't quite right, but it helped to locate the answer to this age-old question in optical science.

Light had not shaken off its religious connotations when the great scientists of the seventeenth century, such as Isaac Newton, Robert Boyle and Robert Hooke, began to study it. In popular culture, light was as much demonic as it was divine, to be feared as well as revered. Things that glitter and glow in the dark are the stuff of folklore. Boyle's servants

1. Quoted in Georges Duby, *The Age of the Cathedrals: Art and Society 980–1420*, trans. Eleanor Levieux and Barbara Thompson, University of Chicago Press, Chicago, 1981, p. 148.

summoned him in terror to investigate a side of meat hanging in his pantry, gleaming with luminescent bacteria. Phosphorus, discovered around 1669, was attributed miraculous healing powers because of its spontaneous glow, the result of chemical reactions with air. When phosphorus was demonstrated to Boyle at his house in 1677 by tracing, in the dark, the word 'DOMINI' on the carpet with a finger dipped in the liquid element, you can sense Boyle's awe at this 'mixture of strangeness, beauty and frightfulness'.[2] His colleague John Beale worried that studying it would 'raise stories of Ghosts in my house'.[3]

Light and Colour

Boyle's assistant, Robert Hooke, a less pious man, was more interested in the technologies of light and optics. Hooke wanted to know what light is, and his answer clashed with Newton's. For Newton, light was 'corpuscular' – a stream of little particles. Hooke insisted that it must be a wave, a vibration of some all-pervading substance called 'the ether'. As Hooke very nearly understood, the interference of wavy light may explain the iridescence of peacock feathers (in which light bounces off microscopic stacked layers of reflective material) and of oil slicks on water.

ADDITIVE (LEFT) AND SUBTRACTIVE (RIGHT) METHODS OF COLOUR COMBINATION

How light makes colour was Newton's forte. In *Opticks* (1704) he gave the first complete account of how the rainbow is made, explaining not only its arc shape – a slice of a cone of light reflected from raindrops onto the observer, as René Descartes had already adduced – but also its chromatic bands. As light enters and exits a raindrop, it is refracted: the ray's path is altered. When light is refracted through different angles, the rainbow spectrum that sunlight contains is teased out into its component colours. That same distillation of light, albeit from an artificial source, is effected in Olafur Eliasson's 1993 work, *Beauty* (p. 78), in which a bright light shone on a fine mist falling elicits a fugitive rainbow.

Newton asserted that the arc has seven fundamental colours: red, orange, yellow, green, blue, indigo, violet. This tenet, still recited by schoolchildren, is sheer numerology: Newton believed that the rainbow was seven-hued by spurious analogy with the seven notes of the musical

2. Quoted in Michael Cooper and Michael Hunter (eds), *Robert Hooke: Tercentennial Studies*, Ashgate Publishing, Aldershot, 2006, p. 112.

3. In J.V. Golinski, 'A Notable Spectacle: Phosphorus and the Public Culture of Science in the Early Royal Society', *Isis*, 80, 1989, pp. 11–39, quoted on p. 31.

scale. Scientists today usually recognise just six colours, indigo and violet being merged as purple.

Here, then, was something new about light: its 'whiteness' is a condensation of all the colours of the rainbow. Newton proved that fact in a celebrated experiment in 1665, when he demonstrated that sunlight separated by a prism into a multi-coloured spectrum can be recombined by a second prism and lens to create pure white illumination. But didn't this contradict everything artists knew about colour from mixing paints? The reason for the discrepancy is that mixing coloured light adds colours (and brightness) to the rays – it is called additive mixing. But mixing pigments subtracts colours, because each pigment absorbs parts of the light reflected from the mixture. This subtractive mixing inevitably diminishes the brightness of the reflected rays (see opposite).

Before any of this was understood, Newton's theory of light and colour seemed strange, even absurd. Johann Wolfgang von Goethe rejected it, proposing instead a muddled theory of colour, which made yellow and blue the 'primaries' from which all other colours are composed. Goethe's ideas have always exerted a peculiar attraction for artists – J.M.W. Turner, a 'light mystic' of almost Neoplatonic proportions, produced a startling vision of the post-diluvian world based on these ideas in 1843 (see below). But there is little in Goethe's theory for the scientist.

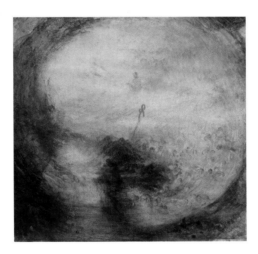

J. M. W. TURNER, *LIGHT AND COLOUR (GOETHE'S THEORY) – THE MORNING AFTER THE DELUGE – MOSES WRITING THE BOOK OF GENESIS*, 1843

The ambiguities and effects produced by additive mixing of light are apparent in several works by Dan Flavin in which differently coloured fluorescent tubes are placed side by side, modulating one another's appearance. The effect is striking in his *Untitled (to Don Judd, Colorist)* (1987), where vertical quartets of white, red, yellow, blue and green light are topped with horizontal white tubes: the white seems to bleach the blue and green tubes in particular, except where the light bounces off the dark floor and regains its chromatic intensity. Flavin also combines yellow and pink additively to make a delicately graded salmon/peach hue in *untitled (to the "innovator" of Wheeling Peachblow)* (1966–8, p. 89).

Deconstructing Light

After Newton, the common belief was that light is a substance. At the start of the nineteenth century the English polymath Thomas Young begged to differ, showing that a wave theory was needed to explain light's interference effects. Waves are excited whenever a body becomes luminous: for example, when the tungsten filament of a light bulb is heated by electrical current passing through. As James Clerk Maxwell showed several decades later, the waves are vibrations of electrical and magnetic fields: they are electromagnetic waves. The wavelength of light – the number of waves per millimetre, say – determines its colour. As Young correctly estimated, the wavelength of violet light is around 400 nanometres (i.e. 400 thousand-millionths of a metre), and that of red light is around 700. Young pointed out that there was no reason for the waves to cease at these visible extremes. Ultraviolet light – known in Young's time as 'blackening rays' (we still speak today of 'black light') – has wavelengths shorter than violet; and infrared light, which we cannot see but can feel as heat, has wavelengths longer than red.

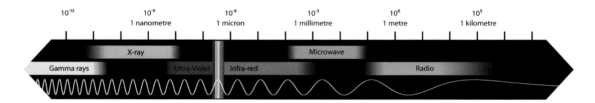

DIAGRAM SHOWING THE ELECTROMAGNETIC SPECTRUM. FREQUENCY (IN METRES) IS SHOWN ALONG THE TOP OF THE DIAGRAM, WITH VISIBLE LIGHT INDICATED BY BANDS ON THE SPECTRUM AT CENTRE-RIGHT.

Ultraviolet light may be rendered 'visible' when it stimulates fluorescence, whereby it is absorbed by a material and re-emitted at a slightly longer wavelength, typically in the violet part of the spectrum. The result is that only the fluorescent medium is rendered visible, and, moreover, often with a flat, ghostly appearance that disturbs perceptions of distance and contour. Doug Wheeler makes use of ultraviolet neon tubes (described below) to 'dissolve' the edges of a wall-mounted acrylic panel, transforming it into a light installation.

There was no obvious upper or lower limit to the wavelengths of Young's light: that which we see is merely an arbitrary slice of a continuous spectrum, to which our eyes happen to be sensitive. At wavelengths shorter than ultraviolet, there are X-rays and then gamma rays; the long-wavelength end of the spectrum extends to microwaves and radio waves, with wavelengths measuring perhaps several kilometres. Scientific instruments such as astronomical telescopes can reveal this otherwise invisible universe.

In 1905, Albert Einstein asserted that light is quantised: it comes in little packets (quanta) of energy, called photons. When an object glows, it emits a stream of these 'pieces of light'. Photons (unlike Newton's

44

corpuscles) have no mass, but they have energy, which is proportional to their frequency: blue photons are more energetic than red ones. The quantum view of light doesn't replace Young's waves with particles. Instead, it says that light can display both wave-like and particle-like behaviour, depending on how you observe it. This 'wave-particle duality', which also applies to fundamental particles such as electrons, is easily misconstrued. It doesn't mean that light is sometimes a wave and sometimes a particle: it's always just light, but we can sometimes better understand what light does by considering it as a particle (photon), and at other times by considering it as a wave.

Seeing Light

Goethe's notion of what light is might have been incorrect, but a more fruitful aspect of his work was the recognition that colour is a phenomenon not simply of light but of perception too: light has an effect on the visual sense, which is capable of conjuring results that could not be guessed by focusing on Newton's 'light corpuscles' alone. The quirks of our visual system can, for example, make us see light that isn't really there, evoking yellow from red and green light, say. In daylight, colour is decoded by the light-sensitive cone cells in our retina, of which there are three types, each with a strongest sensitivity to red, green or blue-violet light. The neural signals from these three types of receptors are combined before being interpreted by the brain as a particular colour. That's why red and green mix additively to make yellow: they generate the same 'sum'.

Goethe also recognised that spectral colours can be grouped into complementary pairs – red/green, yellow/purple, blue/orange – and that strong colours can stimulate the appearance of a surrounding aura of the complementary, noting that after staring at a bright colour for a long time, one may see an after-image in the complementary colour when one looks away. This effect is elicited in Ann Veronica Janssens' work *Donut* (2003), in which concentric rings of strongly coloured light are projected onto a wall and rapidly alternated with moments of darkness, stimulating coloured 'phantom' images of the shapes in the viewer's perceptual field when no light is projected. The eye also adjusts our perception of colour to accommodate changes in overall light intensity – an effect called colour constancy, which has the evolutionary rationale of ensuring that hues don't seem to alter in confusing ways as the sun slips behind cloud. James Turrell's *Space Division Constructions* series exploit this feature of vision to produce 'screens' of coloured light intersecting a space apparently enclosed by white walls, whose 'whiteness' is sustained by colour constancy.

In very dim light, the cone cells don't register the illumination very strongly, and instead our visual sense switches over to using rod cells, which are more light-sensitive but don't convey any sense of colour,

which is why objects seem to lose their colour in darkened environments. Also, rod cells are rather more sensitive to blue than to red light, making greenish and bluish objects, such as foliage, relatively more visible at night. This shift in colour sensitivity happens at dusk as rods take over from cones, and is known (after its discoverer) as the Purkinje shift. Turrell's *Dark Spaces*, made in the 1980s, exploit this adaptation of colour vision. Installed in very dim environments, they require viewers to sit for several minutes while adaptation to the dark takes place, so that if they are patient and attentive they can begin to make out the faint projected light. The intensity is sometimes so low that one can't be sure if what is seen is real or just a trick of the retina: the light acquires what has been called a 'questionable existence'.[4]

4. Quoted in Craig Adcock, *James Turrell: The Art of Light and Space*, University of California Press, Berkeley, CA, 1990, p. 111.

Turrell, who has studied perceptual psychology, has also exploited a visuosensory variant of the ganzfeld effect, in which the brain responds to the lack of stimulus from a highly uniform visual field by amplifying random 'neural noise', producing hallucinations – or alternatively, by creating a sensation of 'blackness' or blindness. Both consequences have been reported by Arctic explorers in dazzling white snowscapes. Turrell's 'ganzfeld' works saturate a space with coloured light that reflects off pure white surfaces, causing a disorientation of perceptions of space and scale. This optical effect is also manipulated by Carlos Cruz-Diez in his *Chromosaturation* (pp. 66-7, 69) installations, in which visitors walk through three adjoining chambers, each flooded with red, green or blue light. Coloured light merges at the boundaries of the chambers, summoning a range of hues through additive mixing. Alternatively, Cruz-Diez presents the viewer with simultaneous, sharply contrasting colours at different points in the environment, so that complementary colours may enhance one another's vibrancy – an effect that painters have exploited, instinctively at least, since the Renaissance.

Making Light

It's sobering to realise that the scientists of Newton's generation had a sophisticated understanding of optics – they knew the laws governing the reflection and refraction of light, and could use lenses and prisms to manipulate it – but still had to work in the evenings by candlelight and oil lamp. Not until the advent of gas lighting in the early nineteenth century was there more than the feeblest relief from night's gloom, and only after electrification in the latter part of that century was there an alternative to the glow of the naked flame.

Science was more the beneficiary than the begetter of these new light technologies. Thomas Edison's carbon-filament incandescent bulbs, filed for patent in 1879, were the result not of theory but merely trial-and-error testing of different materials. There were plenty of electrically-powered incandescent lamps before then, some also using carbon filaments, but the key to commercial success lay with finding

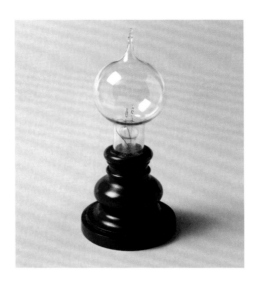

the optimal design and making the device affordable and convenient. Incandescent tungsten-filament lamps were improved in the early twentieth century by adding a halogen element, usually bromine or iodine, to the chamber, which allows tungsten evaporated from the hot filament to be re-deposited back onto it, enabling it to last longer. Most bright film, stage and projection lighting uses tungsten halogen bulbs. The greater robustness of these filaments allows halogen bulbs to withstand the strong forces of acceleration that they experience in Conrad Shawcross's dynamic lightworks, such as *Loop System Quintet* (2005, p. 155). Here, single bulbs are attached to articulated arms, which rotate at high speed, tracing out apparently solid trails of light.

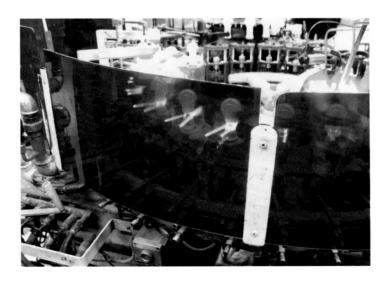

KATIE PATERSON, *LIGHT BULB TO SIMULATE MOONLIGHT*, 2008.
BULBS IN PRODUCTION, OSRAM FACTORY, NOVÉ ZÁMKY.

Incandescent bulbs have been stripped of their banal familiarity when reconfigured for artistic purposes. By modifying the filament to tune the colour spectrum of the light, and applying a special coating to the glass, engineers at OSRAM were able to reproduce the light spectrum of moonlight for Katie Paterson's *Light bulb to Simulate Moonlight* (2008). And the wasteful heat of their glowing filaments – one reason for their disappearance in this age of energy efficiency –

is an intrinsic aspect of the viewing experience for Cerith Wyn Evans' *S=U=P=E=R=S=T=R=U=C=T=U=R=E* *('Trace me back to some loud, shallow, chill, underlying motive's overspill...')* (2010, pp. 176–7): dazzling columns made of long glass tubes threaded from end to end with a hot filament.

Science also benefited from the invention of the gas-discharge tube, the forerunner of the neon light. When an electrical discharge is passed through a gas (such as mercury or sodium vapour), electrons in the current may collide with gas molecules and excite them into emitting light of a colour characteristic of the elements in the gas. In the 1850s the German scientific-instrument maker Heinrich Geissler invented tubes that exploited this effect, producing richly coloured light sources that were sold for demonstrations in universities and schools. In some cases – for example, with argon gas and mercury vapour – the emitted light lies outside the visible range in the ultraviolet zone. Filling the tube with a liquid that fluoresces under ultraviolet irradiation, or coating the walls with a phosphor material that does the same, allows this 'black light' to be converted to a form visible to the human eye: this is a fluorescent tube. The latter approach was developed by the French physicist Edmond Becquerel in studying fluorescence. The colour of the light can then be selected by choosing an appropriate phosphor.

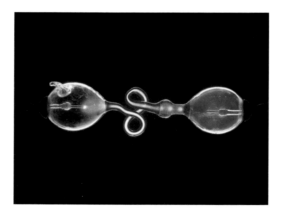

WORKING GEISSLER TUBE, c. 1988

At the end of the nineteenth century, the advantages of using so-called inert gases – helium and argon, but especially neon – in gas-discharge tubes become apparent. Neon was discovered in 1898 by William Ramsay and Morris Travers in London. Using gas-discharge tubes to study its properties, Travers wrote that 'the blaze of crimson light' from a neon tube 'was a sight to dwell upon and never forget'.[5] That was precisely what recommended this gorgeous orange-red glow for advertising signs and displays. The trouble was that neon was rare. Only when the liquefaction of air became an industrial affair, first by French inventor Georges Claude's company Air Liquide in 1902, did neon become readily available as a by-product. Claude (the 'French Edison') unveiled his large neon tubes in 1910. Three years later they were being used in advertising and signage, and in 1919 they lit up the entrance to the Paris Opera.

5. M.W. Travers, *A Life of Sir William Ramsay, K.C.B., F.R.S.*, E. Arnold, London, 1956; quoted in John Emsley, *Nature's Building Blocks: An A–Z Guide to the Elements*, Oxford University Press, Oxford, 2011, p. 341.

When Dan Flavin began to use fluorescent tubes in the 1960s, their commercial, ready-made aesthetic was part of the appeal, just as painters such as Frank Stella took to using industrial paints: the choice was a political statement, a challenge to authority and, given the standardisation of commercial products and the 'cool' quality of the fluorescent light, a depersonalisation of the artistic gesture. Flavin worked primarily with fluorescent tubes because he wanted a choice of colours – but he simply took these 'off the shelf' from what was available. That ready-made philosophy means that most of Flavin's works are composed of linear tubes, whereas the neon tubes used for commercial signage are typically customised: bent to form letters or images. Several artists who work with neon tubes – Joseph Kosuth, Bruce Nauman, Glenn Ligon, Tracey Emin, Cerith Wyn Evans – adopt the message along with the medium, spelling out glowing slogans that subvert, echo or even exploit the intimate association with advertising.

Quantum Light

The advent of light-emitting diodes (LEDs) in the 1950s, and then the laser in the 60s, marked the capacity of advanced science at last to contribute substantially to the art of illumination. These devices can be understood, and thus designed, only using quantum physics, but the principles are not so different from the gas-discharge tube: electrical current stimulates the emission of light, with a wavelength (colour) determined by the chemical nature of the emitting fabric. In the late 1950s scientists discovered that the semiconductor gallium phosphide, laced with other elements, can be used in red-light LEDs – initially called 'crystal lamps' because the glowing component was crystalline. Tinkering with the chemical composition yielded green and yellow lights in the 1970s, while strong blue-light LEDs, made from gallium nitride, did not appear until the 1990s. LEDs not only last longer than incandescent bulbs but use much less power – a valuable asset in just about any application.

BLUE-COLOURED LEDS, 2012

When LEDs became widely used in advertising billboards in the 1970s, artist Jenny Holzer appropriated the idiom in artworks that undermined the commercial-propagandist function of the medium: for example, in her use of a huge LED sign in New York's Times Square to broadcast the message 'PROTECT ME FROM WHAT I WANT' (p.107). Scrolling messages on LED displays have remained a signature feature of her work, but as LED technology shifted from bulb-like capsule units to miniaturised, flat devices, she made more use of bespoke polychromatic arrays that adapt to the surrounding architecture and bend in sculptural ways.

The direct conversion of electricity to light in LEDs and lasers, without the intervention of heat, allows light technology to be miniaturised. Because they are small, robust, can be switched on and off almost instantly, and can be tailored to specific colours, LEDs have transformed display technology. The crystalline semiconductors in these devices can be expensive and brittle, and require high-tech processing methods. But, over the past two decades, LEDs have also been made from electric-conducting plastics that will emit light, which are flexible, cheap and easy to manufacture using printing technology. Plastic LED screens are now being commercialised for laptops and televisions, and their low cost, low power consumption and bendiness are sure to stimulate new uses: light-emitting textiles, paper-like screens with moving images, expansion into art, design and architecture.

FLEXIBLE ORGANIC LED (OLED) LIGHTING
DEVELOPED BY HOLST CENTRE, EINDHOVEN

The rapid electronic switching of LEDs and lasers also means that binary information – the currency of information technology – can be encoded in pulses of light, rather than the electrical pulses of silicon micro-electronics. This is a major motivation for the recent growth of photonic technology, which introduces new methods of controlling and manipulating light. For example, photonic crystals – 'mirrors' made from tiny arrays of reflective objects, such as stacked microscopic beads, honeycombs of holes, or alternating layers of two materials – can contain light almost perfectly, leading to tightly-curved light channels and leak-proof optical fibres. Many of these tricks for controlling light are already

used by nature: in, for instance, the brilliantly reflective wings of the Blue Morpho butterfly, or indeed the peacock feathers that fascinated Robert Hooke. The uses of highly reflective and iridescent pigments with such layered microstructures have so far been confined to applications such as car paints; artists are just beginning to understand how to use these materials to guide light and blend colours.

The new technologies of light go much further. It is now possible to subvert the laws of optics themselves: for example, artificial materials that can refract light 'the wrong way', or that can guide light rays along artfully curved paths that skirt an object – like river water running round a protruding rock – in effect rendering the object invisible. These 'invisibility cloaks' were first made for operating at microwave frequencies; now they work for visible light too. Even light itself is not immune to reinvention: quantum engineering that reconfigures the way light is absorbed and re-emitted as it travels through a transparent substance can effectively slow down light to a crawl, and even bring it to an apparent standstill – and even more extraordinary, can make it seem to exit a material before it even enters. Whether these tricks will find practical uses – storing information in arrested light pulses, for example – remains to be seen.

Trick of the Light

Art has always been beholden to technology to a greater extent than is commonly acknowledged, whether it be the glassmaking expertise that contributed to the manufacture of Egyptian faience, the pigment-making alchemy of the Middle Ages, or the invention of photography or of acrylic resins. In most such instances, the technologies themselves had other motivations; artists see opportunities that scientists and inventors rarely imagine, happily appropriating technical innovation, but also subverting and redirecting it. The technologies of light are no exception, and that is why advanced photonic engineering will surely enter the gallery.

But there are additional dimensions to this relationship. For one, light has a symbolic cultural resonance that science has not eroded, that it even enhances as it offers new possibilities for luminal play and new insights into the nature of light itself. Through relativity, light becomes the determinant of time. Quantum engineering imbues light with information and meaning and makes old certainties – the path of a light ray – contingent. Moreover, light is not just about electromagnetism and photons, but about perception and illusion. There are many tricks of light, and they force us to question the relationship between the world that impinges on the senses and the world that the senses reconstruct from that stimulus. There is a science of effect that light mediates. And this is a part of what makes it, and has always made it, such a powerful medium for the artist.

DAVID BATCHELOR, *MAGIC HOUR*, 2004/7

DAVID BATCHELOR

David Batchelor's subject is the vivid, saturated, synthetic colour that characterises modern cities. He has no interest in the colours found in nature; it is unnatural, artificial colour that excites him: 'industrial colours ... chemical, electrical, plastic, metallic, neon'.[1] Because illuminated colour is such a conspicuous feature of the urban environment, light has become an important aspect of Batchelor's work. His sculptures and installations are created from the plastics and electricity that generate what he regards as 'the great colours of the city'.[2]

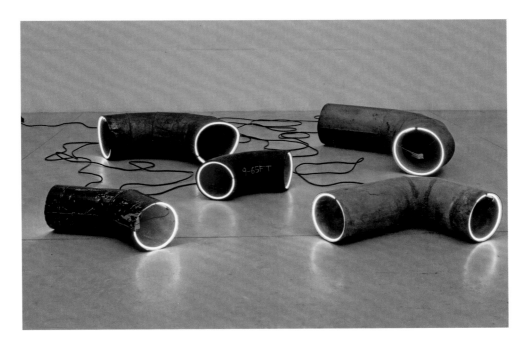

DAVID BATCHELOR, *SLUGFEST 2*, 2012

Batchelor finds most of his materials in the supermarket or on the street. The discarded commercial light boxes that populate many of his installations are acquired from skips and salvage companies. Having begun life as exit signs, shop signs, signs for burger joints and so on, Batchelor regenerates them by cleaning up the insides, re-lighting them and inserting monochromatic Perspex or vinyl panels, which might be opaque, translucent or transparent. They are then mounted on metal shelving units to form free-standing towers, totems or more complex

OVERLEAF: DAVID BATCHELOR, *BARRIER (FRONT AND BACK)*, 2003

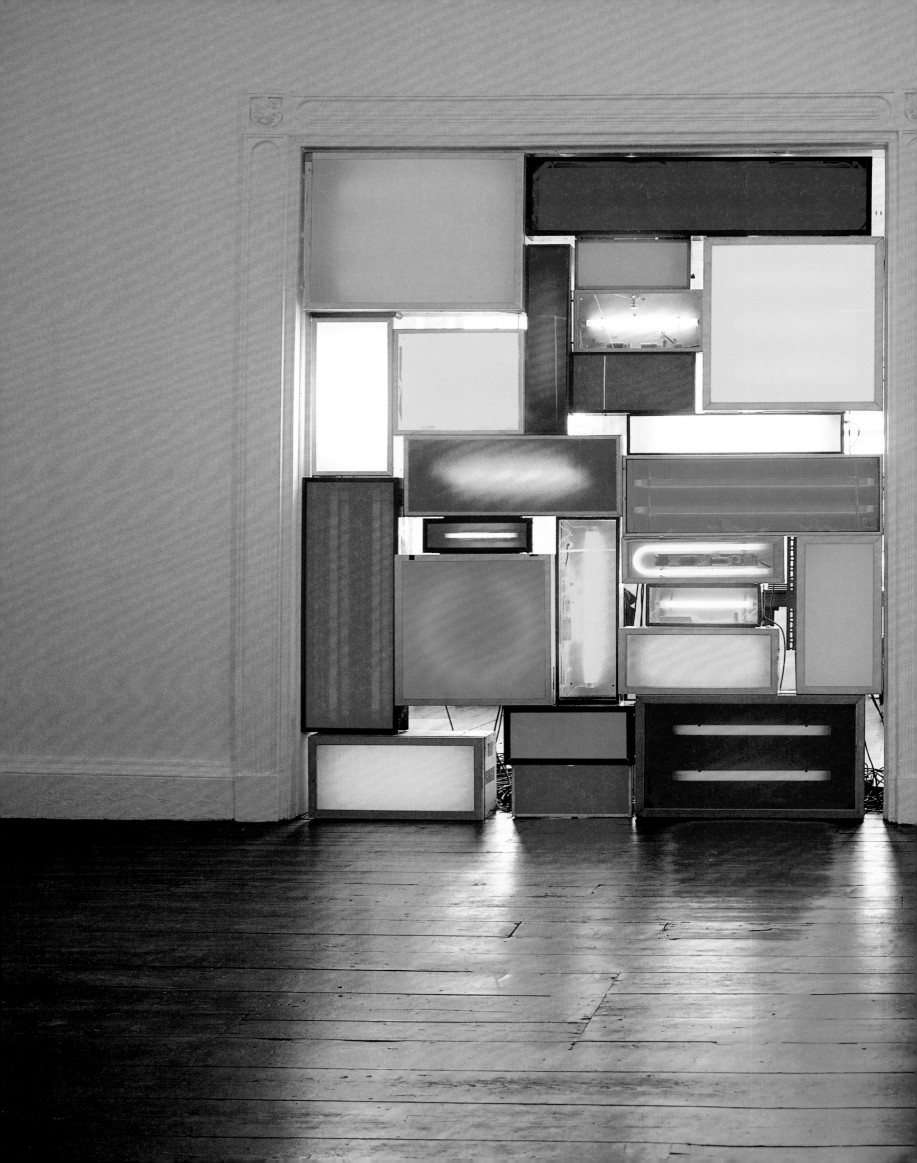

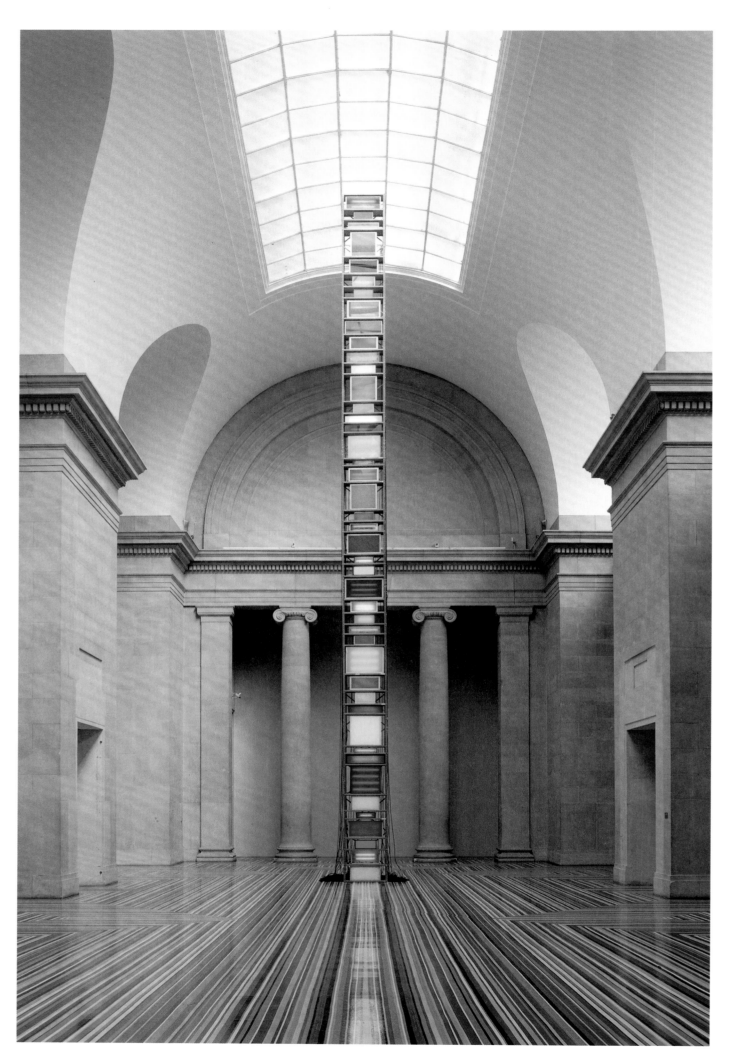

DAVID BATCHELOR, *SPECTRUM OF BRICK LANE*, 2003,
WITH JIM LAMBIE, *ZOBOP*, 1999–2003 (FLOOR)

configurations. *Treasury Magic Hour* (2004), a site-specific installation for the Treasury building in Whitehall, is a glowing column of light boxes stacked one on top of the other and positioned, facing outwards, at the top of a flight of stairs, where it lights up a particularly dreary, gloomy area. As with many of his works, the effect of *Treasury Magic Hour* changes throughout the day, according to ambient light conditions. It appears much brighter at night and, as Batchelor says, 'at dusk – called the "magic hour" in Las Vegas – it would make you want to throw away all your money'.[3]

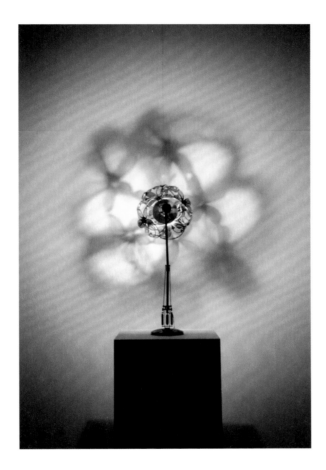

DAVID BATCHELOR, *EYEMOBILE*, 2008

Since then, Batchelor has made a number of works that appear to turn their backs to the viewer. Facing the wall, they produce aureolas of bright, vivid light around dark forms that are often, as he puts it, 'dirty, contingent and crude'.[4] *Magic Hour* (2004/7, p. 52) was the first of these, and owes its present orientation to one of the 'studio accidents' that Batchelor values as catalysts for shifts in thinking and working. *Magic Hour* was originally intended to be seen from both the illuminated 'front' and the shadowy 'back'. Batchelor was never happy with the 'front', but it was not until he tried placing it face to the wall that he realised that, in this position, the lights produced an unusual effect, creating a glowing, multicoloured halo.

Among other aspects of urban colour that Batchelor exploits are the lurid plastic bottles made to contain cleaning fluids, hair-care products and fizzy drinks. Finding that these glowed in an extraordinary way when lit from inside, he began making 'kebabs' of bottles skewered

on fluorescent tubes, which he leaned against the wall. He went on to make chandeliers and festoons of bottles individually lit with low-energy bulbs. Here, as in all his work with light, he makes the mechanics – plugs and cabling – visible in order to emphasize its everyday-ness. 'There's always someone who will mistake a bright light in a darkened space for a religious experience,' he remarks.[5] 'If you can see the plug, then it stops you getting mystical.'[6]

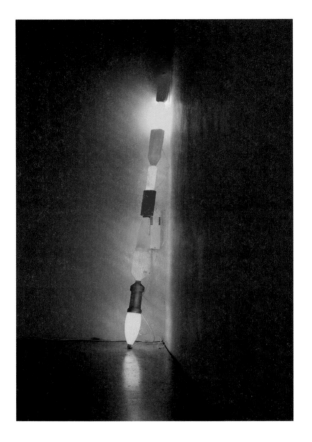

DAVID BATCHELOR, *IDIOT STICK 1*, 2000

As Batchelor points out, illuminated colour is just one of the many forms of colour experienced in today's cities. His work, which encompasses drawing, photography and other colour-based three-dimensional work, as well as illuminated constructions and installations, explores the intense, unmodulated urban colours that are often overlooked. In particular, he says, he is drawn to the way in which vivid colour co-exists with dirt and a degree of darkness: 'That's often how colour is in the city. It isn't pure or detached or disembodied.'[7] HL

1. 'David Batchelor interviewed by Clarrie Wallis, 07.11.03' in *David Batchelor: Shiny Dirty*, exh. cat., Ikon Gallery, Birmingham, 2004.

2. David Batchelor, 'GI symposium: Painting as a New Medium', *Art & Research: A Journal of ideas, context and methods*, vol. 1, no. 1, Winter 2006/7; http://www.artandresearch.org.uk/v1n1/batchelor.html

3. David Batchelor, statement for Field Art Projects; http://www.fieldartprojects.com/docs/artist.php?id=2:4:32:3:0, accessed 20.09.2012.

4. From 'David Batchelor interviewed by Clarrie Wallis, 07.11.03', *op. cit.*

5. From *theEYE: David Batchelor*, interview-based profile on DVD, 26 mins, *Illuminations*, 2006.

6. David Batchelor, 'GI symposium: Painting as a New Medium', *op. cit.*

7. David Batchelor, unpublished statement ,'Magic Hour', 31.3.2012.

JIM CAMPBELL

JIM CAMPBELL, *EXPLODED VIEW (COMMUTERS)*, 2011

Jim Campbell's 'exploded views' consist of assemblies of flickering LED lights suspended in space. These low-resolution works conflate elements of sculpture and cinema, stretching the moving image into three dimensions. They are concerned with what Campbell refers to as 'primal perception'. In his words, these works are 'about creating an image that somehow "clicks" into us recognising something without even really

imaging it – you just kind of feel it'.[1] Their legibility depends on two factors: the movement of the image and the position of the viewer. Viewed from most perspectives, the works appear as a random array of lights that blink on and off. But, from a certain distance, and at a particular angle, a discernible image emerges. In the case of *Exploded View (Commuters)* (2011, previous pages) the impression of shadowy figures that dissolve and resolve as the viewer moves around is created by more than a thousand LED bulbs, which together draw less power than a toaster, and are controlled by customised electronic circuit boards. Suspended individually on a grid of wires attached to the ceiling, each light flickers like a pixel; collectively, they appear to coalesce as an image.

Before he began the 'exploded views', Campbell had made other low-resolution works, using 'curtains' of LEDs in which the suspended lights face inwards, producing diffuse reflections on the gallery wall. One of these, *Taxi Ride to Sarah's Studio* (2010), was created from a video that he filmed from the window of a New York taxi cab as it crossed the Brooklyn Bridge. Explaining that the work is about peripheral vision, Campbell points out that as you look from one side to the other the resolution changes (the lights become exponentially fewer and further apart as the wires spread to the right), giving the impression of being in a moving vehicle.

Although constructed very differently, these LED installations refer back to some of Campbell's first experiments with perception, in that the closer you get to the work itself, the less you see. Produced in the early 1990s, *Untitled (for Heisenberg)* and *Shadow (for Heisenberg)* – which feature, respectively, a naked couple embracing and a Buddha positioned on a piece of text – were both designed to change their appearance in response to the viewer's presence. They are based on the quantum physicist Werner Heisenberg's 'uncertainty principle', a theory based on the fact that the more precisely one tries to observe or measure something, the more obscure it becomes. In these works, the images elude the close investigation that they each invite; the nude figures become abstractions, while the image of the Buddha fades from view and is replaced by the sculpture's shadow.

Campbell, whose background is in mathematics and electrical engineering, made his first LED artwork in 2000. Though most of his electronic installations involve an image, however fugitive, *Last Day in the Beginning of March* (2003) consists only of circular pools of light that fluctuate in intensity. He describes it as a 'non-linear rhythmic narrative' that chronicles the last day of his brother's life. Each of the 26 lightbulbs is connected to a circuit containing a fictionalised electronic 'memory' of a specific event, such as breathing (and coughing), rain, driving or anxiety, which modulates the brightness of the light cast on the floor. HL

1. 'Jim Campbell on the genesis of "Exploded Views"', video, July–October 2011, San Francisco Museum of Modern Art; http://www.youtube.com/watch?v=W4T5kECTYaE, accessed 7.10.12.

JIM CAMPBELL, *MOTION AND REST 1, 5* AND *2*, 2001

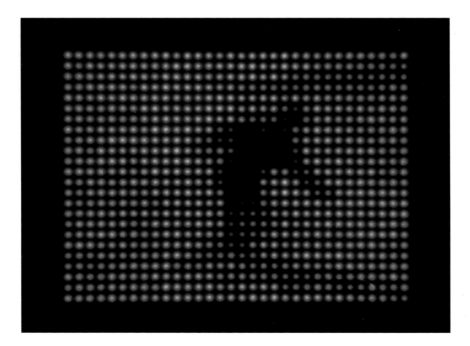

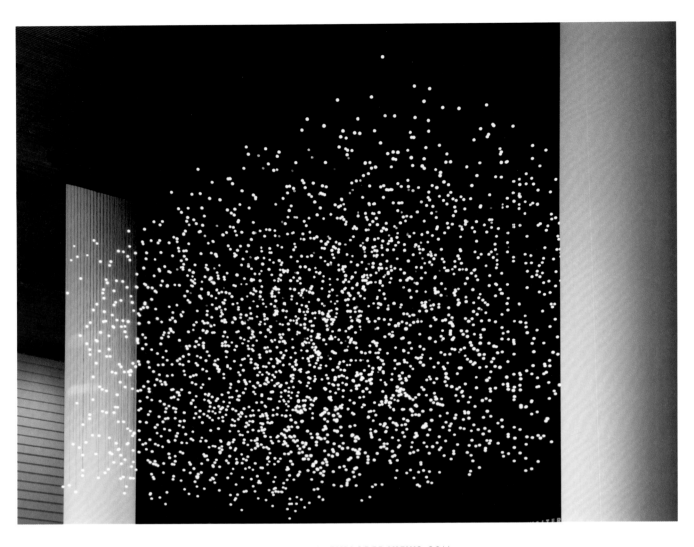

JIM CAMPBELL, *EXPLODED VIEWS*, 2011

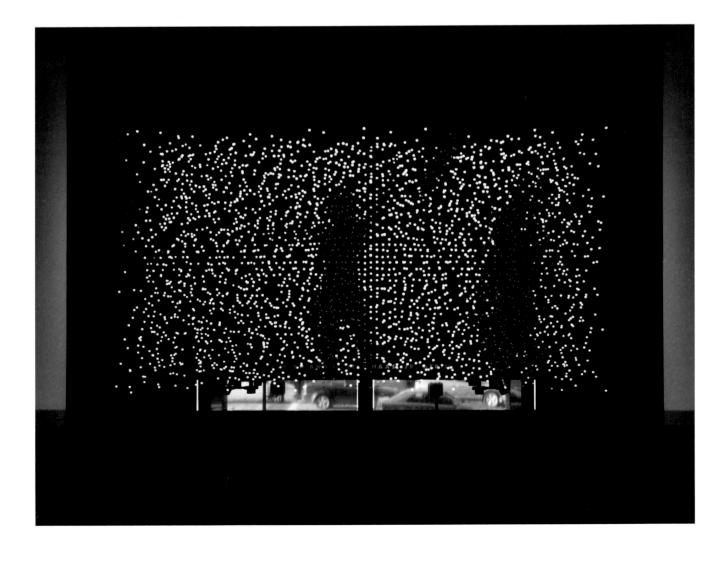

CARLOS CRUZ-DIEZ

The work of Carlos Cruz-Diez explores colour as an autonomous and physical entity. One of the innovators of Kinetic and Op Art, first in Venezuela during the 1950s, and then in Europe after his move to Paris in 1960, Cruz-Diez helped to pioneer a shift in the object–viewer relationship that brought the spectator's moving body directly into the work. Emerging from a tradition of specifically Latin American forms of Modernism, Cruz-Diez's practice stems from the political debates that took place in Venezuela in the 1950s over the social function of the artist. Deeply interested in the social and aesthetic value of art, he looked to the viewer's physical involvement as a way to demystify it, to return it to a simple human activity. The colour theories of Michel-Eugène Chevreul and, in particular, Johann Wolfgang von Goethe's explanation of colour as a sensorial experience common to people of all classes, played an important role in influencing Cruz-Diez's focus on the three abstractions core to his work – colour, light and space – and their perceptual and phenomenological effects on the viewer.

Cruz-Diez's first colour experiments culminated in his *Physichromie* series (begun in 1959), in which narrow strips of multicoloured cardboard, acrylic or PVC are placed on flat painted planes in various geometric configurations. Acting as a 'light trap', the coloured strips and planes interact, causing the viewer to perceive ranges of colour that are not present on the support. The impression of a vibrating surface is generated by the viewer's shifting position in relation to the wall-hung work and variations in the quality of light. These two factors became paramount to the artist, leading to new optical formulations in such subsequent series as *Chromo Interferences*, *Chromatic Inductions* and *Chromosaturations* (overleaf and p. 69), all begun in 1965. Giving the visitor the freedom to exercise their perception through active, moving participation, these works took the artwork off the wall, creating environments that were animated by the spectator's body.

The *Chromo Interferences* reconstitute the entire spectrum of light, either by addition or subtraction, depending on the materials used and the type of support they are projected onto, immersing the viewer in

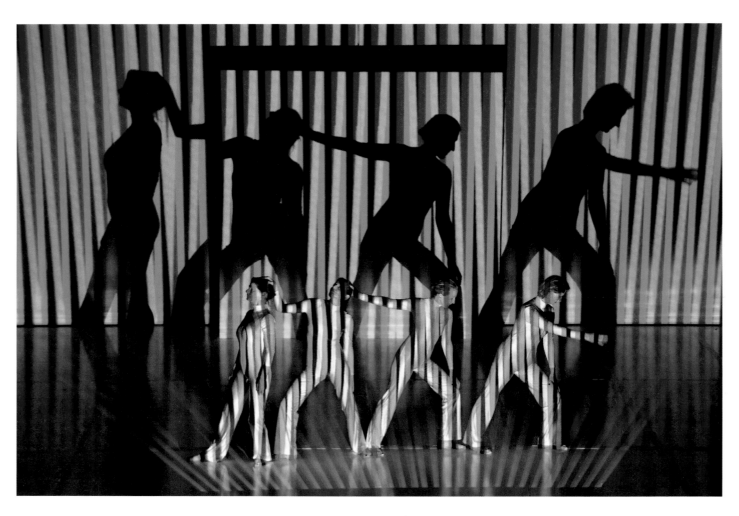

CARLOS CRUZ-DIEZ, *PERFORMANCE 'CHROMATIQUES'*, 2011

CARLOS CRUZ-DIEZ, *PERFORMANCE CHROMATIQUE*, 2008

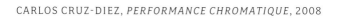

CARLOS CRUZ-DIEZ, *CHROMOSATURATION*, 2010

the optical effects of what the artist refers to as 'physical colour'. The *Showers of Chromatic Induction* are based on the phenomenon of retinal persistence by which, after gazing at a colour for a certain length of time, the eye's retina retains an induced image of the complementary colour. In these interactive installations, narrow transparent coloured strips

CARLOS CRUZ-DIEZ, *CROMOPRISMA ALEATORIO*, 1975

hang around the circumference of a circular cubicle, separated by gaps. Stepping in and looking out, the viewer perceives the colour of the strips and its complement simultaneously. *Chromosaturation* is an artificial environment composed of three adjoining white rooms transformed into colour chambers – one red, one green and one blue – by gels on the individual light arrays. Because the human retina is accustomed to receiving a wide range of colours simultaneously, the visitor walking through these rooms is subject to perceptual disorientation through the experience of being immersed in a completely monochrome situation that intensifies each time he or she moves from one chamber to another. *Chromosaturation* presents colour as a pure material and physical phenomenon in isolation from any form of cultural inflection and within a perpetual present. EM

BILL CULBERT

BILL CULBERT, *BULB BOX REFLECTION II*, 1975

When Bill Culbert embarked on his first light works in the late 1960s he moved from being an abstract painter concerned with pictorial movement to becoming a sculptor whose interest was in perceptual motion. After collaborating with Stuart Brisley on kinetic works constructed from coloured neon tubes, which were programmed to switch on and off, producing a succession of light and colour changes (*Neons*, 1967–8), Culbert's first solo experiments with electric light

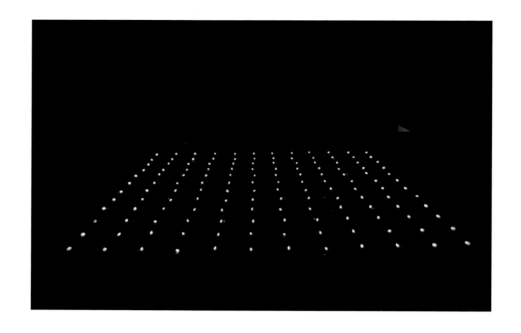

BILL CULBERT, *LIGHT FIELD BLAZE (CARPET), PHASES I – III*, 1968

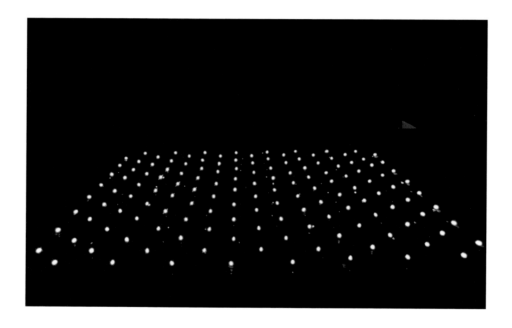

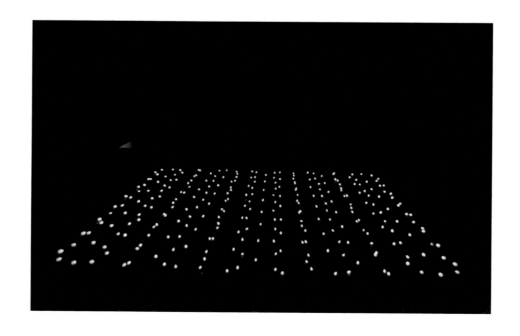

involved a series of perforated *Light Fields* (1968). These time-based installations were composed of 'walls' or 'carpets' of lightbulbs activated by phased electrical switching which, in the case of *Light Field Blaze*, (1968, opposite) produced a sequence of three different configurations: linear, triangulated and moiré. Other aspects of Culbert's continuing

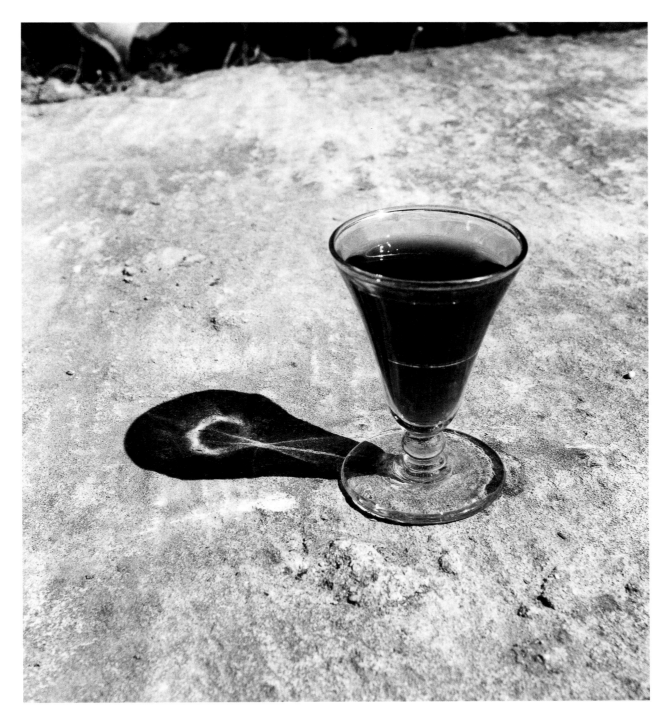

BILL CULBERT, *SMALL GLASS POURING LIGHT*, 1979

'visual research' included sculptures and installations that exploited the effects of the camera obscura. *Cubic Projections* (1968), which consists of an incandescent bulb enclosed within a perforated globe, projects pinpoints of light (images of the unseen bulb's filament) onto the surrounding walls in a darkened room.

In the early 1970s Culbert began to combine incandescent light bulbs with bric-à-brac salvaged from French rubbish tips. At the same time he made a series of visually puzzling lightbulb works that are,

73

in effect, conjuring tricks. *Bulb Box Reflection II* (1975, p. 71) appears
to present nothing more than a lightbulb and its reflection in a mirror,
except that, while the physical bulb is unlit, its reflected image is alight.
The illusion is achieved through the use of a one-way mirror. The work
actually consists of two identical lightbulbs, one of which is lit but hidden
behind a mirror that is partially reflective and partially transparent. While
the one-way mirror reflects the unlit bulb, it also allows the glowing
filaments of the lit bulb to shine through.

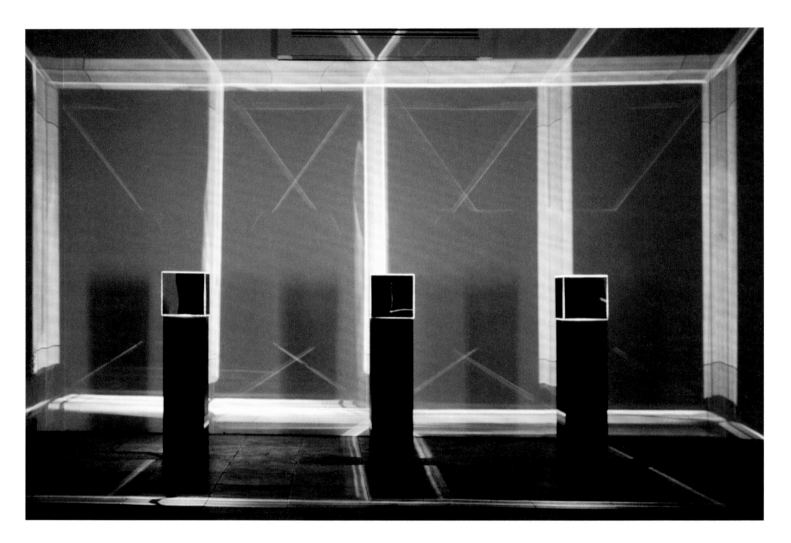

BILL CULBERT, *OUTLINE*, 1970

Alongside his sculptural works, Culbert has used photography
to investigate the phenomenon of light both in its natural and artificial
forms. While some of these photo-works picture his sculptural light
objects, others document tricks of the light, particularly in relation to
wine glasses, where the shadows of upended goblets seem to stand
upright on a table, and the shadows of bistro glasses full of wine appear
as dark images of the light bulbs that illuminate them (p. 73). A series
of *abats-jours* (lamp shades) features the shades' skeletons without
their coverings; in one of these, *Sunrise* (1989), the armature, displayed
on a garden table in full sun, becomes a sundial. In larger-scale works,
fluorescent tubes interact with landscape photographs in such a way
that glaciers seem to materialise in front of images of mountains,
or lightning strikes cleave the air above a valley.

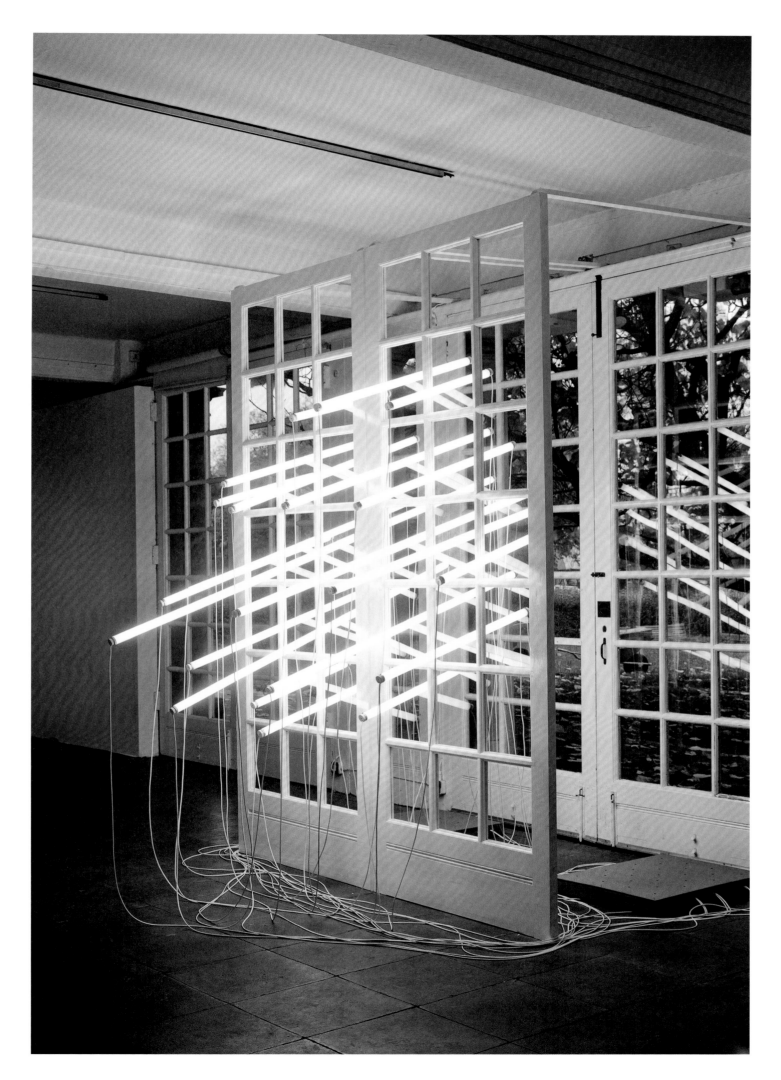

BILL CULBERT, *AN EXPLANATION OF LIGHT*, 1984

Culbert's practice of combining electric light with found objects has remained an important facet of his art. Amongst the many materials that he has used, several recur in different forms and guises: white fluorescent tubes, suitcases, and plastic containers of various sorts. Often Culbert causes fluorescent tubes to pierce suitcases or skewer furniture, and he has used them to impale glass bottles and plastic jerry-cans, but he has also used fluorescent light in combination with theatrical gels to turn suitcases into lightboxes that resemble televisions. He has gathered assemblies of fluorescent tubes – accompanied by nothing more than their own cables and ballasts – in large, site-specific installations. One of these, *An Explanation of Light*, was created for the Serpentine Gallery, London, in 1984 (p. 75). Culbert pierced a replica of the gallery's full-length French windows with a thicket of slanting tubes and placed this in front of the actual windows, which look out over the surrounding park. His false window, with its beams of fluorescent light, was reflected in the real window and the lamps appeared to project into the park outside. In a related work, *Nuage lumineux/Light Cloud*, made for the first Tyneside International exhibition in 1990, a swarm of fluorescent tubes was suspended inside a new, but empty, house. They were visible from the outside, where they shone through the naked windows, as well as inside, where they formed the shafts of light that appeared to enter the floorless, two-storey building through the upper windows.

Since then, Culbert has become increasingly involved in the creation of works for public spaces. Many of these have been made in neon, a material that he used for the first time in 1990. With *Coup de Foudre II* (2009), dynamic lines of coloured neon snake through a dockside shopping centre in London's Canary Wharf, and are reflected in the water outside.

BILL CULBERT, *PACIFIC FLOTSAM*, 2007 (DETAIL)

OLAFUR
ELIASSON

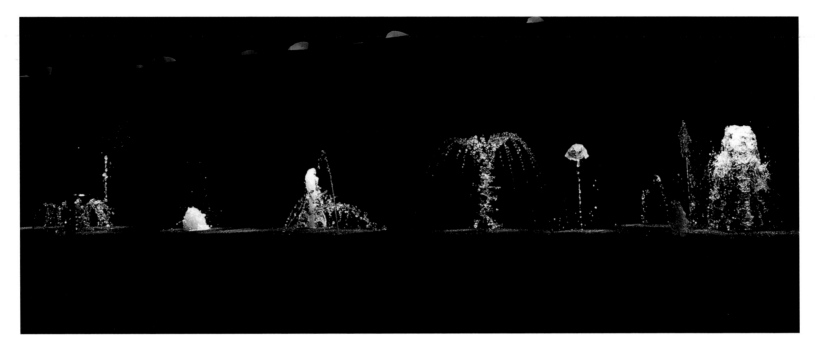

OLAFUR ELIASSON, *MODEL FOR A TIMELESS GARDEN*, 2011

The Danish-Icelandic artist Olafur Eliasson uses light, earth and water to examine the relationship between the individual and the environment, focusing on the self-reflexive quality of experience. Based in Berlin since 1995, where he set up a laboratory for spatial research, Eliasson regularly collaborates with specialists in the fields of architecture, geometry and engineering for the creation of large-scale public works. Referring to his installations as 'experiment set-ups' – evoking the real-time investigation of the laboratory – he presents structures in which the viewer's visual, physical and psychological perception is the central focus, becoming part of the artwork itself. Ice floors and icicle pavilions, scaffolded waterfalls, kaleidoscopes, dyed rivers and haze-filled chambers have all featured as part of his practice.

Eliasson is particularly interested in artificial light because of its capacity to perform different roles simultaneously: it may be an independent object – such as a projection – while at the same time being the source of light for the whole room, thus constituting an object, a phenomenon and an environment all at the same time. In one of his earliest works, *Beauty* (1993, overleaf), the light from a spotlight shines on a curtain of water droplets in a space that is otherwise dark.

OLAFUR ELIASSON, *BEAUTY*, 1993

From a particular vantage point in the room, the viewer will see a rainbow in the screen of water. In a later work, Eliasson uses pulsing strobe lights on water dripping from the end of a suspended hose mounted on the ceiling of a darkened space to make curtains of drips that appear momentarily frozen with each flash of light. Propelled into the air by pumps to create fountains, in one of the artist's most baroque and poetic works – *Model for a timeless garden* (2011, p. 77) – flashing strobe lights transform drops of cascading water into lacy garlands of ice that form a constantly changing landscape of light.

OLAFUR ELIASSON, *360° ROOM FOR ALL COLOURS*, 2002

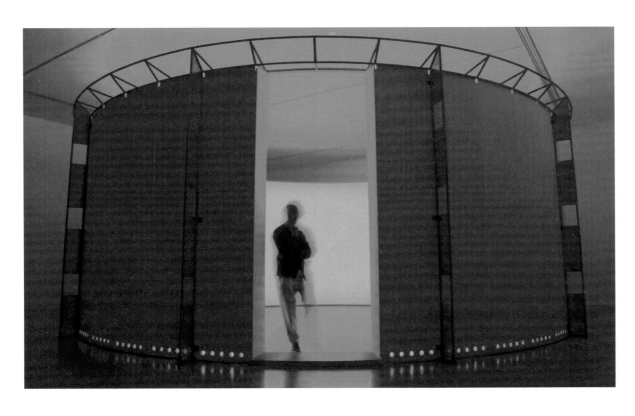

OVERLEAF: OLAFUR ELIASSON, *ROOM FOR ONE COLOUR*, 1997

Eliasson is also interested in exploiting the optical effects of projected light and the after-image, allowing the viewer to 'complete' his work through their own physical experience. In such works as *Your blue/orange afterimage exposed* (2000) a spotlight projects an intense orange square onto a wall, which suddenly disappears after 15 seconds, to be replaced by the complementary image of a blue square that is 'projected' from the viewer's retina back onto the wall. In *360° room for all colours* (2002, p. 79) a computer-animated matrix of red, green and blue lights

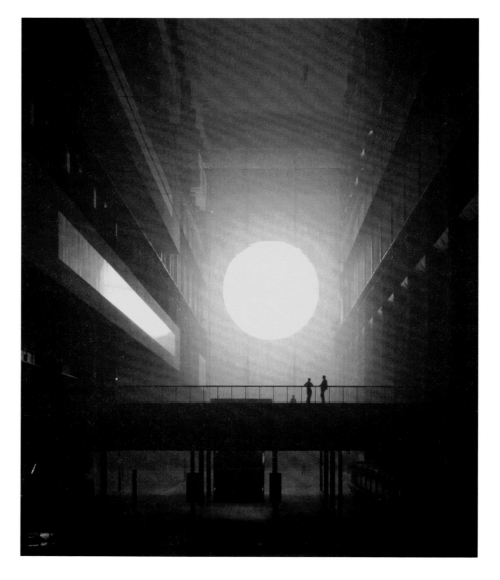

OLAFUR ELIASSON, *THE WEATHER PROJECT*, 2003

changes every 30 seconds, creating bands of colour that move around the circular walls of the space, resulting in a mixture of projected light and after-image effects that is different for each viewer, depending on the moment they entered the room. Yellow monofrequency light has a particular significance for Eliasson, and he has used it on numerous occasions, most notably in *Room for one colour* (1997, pp. 80–1), where it transformed a room into a two-tone environment in which only yellow and black could be discerned. In *The weather project* (2003, above) a giant circular disc radiated monofrequency yellow light through a cloud of mist under a ceiling of reflective mirrors in Tate Modern's Turbine Hall, setting up a phenomenologically disorientating environment.

FISCHLI AND WEISS

During their long artistic collaboration, Peter Fischli and David Weiss aimed to achieve a simultaneity of 'irony and seriousness'. According to Weiss, they tried 'to look at things from different angles at the same time', while Fischli described their practice as 'operating on two planes at once'.[1] Their work, which includes photographs, films, sculpture and installations, is characterised by a delight in the home-made and the improvised, and is often resourceful and apparently artless, in a childlike

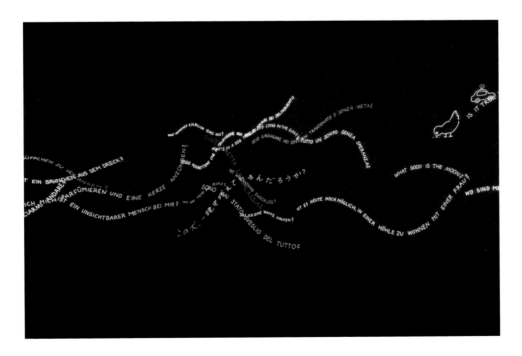

PETER FISCHLI / DAVID WEISS, *OHNE TITEL (FRAGENPROJEKTION)*
(UNTITLED (QUESTIONS PROJECTION)), 1981–2001

or amateur way. Nowhere is this more apparent than in their 30–minute film, *The Way Things Go* (1987). In this slapstick sequence of collisions punctuated by chemical reactions, household objects roll, fall, crash, explode and continue on their way in an increasingly manic succession of events and counter-events.

In 1981, shortly after Fischli and Weiss started working together, they produced their first film, *The Least Resistance*, in which the artists'

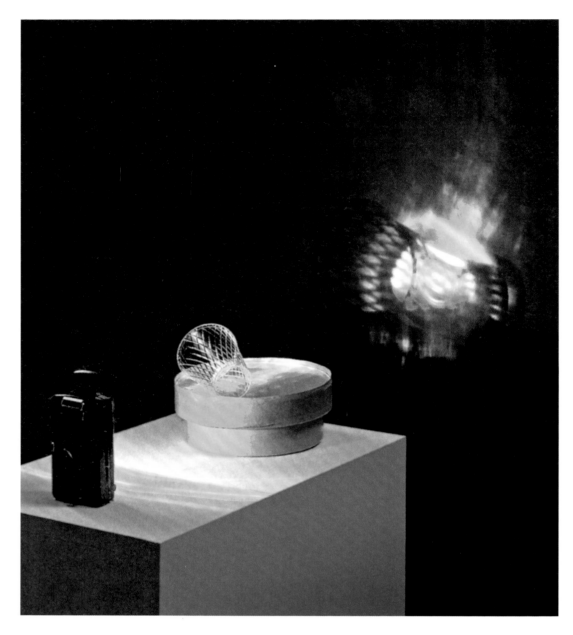

alter egos, Rat and Bear, plan to infiltrate the art world in order to combat its widespread boredom. At the end of the film, having discovered that philosophy is the key to art, Rat announces: 'We're bringing light into the darkness!' Some years later, Fischli and Weiss began to make 'light sculptures', creating a series of works called *Surrli* (1986–98) that were presented as slow-dissolve slide projections. These images, in which coloured lights trace whirling spools of lines against black backgrounds, were produced mechanically by means of a 'Surrli machine' (named after the Swiss-German word for a spinning-top) which Fischli and Weiss devised. Its spinning lights were photographed at a low angle and with long exposures, producing effects like those made by twirling lighted sparklers around in the dark. The resulting abstract patterns of ever-changing ellipses and overlapping loops capture an optical illusion known as 'persistence of vision'.

In 1990, soon after beginning the *Surrli* series, Fischli and Weiss created *Son et Lumière (Le rayon vert)*. This was a different sort of light sculpture, assembled from an electric torch, a clear 'cut-glass' plastic cup and a motorised cake-stand. Among its allusions – to spectacular

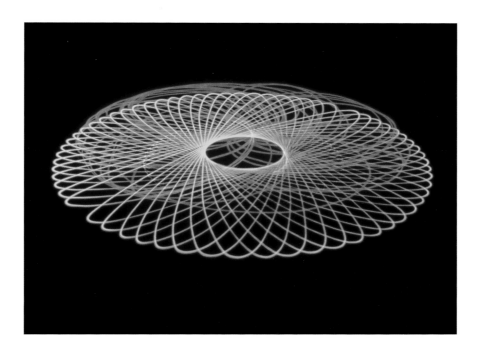

PETER FISCHLI/DAVID WEISS, *SURRLI*, 1986–98

outdoor night-time entertainments composed of sound and light, and also to an elusive atmospheric phenomenon celebrated in a book by Jules Verne and in a film by Eric Rohmer – it harks back to one of Fischli and Weiss's earlier images. The eerie green glow (the '*rayon vert*') which makes momentary appearances in the sunset red of *Son et Lumière*, together with the faceted plastic cup that refracts the light, had both featured in *Moonraker* (1979). This re-imagining of a scene from the James Bond film takes place in the interior of a fridge and forms part of Fischli and Weiss's *Sausage Photographs*, their first ever collaboration.

PETER FISCHLI / DAVID WEISS, *OHNE TITEL (SURRLI)* (UNTITLED (SURRLI)), 1989

Casting a sly glance at the history of Modernism, both *Surrli* and *Son et Lumière* pay tribute to the work of the Bauhaus artist and photographer László Moholy-Nagy. The *Surrli* images recall Moholy-Nagy's early experiments with colour slide film, which included abstract light compositions and long exposures of firework displays. But, if the Surrli machine is an exaggerated version of a child's plaything, *Son et Lumière* is a simplification of Moholy-Nagy's *Light Prop For an Electric Stage* (p. 33), a pioneering work in kinetic light art which, Moholy-Nagy said, 'was so startling in its… articulations of light and shadow sequences that I almost believed in magic'.[2] HL

1. Claire Bishop and Mark Godfrey, 'Between Spectacular and Ordinary', an interview with Fischli and Weiss, *Flash Art*, no. 251, November–December 2006.
2. Quoted in Peter Weibel, *Beyond Art: A Third Culture: A Comparative Study in Cultures, Art, and Science in 20th-Century Austria and Hungary*, Springer, New York, 2005, p. 95.

DAN FLAVIN

Describing the fluorescent light art that he pursued from the start of his career in 1963 until his death in 1996, Dan Flavin remarked: 'It is what it is and it ain't nothin' else… There is no hidden psychology, no overwhelming spirituality you are supposed to come into contact with… it is as plain and open and direct an art as you will ever find.'[1]

Flavin had begun making notes about an 'electric light art' as early as 1961 and, over the next two years, he produced a series of eight

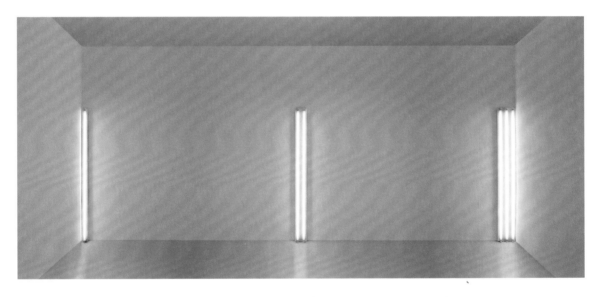

DAN FLAVIN, *THE NOMINAL THREE (TO WILLIAM OF OCKHAM)*, 1963

assemblages incorporating various types of electric light. These 'icons', as he called them, were painted constructions: monochromatic box-like reliefs made from canvas with lighting – consisting of incandescent bulbs and fluorescent tubes – attached, usually, to the sides. Despite the religious overtones suggested by their collective name and individual titles, Flavin described these 'anonymous and inglorious' works as 'constructed concentrations celebrating barren rooms'.[2]

After the icons, Flavin abandoned canvas and paint and concentrated on artificial light alone. For the next thirty years he worked exclusively with mass-produced, commercially-available fluorescent lights, using a limited 'palette' of mainly two-, four-, six- and eight-foot tubes in ten colours (including four different whites). These essentially characterless and utilitarian objects became the medium for works of

phenomenal intensity and beauty. One of the earliest, *the nominal three (to William of Ockham)*, from 1963 (previous page) is a work of radical simplicity, as the title (a reference to Ockham's Razor, the nominalist philosopher's principle advocating parsimony and succinctness) implies. The work's one-two-three progression of white vertical fluorescent lamps spaced out across a single wall suggests that the work could be extended endlessly, with further units of four, five, and so on, *ad infinitum*. Though this work, like his icons, was originally intended to be hung on the wall, in the same way as a picture, Flavin soon began to explore the potential of less conventional sites, such as the edge of a wall or the corner of a room. In his series of fifty 'monuments' to the Russian Constructivist Vladimir Tatlin, made between 1964 and 1990, the varied lengths and positions of the fluorescent tubes suggest the dynamism of Tatlin's unrealised *Monument to the Third International*, a colossal, spiralling tower of glass and steel, designed in 1919.

Flavin's first solo exhibition of works using only fluorescent light was held in New York in the winter of 1964, and it was here that he was first able to engage directly with architecture by 'planting illusions of real light, electric light, at crucial junctures in the room's composition'.[3] From this point on, Flavin's 'situational' art, as he called it, was made in direct response to the architecture of the spaces in which he worked, which included independent galleries, public museums and university art departments, in North America and abroad. Describing his lights as 'structural proposals', he created room-sized environments of ambient light, in which the intensity of the illuminated spaces alters perception. Throughout his extraordinarily rich and varied body of work, Flavin displays a fascination with what he called 'retinal optics', exploring coloured auras, which he created by varying the arrangement of fluorescent tubes. A visitor to his retrospective exhibition in 2005 describes the effect: 'staring long enough at a concentration of green lights will cause an ocular whiteout, as the light's intensity tattoos your retinas with the bulbs' after-image. Afterwards, other hues look skewed: truly white lights appear pink.'[4] HL

1. Dan Flavin, quoted in Michael Francis Gibson, 'The Strange Case of the Fluorescent Tube', *Art International*, no. 1, Autumn 1987, pp. 105–10 (revised by the author, March 2004, in Paula R. Feldman and Karsten Schubert (eds), *It is what it is: writings on Dan Flavin since 1964*, Thames and Hudson, London, 2004, p. 174).

2. Notebook entry quoted in *Dan Flavin, three installations in fluorescent light/Drei Installationene in fluoreszierendem Licht*, exh. cat., Kölnische Verlagsdruckerei, Cologne 1973, p. 83.

3. Dan Flavin, from an early version of '"... in daylight or cool white." an autobiographical sketch', 1964, quoted in Anne M. Wagner, 'Flavin's Limited Light' in Jeffrey Weiss (ed.), *Dan Flavin: New Light*, Yale University Press, New Haven, CT, National Gallery of Art, Washington, DC, 2006, n. 7, pp. 128–9.

4. Catherine Deitchman, 'Dan Flavin: Saturated in Flavin's Fluorescence', *Glasstire*, 2 February 2005; online magazine at http://glasstire.com/2005/02/02/dan-flavin-saturated-in-flavins-fluorescence/ accessed 12.11.2012.

OVERLEAF: DAN FLAVIN, *UNTITLED (TO S.M. WITH ALL THE ADMIRATION AND LOVE WHICH I CAN SENSE AND SUMMON)*, 1969

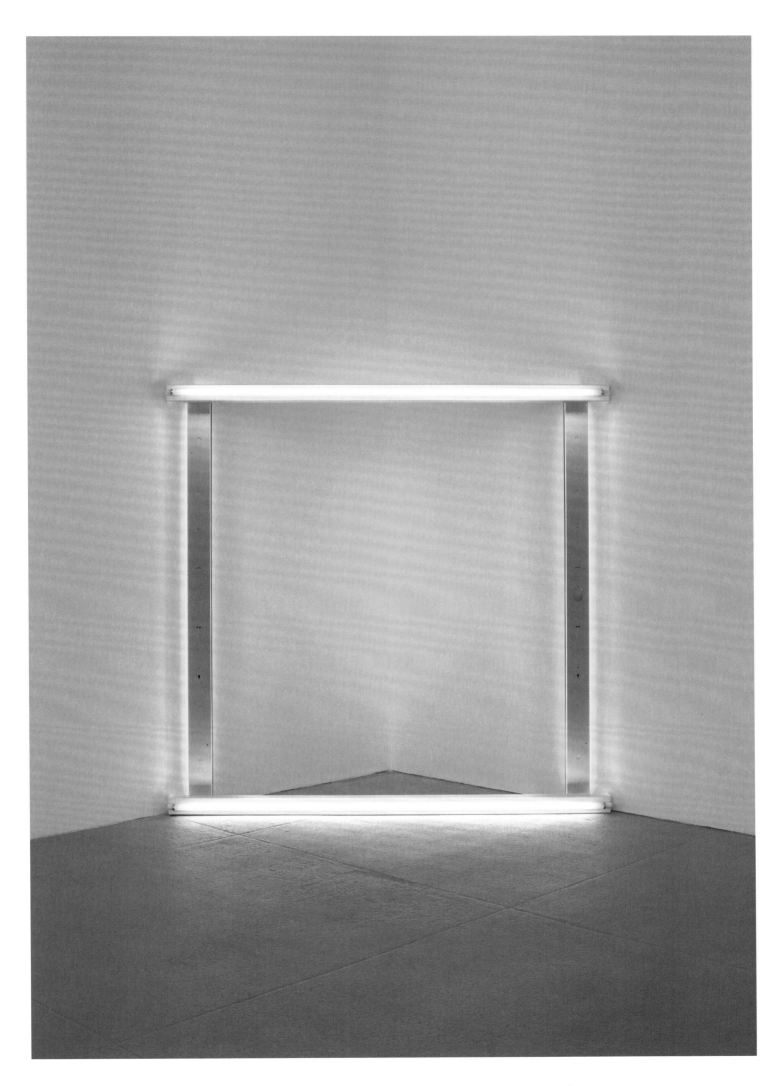

DAN FLAVIN, *UNTITLED (TO THE "INNOVATOR" OF WHEELING PEACHBLOW)*, 1966−8

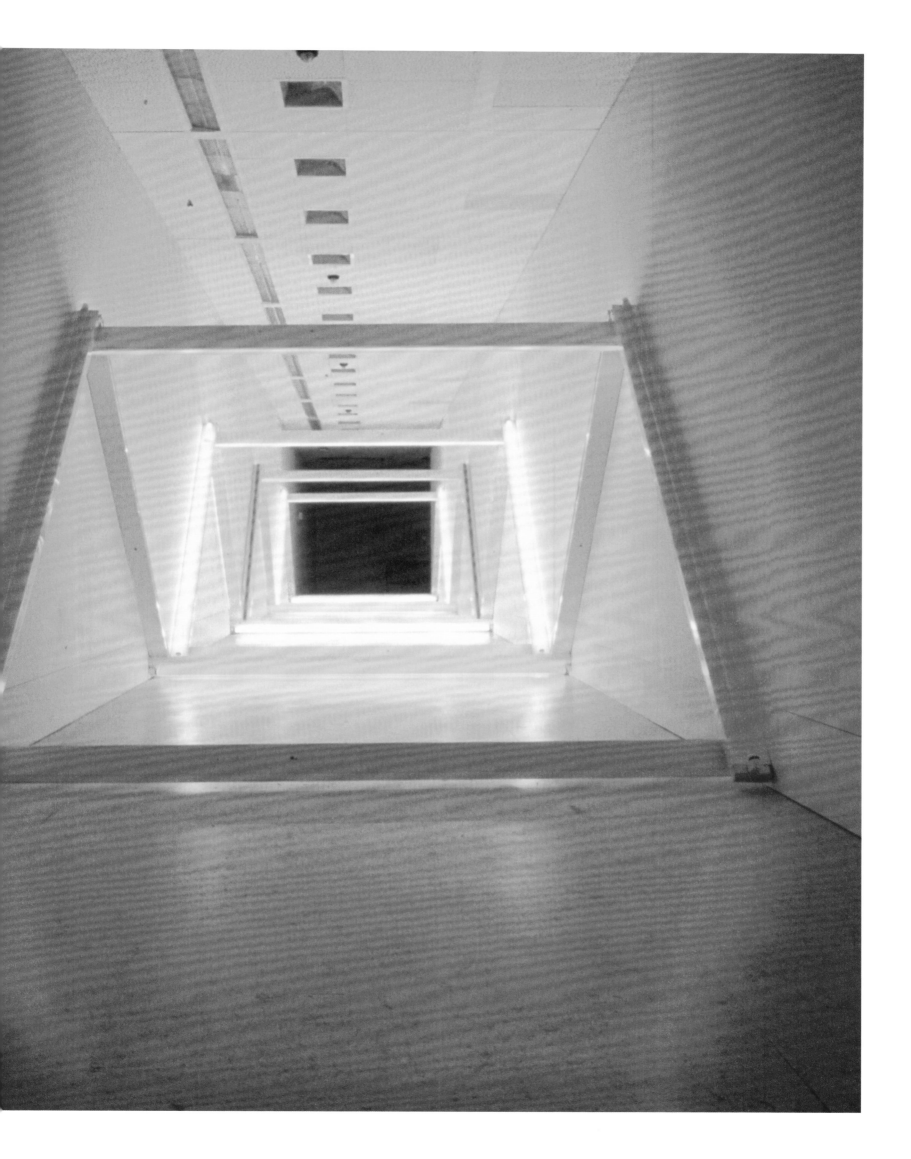

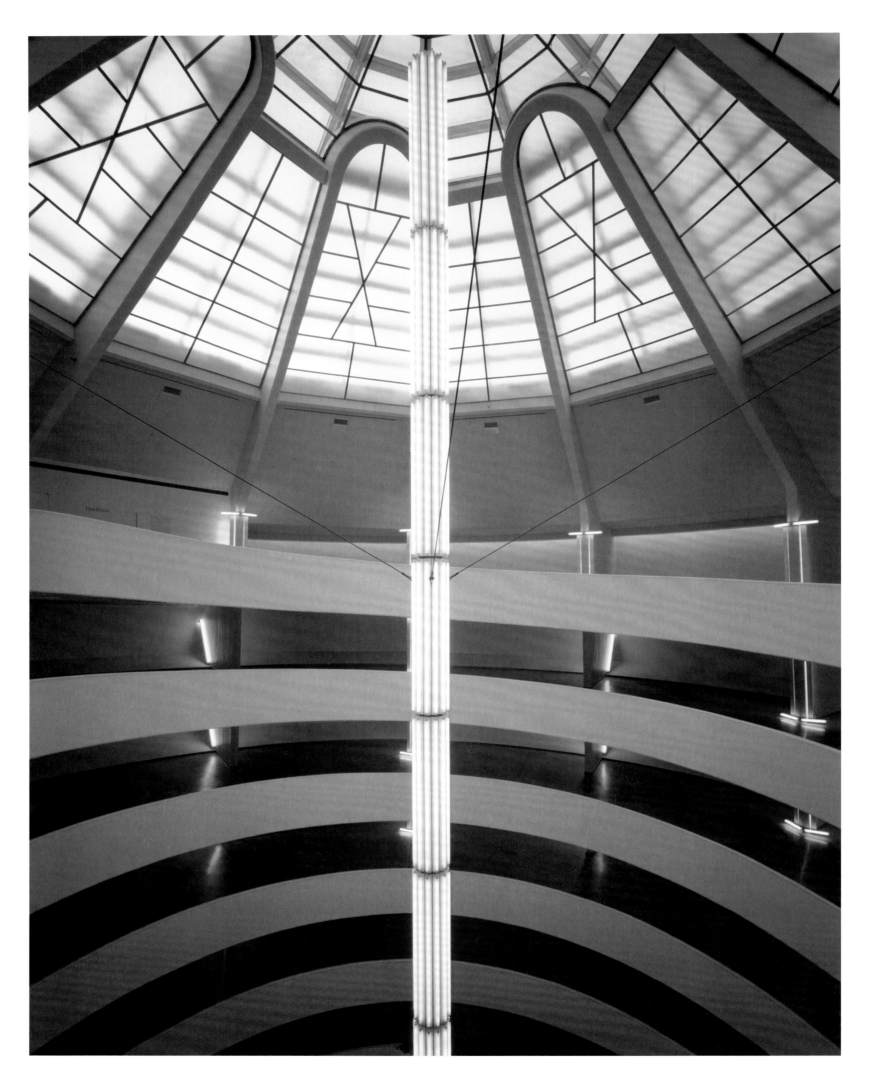

DAN FLAVIN, *UNTITLED (TO TRACY, TO CELEBRATE THE LOVE OF A LIFETIME)*, 1992

CEAL FLOYER

Ceal Floyer, who once described her practice as 'manifesting uncertainty in art', makes conceptual works that focus on the interaction between expectations and perception, and often play with the spectator's awareness of space and light in addition to idea and physical presence. The deceptive simplicity of her installations and interventions draws attention to aspects of reality that are often so unremarkable that they go unnoticed.

Light, as both medium and subject, has played a major part in Floyer's art since the beginning of her career. At the same time, wordplay is a concomitant part of her works, which are often as dependent on

CEAL FLOYER, *THROW*, 1997

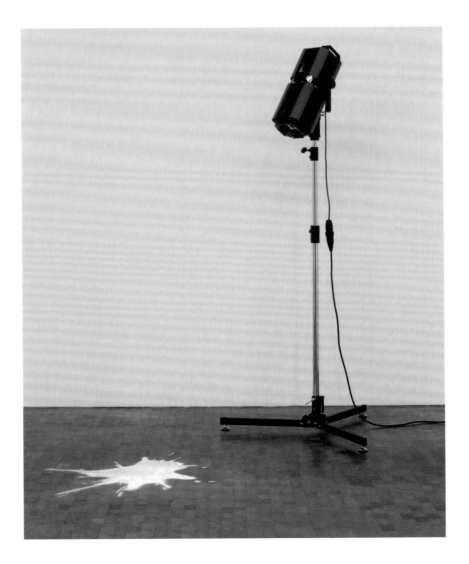

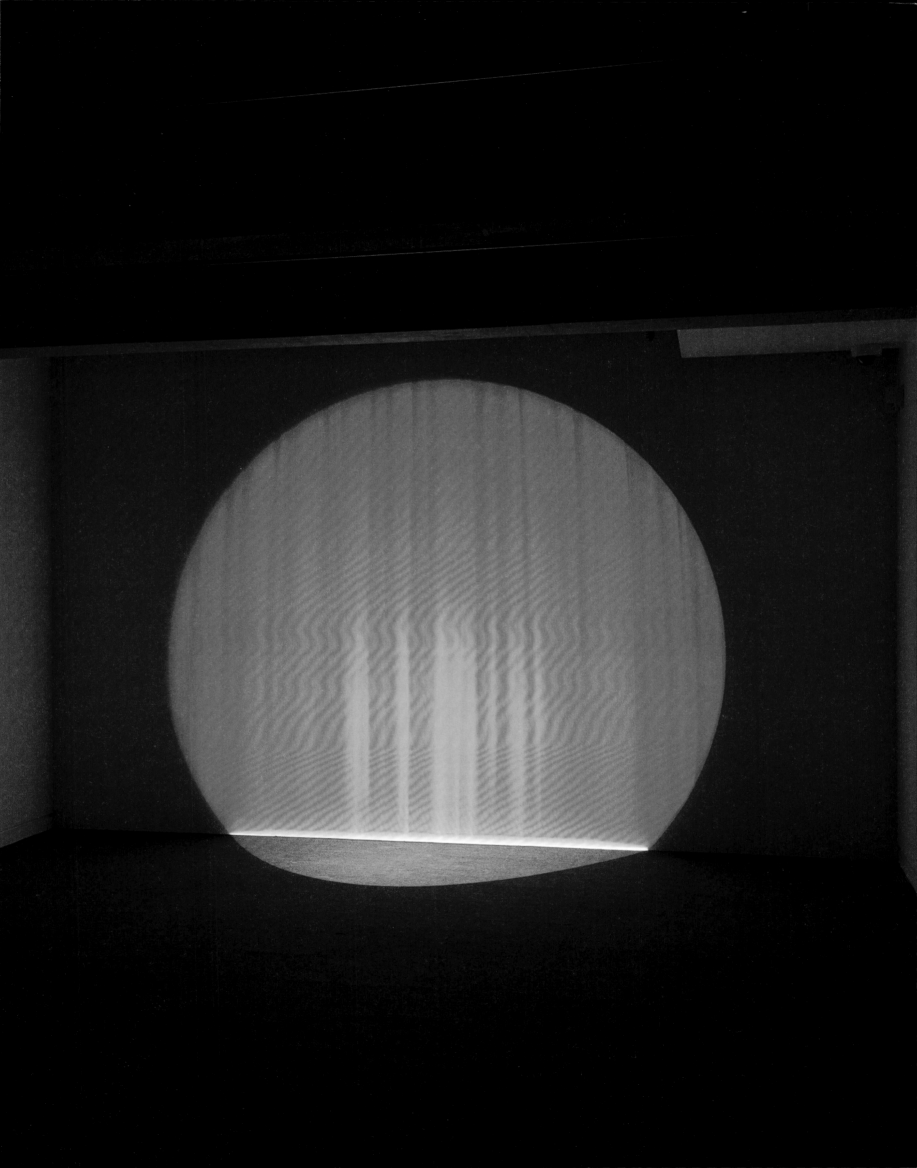

their titles for illumination as they are on a source of light. Floyer herself has referred to the physical manifestation of her works as 'stuffing' for their titles, which give rise to visual puns, statements of the obvious, contradictions and repetitions.[1] One of her earliest works, *Light Switch* (1992–9, overleaf), is just what the title says, both literally and conceptually. It consists of an image of a light switch projected onto a wall. The switch will not work, but it lights the room in which it is

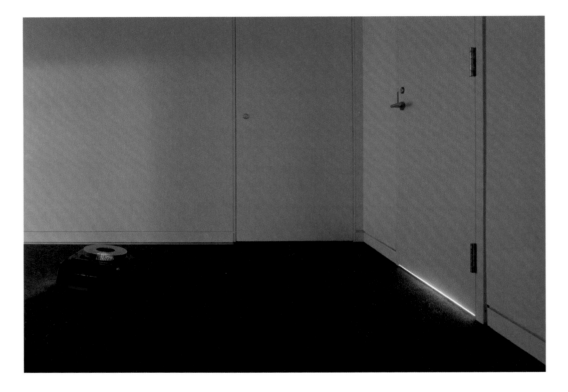

CEAL FLOYER, *DOOR*, 1995

shown and so enacts a conceptual switch. The wall-mounted apparatus it impersonates is not there, but the equipment that produces the apparition is in full view. When *Light Switch* was first shown, all that could be perceived on entering the darkened room were the mechanics of the work – the slide projector and the plinth it sits on. In order to see the projected image, which was positioned beside the door, exactly where you would expect to find a light switch, viewers had to turn and look behind them.

This turn of the head is a characteristic effect of the double-takes inherent in most of Floyer's projected light work. *Light* (1994), which features an actual lightbulb with a disconnected flex, is obviously and emphatically cut off from any power supply. Instead, it is lit – in a gesture of absurd over-elaboration – by the modified beams of four projectors. Their combined efforts produce a fraction of the light that the bulb itself would emit, while expending vastly more energy. The viewer's attention is drawn to the actual source of light by the projectors' whirring hum. By contrast, *Double Act* (2006, previous page) is eerily still. In this visual conundrum, a spotlight is focused on a theatre curtain, spilling light onto

96

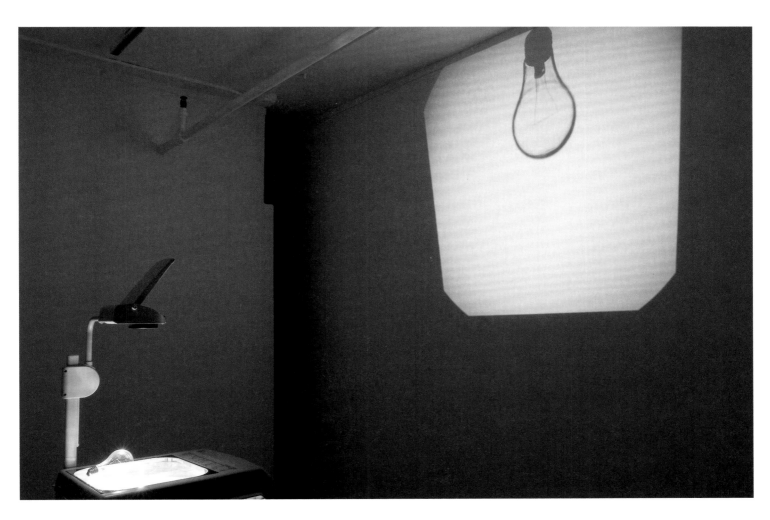

CEAL FLOYER, *OVERHEAD PROJECTION*, 2006

CEAL FLOYER, *DAY FOR NIGHT*, 2001

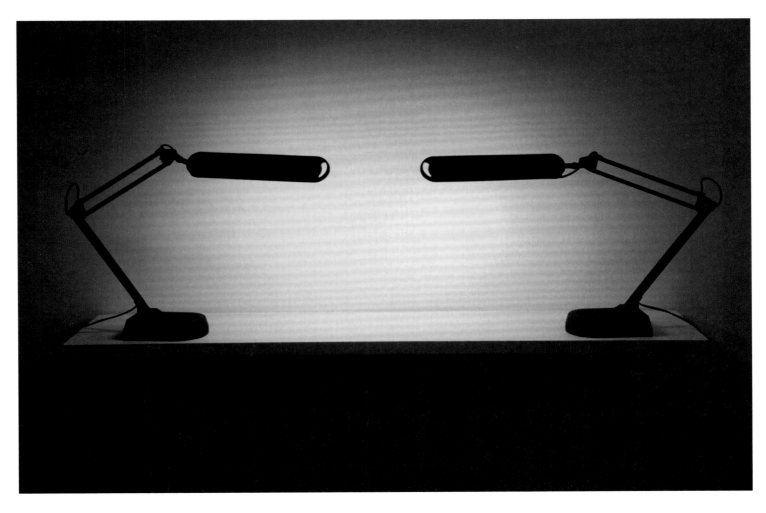

the floor in front. The stage is apparently set for the start of a show. But nothing happens, and it transpires that there is no stage and no curtain; there is only light. As in the earlier work *Throw* (1997, p. 93), where a puddle of light is thrown onto the bare floor like a splodge of spilled paint, the whole illusion is created by a theatre lamp fitted with a gobo,

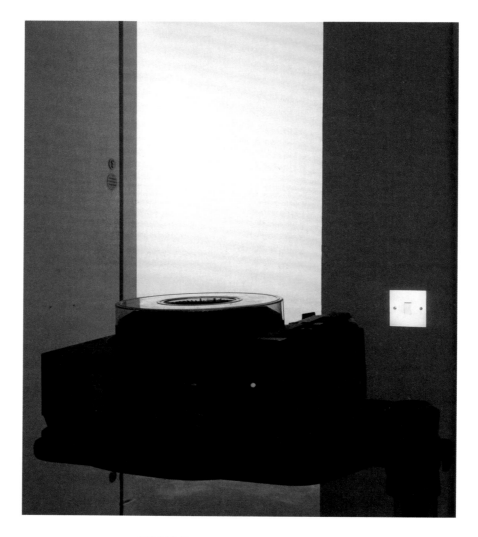

CEAL FLOYER, *LIGHT SWITCH*, 1992–9

a screen which controls the shape of the emitted light. At the same time, because the mechanics of the projection are not hidden but are completely visible, it ceases to be illusory. As was the case with *Light Switch*, both the image and the light that illuminates it come from the same source. Floyer has always said that she considers the things she makes to be self-reflexive. Speaking of her light works she draws attention to the fact that 'they are not necessarily about anything outside of the work itself and the context of its production'.[2] Rather, they are a matter of 'cause and effect, one thing leading to another and it being a sort of short-circuit'.[3] HL

1. Quoted by Mark Godfrey in Mario Codognato and Mark Godfrey, *Ceal Floyer*, Electa, Milan, 2008, p. 18.

2. 'Freddy Contreras and Ceal Floyer in conversation with Kim Sweet' in *Freddy Contreras and Ceal Floyer*, exh. cat., The Showroom, London 1995, n.p.

3. Ceal Floyer interviewed by Marcelo Spinelli for *The British Art Show 4*, a National Touring Exhibition organised by the Hayward Gallery for Arts Council England, 1995 (unpublished transcript).

NANCY HOLT

NANCY HOLT, *HOLES OF LIGHT*, 1973

A pioneer in the development of environmental art in the US, Nancy Holt is known for her large-scale interventions into natural and man-made landscapes, charting the changing position of Earth in relation to the sun. Holt formed her artistic practice in the early 1960s in dialogue and collaboration with Robert Smithson, her husband from 1963, and a group of New York-based Minimalist and conceptual artists, including Carl Andre, Sol LeWitt, Robert Morris, Michael Heizer and Eva Hesse. Holt's earliest work followed the conceptual shift away from creating objects, toward an emphasis on process and place that was characteristic of this period, taking the form of concrete poems that indicate the details of the shape and constitution of the physical world. During her first trip into the American West in 1968, she began a photographic series of graveyards, marking the beginning of her ongoing interest in human interventions in the landscape. A few years later, in her 1972 series *California Sun Signs*, she photographed signs that she

OVERLEAF: NANCY HOLT, *MIRRORS OF LIGHT I*, 1974

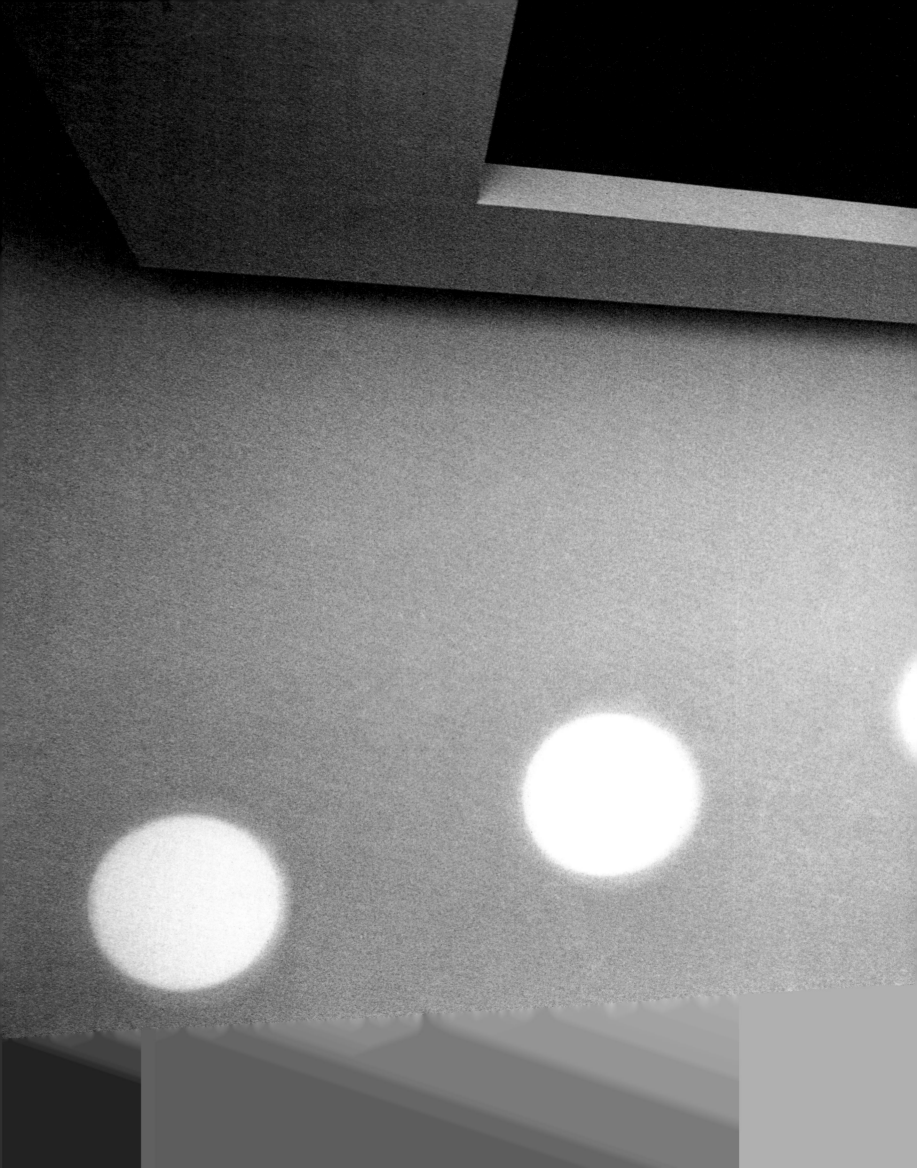

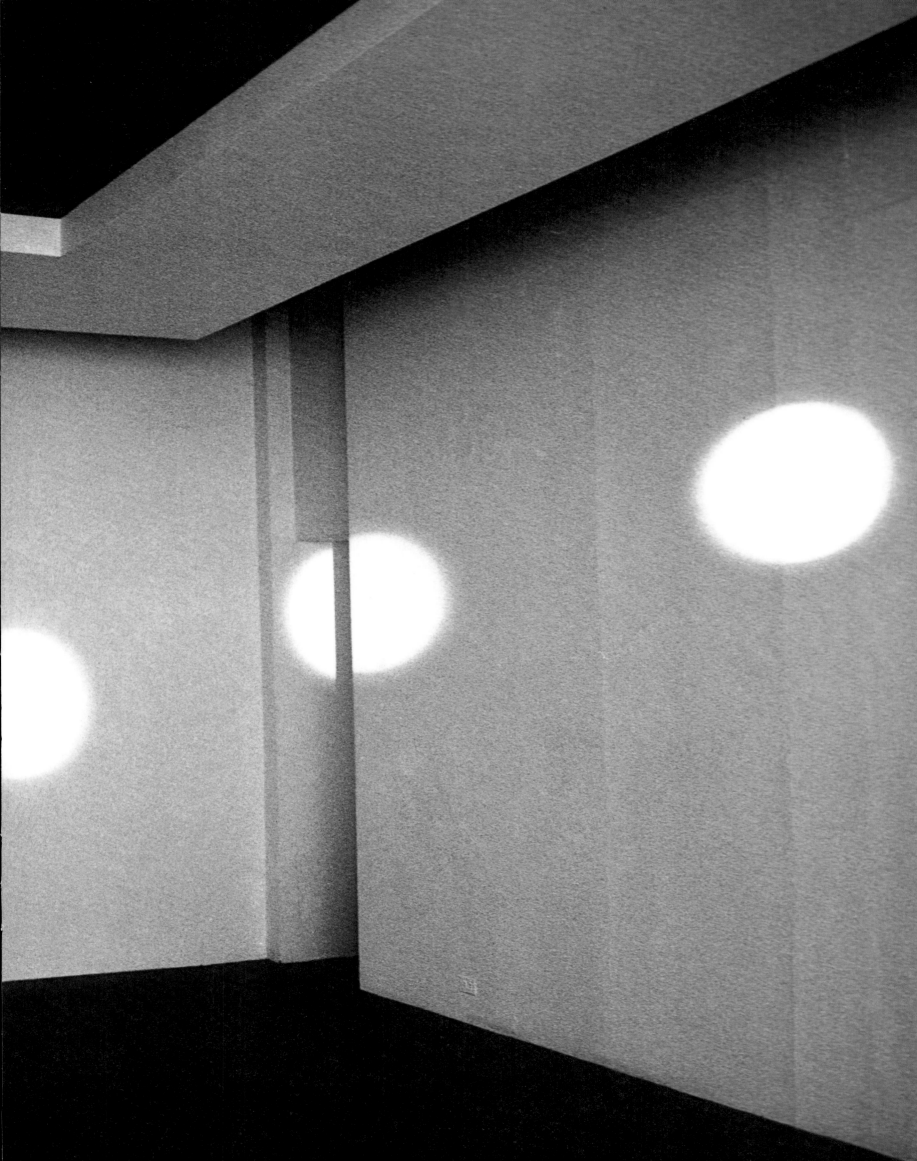

encountered on her way to the Mojave Desert in which the sun was referenced as part of the name of a street or a commercial outlet.

Holt's encounter with the desert was formative; travelling into remote locations with Smithson and other artists during the 1970s, she created a number of innovative film and video works, including *Pine Barrens* (1975), a meditative structuralist film about a vast, undeveloped region in central New Jersey, and *Sun Tunnels* (1978), which documents the creation of her well-known environmental work of the same name. Built on forty acres of land in Utah bought by the artist specifically for the work, *Sun Tunnels* (1973–6, opposite) attempts to bring the overwhelming vastness of the desert landscape back to human scale and to return the viewer to the centre of events of cosmic proportions.

NANCY HOLT, *ELECTRICAL SYSTEM II: BELLMAN CIRCUIT*, 1982

Comprising four enormous concrete cylinders, each pierced with circular holes that replicate the positions of one of four particular constellations of stars, the work maps the cycles of the solar year through the changing pattern of light passing through the star holes and the lateral openings of the tunnels. Looking through them, the spectator sees visual reference points in the landscape framed by their circular diameters, in a manner similar to that set up by the viewing tubes of her *Locators* of 1971–2.

For Holt, light is analogous to sight, and its perceptual effects have been a concern since her earliest gallery installations. In *Holes of Light* (1973, p. 99) two lights shining alternately through a central dividing partition cast circles of light on the opposing walls. The pencil lines that the artist carefully traces around the light circles form a sort of after-image; the patterns of cast light are analogous to visual perception. *Mirrors of Light I* (1974, previous spread) and the *Light and Shadow Photo Drawings* series (1978, overleaf) continue this formal enquiry into artificial light. During the 1980s, Holt became interested in systems of energy flow: in *Electrical System II: Bellman Circuit* (1982) light as a form of electrical energy is channelled through arching steelconduits, illuminating arcs of tungsten filaments in a series of inter-connecting lightbulbs. EM

NANCY HOLT, *SUN TUNNELS*, 1973–6

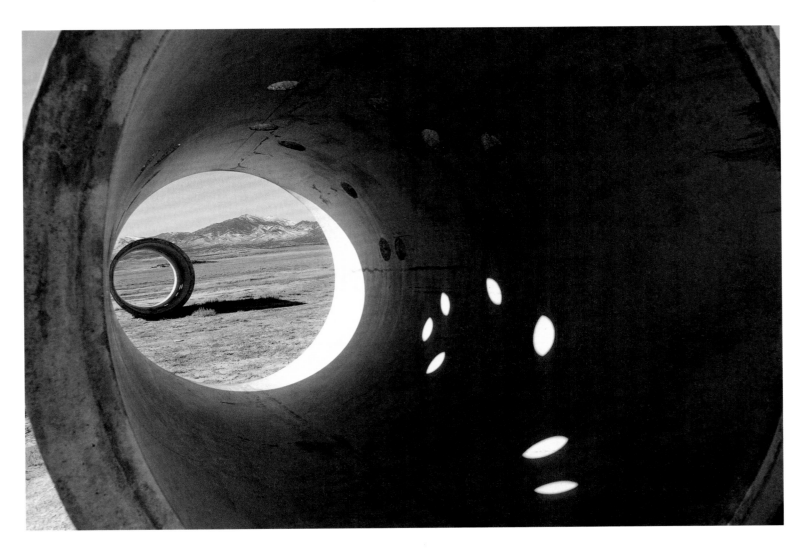

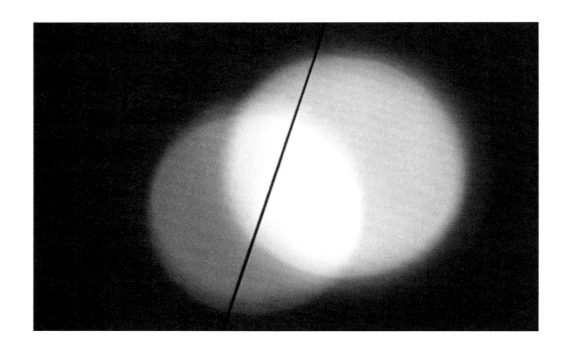

NANCY HOLT, *LIGHT AND SHADOW PHOTO DRAWINGS 13, 18* AND *22*, 1978 (PRINTED 2012)

JENNY HOLZER

In the late 1970s, Jenny Holzer, who had started her career as an abstract painter, began using words to make art. She wanted to communicate with a larger public and turned to language because, she says, 'I wanted to be explicit about things.'[1] Her text-based artworks feature statements,

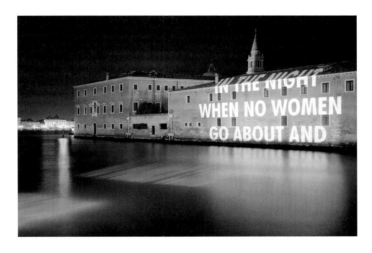

JENNY HOLZER, *XENON FOR VENICE*, 1999

JENNY HOLZER, *XENON FOR PARIS*, 2001

maxims, slogans and longer texts that she has written and words written by other people, including poems and declassified government documents. In one of her first public works, Holzer printed lists of statements – *Truisms* (1977–9), or 'mock clichés', as she calls them – on anonymous posters, which she pasted clandestinely around New York.

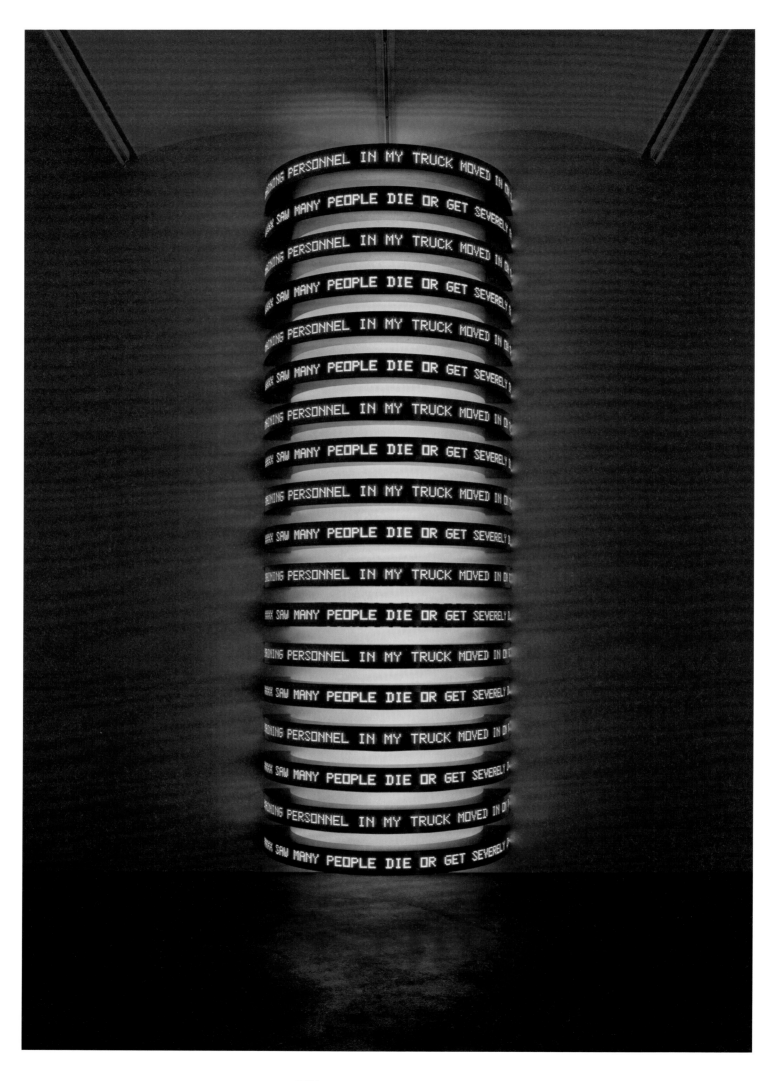

JENNY HOLZER, *MONUMENT*, 2008

Later, she also used billboards, stickers placed on parking meters, T-shirts, condom wrappers, cash register receipts and other forms of mass communication to broadcast aphorisms, observations, directions and warnings from her *Truisms* (1977–9) and *Survival* (1983–5) series – such as 'ABUSE OF POWER COMES AS NO SURPRISE' and 'PROTECT ME FROM WHAT I WANT' – which were spelled out in plain black capital letters.

Holzer first used electronic LED signs in 1982, when she was invited to work on a project for the Spectacolor Board, the world's first computer-programmed, changeable message billboard, which had

JENNY HOLZER, FROM *SURVIVAL* (1983–5), 1985

recently been installed in Times Square, New York. Since then, LED displays have featured prominently in her work, both outdoors in public spaces and indoors in galleries. In 1989–90 she sent a single, continuous line of moving text spiralling up the parapet wall of New York's Solomon R. Guggenheim Museum, producing a dizzying fizz of electronic light. By then she had already begun to create immersive environments in which LED signs were programmed in such a way that they had a physical effect on viewers, in one case making people feel as though they were levitating. In her installation for the 1990 Venice Biennale she surrounded the interior of the US Pavilion with floor-to-ceiling digital displays, which were reflected in the highly-polished stone floor. The intensely-lit signs flashed multiple texts in five languages and, as she put it, 'wrapped people with electronics'.[2]

In the late 1990s, Holzer started using powerful xenon projectors and extremely large film (185 mm) to project huge, slowly scrolling texts

onto buildings, landscapes, mountains, and the constantly moving surface of rivers and the sea. One of these large-scale light projections took place in November 2004 on the facade of the Gelman Library of the George Washington University, which houses America's National Security Archive. Throughout the autumn night, Holzer projected declassified US government documents, made available through the Freedom of Information Act and the collections of the National Security Archive. These related to America's intervention in the Middle East and were the redacted evidence of soldiers, officers, the FBI, detainees, politicians, lawmakers and government attorneys, among others.

Similar texts from the 'war on terror' feature in the sardonically titled *MONUMENT* (2008, p. 106), where a tower of semicircular LED elements are stacked one above the other. Despite the fact that she

JENNY HOLZER, *THE VENICE INSTALLATION: THE LAST ROOM*, 1990 (DETAIL)

has presented her texts in many other forms and media, Holzer has continued to use LEDs to convey hard-hitting political messages. 'A reason I first chose electronics is that people tend to look at them,' she remarks. 'I thought I should employ this fact to have people watch what they otherwise might not.'[3] HL

1. Patrick J. B. Flynn, 'Jenny Holzer – artist – interview', *The Progressive*, vol. 57, issue 4, April 1993, pp. 30–4.

2. Steven Henry Madoff, 'Jenny Holzer Talks to Steven Henry Madoff' in "80s Then', *Artforum*, vol. 41, no. 8, April 2003, p. 83.

3. John Yau and Shelley Jackson, 'An Interview with Jenny Holzer', 6 September 2006, online journal of the Poetry Foundation; http://www.poetryfoundation.org/article/178606 accessed 9.10.2012.

ANN VERONICA JANSSENS

Ann Veronica Janssens creates temporary sites of sensory immersion, using devices such as light, artificial fog, colour projections, mirrors, reflective materials and sound in order to push human perception to its limits. What interests her, she says, are 'situations of dazzlement or the

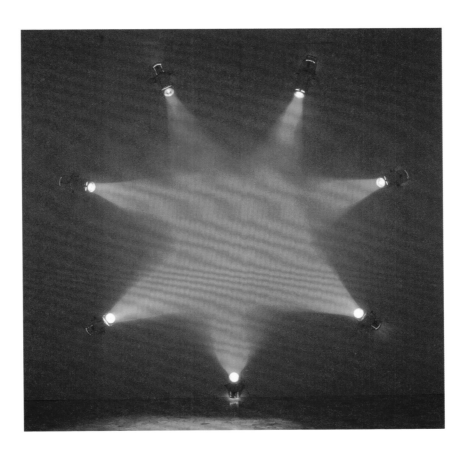

ANN VERONICA JANSSENS, *ROSE*, 2007

persistence of vision, vertigo, saturation, speed and exhaustion'.[1] She describes the space-time experiences at the heart of her work as being close to altered states of consciousness, such as those produced under the influence of drugs or hypnosis.

Janssens explains that, by extending the limits of perception and experimenting with what is visually 'ungraspable', she engineers encounters that 'act as passages from one reality to another'.[2] Her first

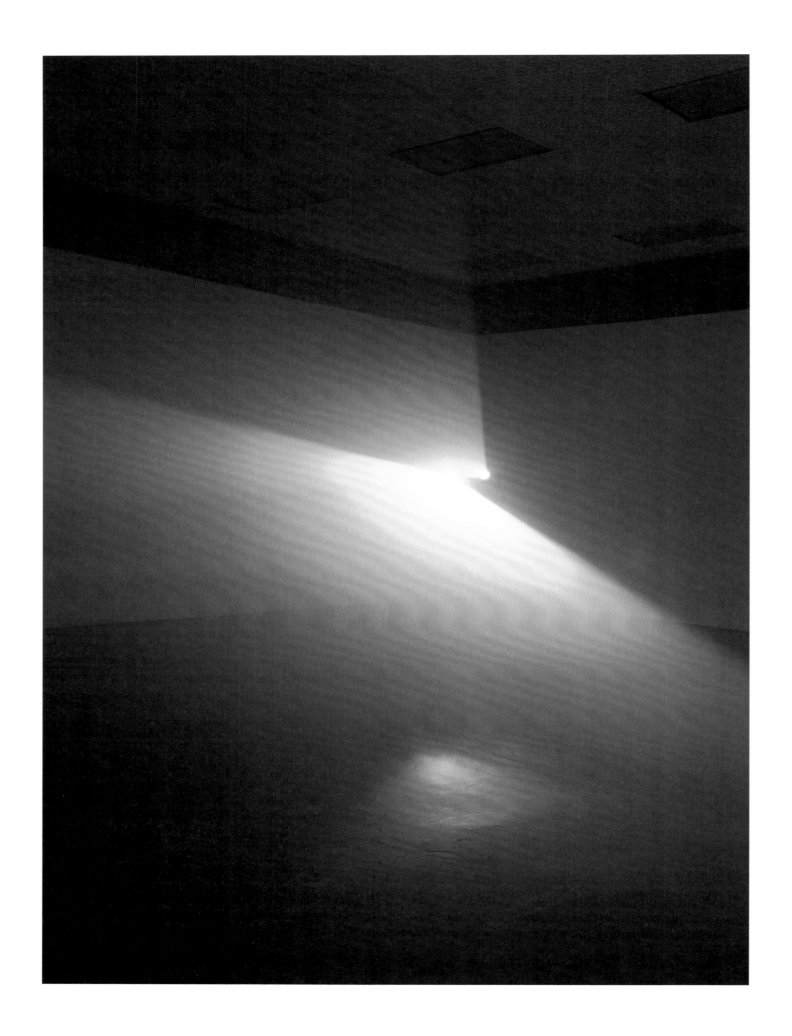

ANN VERONICA JANSSENS, *WHITE YELLOW GREEN STUDY*, 2006

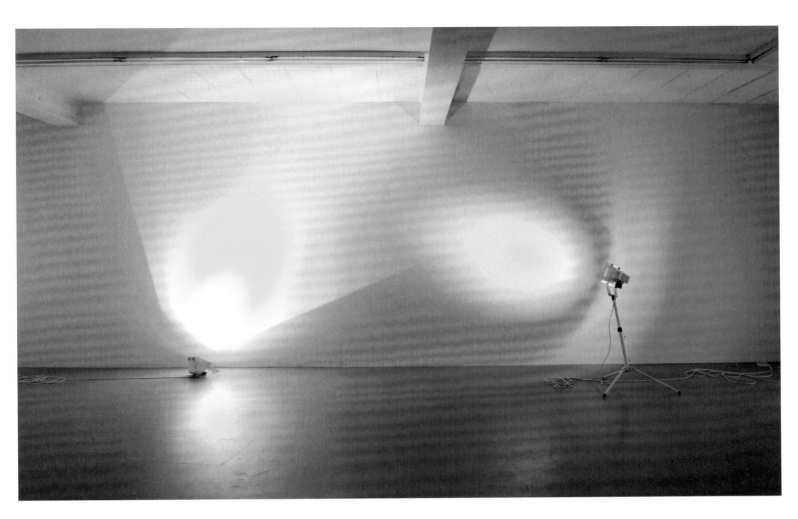

ANN VERONICA JANSSENS, *SKYBLUE & YELLOW*, 2005

ANN VERONICA JANSSENS, *WHITE YELLOW STUDY*, 2005

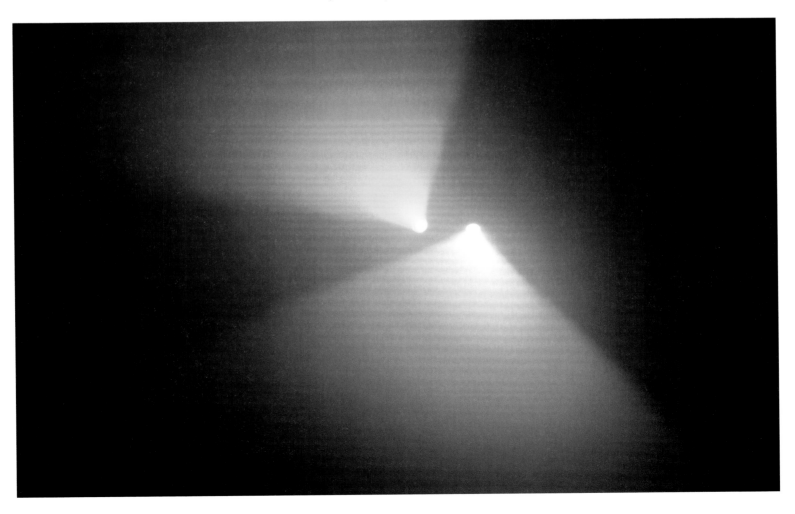

'constructions', made in the 1980s, were spatial extensions of existing architecture: spaces within spaces, spaces surrounding spaces, spaces opening onto other spaces. They were conceived as 'places for the capture of light… springboards towards the void'.[3] One such work, conceived for an exhibition at the Musée d'Art Moderne in Brussels in 1987, consisted of strips of mirror positioned obliquely like a small plinth around the perimeter of the room, reflecting the parquet floor. This had the effect of disorienting visitors, giving them the impression that they were walking on the top of a truncated pyramid suspended in mid-air, with space falling away vertiginously on either side. Here, as in her later works, Janssen's contribution was, she says, 'limited to creating minimal, near-zero preconditions for testing experiences'.[4]

Janssens made her first indoor haze installations in the late 1990s. *Représentation d'un corps rond* (1996) is a Cyberlight projection of a hollow, cone-shaped object in a darkened space filled with artificial mist. This inevitably invites comparison with Anthony McCall's solid light films (pp. 121–6), which were made twenty years earlier, but Janssen's work is not a film and it is not about the slow disclosure of a structure over time. In her representation of a conical form, the light source is fitted with a patterned template and the projected shape periodically spins on its axis. When the beam rotates, the stroboscopic effect increases the physical and perceptual confusion, giving viewers the sensation that the ground is disappearing from beneath their feet.

Following *Représentation d'un corps rond*, Janssens went on to construct enclosed spaces filled with coloured vapour. Speaking of her low-visibility rooms, she says: 'the mist has contradictory effects on the act of seeing. It removes all obstacles, all reality, all contextual resistance, and at the same time, it seems to give materiality and tactility to the light.'[5] More recently, wall-mounted works such as *Rose* (2007, p. 109) have combined artificial fog with beams of light. The haze makes the intersecting beams visible, revealing a luminous star in which light appears to solidify. As with her more overtly architectural works, Janssens' interest here is in sculpting light: 'the idea is to offer a visual experience and make matter dissolve. I use light so that it will seep into matter and architectural structures, in order to create a perceptual experience that puts this materiality into motion and dissolves resistance.'[6] HL

1. Interview with Michel François, 2004, in *Ann Veronica Janssens: experienced*, BasePublishing, Belgium, in collaboration with Espai d'art contemporani de Castelló (EACC), 2009.

2. *Ibid.*

3. *Ibid.*

4. Ann Veronica Janssens, *8' 26"*, Musée d'Art Contemporain (MAC), Marseille, 2003.

5. Michel François, *op. cit.*

6. 'An ABC of the Belgian Scene', *art press 2*, no. 19, 15 November 2010; http://en.artpress.com/article/15/10/2010/online-exclusive---art-press-2-ndeg19-an-abc-of-the-belgian-scene/7606.

BRIGITTE KOWANZ

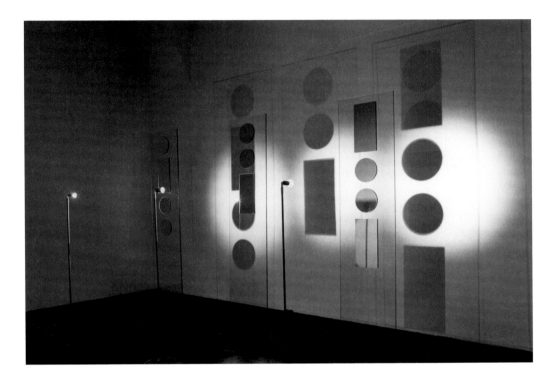

BRIGITTE KOWANZ, *LUX*, 1998

Brigitte Kowanz began using artificial light in her art in the mid–1980s, and her work since then has investigated its relationship with space, language and time. Her early experiments with light included free-hanging paintings made with fluorescent colours that, when illuminated by 'black' (i.e. ultraviolet) light, appear to dissolve and float in space. These were followed by a series of sculptural works called *Transilluminations*, (1985–93) in which glass bottles are illuminated from behind by halogen bulbs; the transparent receptacles contain and refract light in such a way that they look almost spectral, like colourful X-rays. Kowanz then went on to make installations in which she investigated other forms of illumination, including motorcycle and car headlights and fluorescent tubes. These in turn led on to interventions in architectural space: one such work is *Light Steps* (1990/2013, p. 117), an ascending sequence of fluorescent tubes spanning space like a flight of stairs.

Light Steps was devised to intrude on volumetric space in order both to articulate and discompose it. At the same time, Kowanz created site-specific interventions that played with the transformational properties of light in other ways. These included subtle modifications

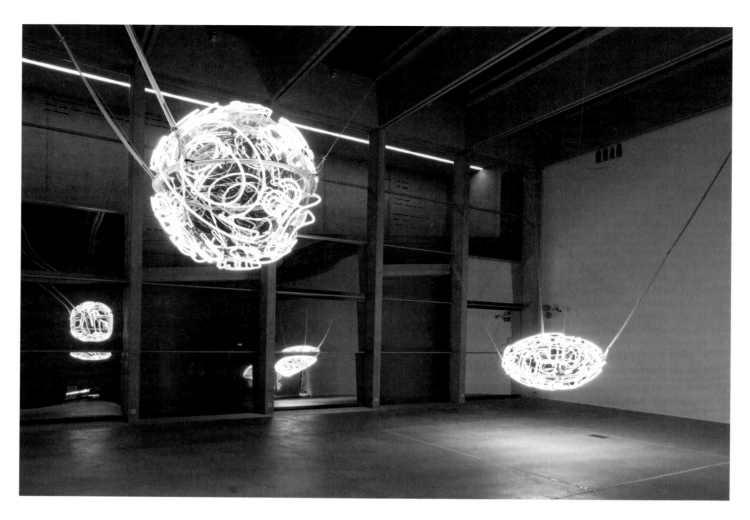

BRIGITTE KOWANZ, *SPATIUM*, 2006 (LEFT); *VOLUME*, 2007 (RIGHT)

BRIGITTE KOWANZ, *LUMINARY ELEVATION*, 1999

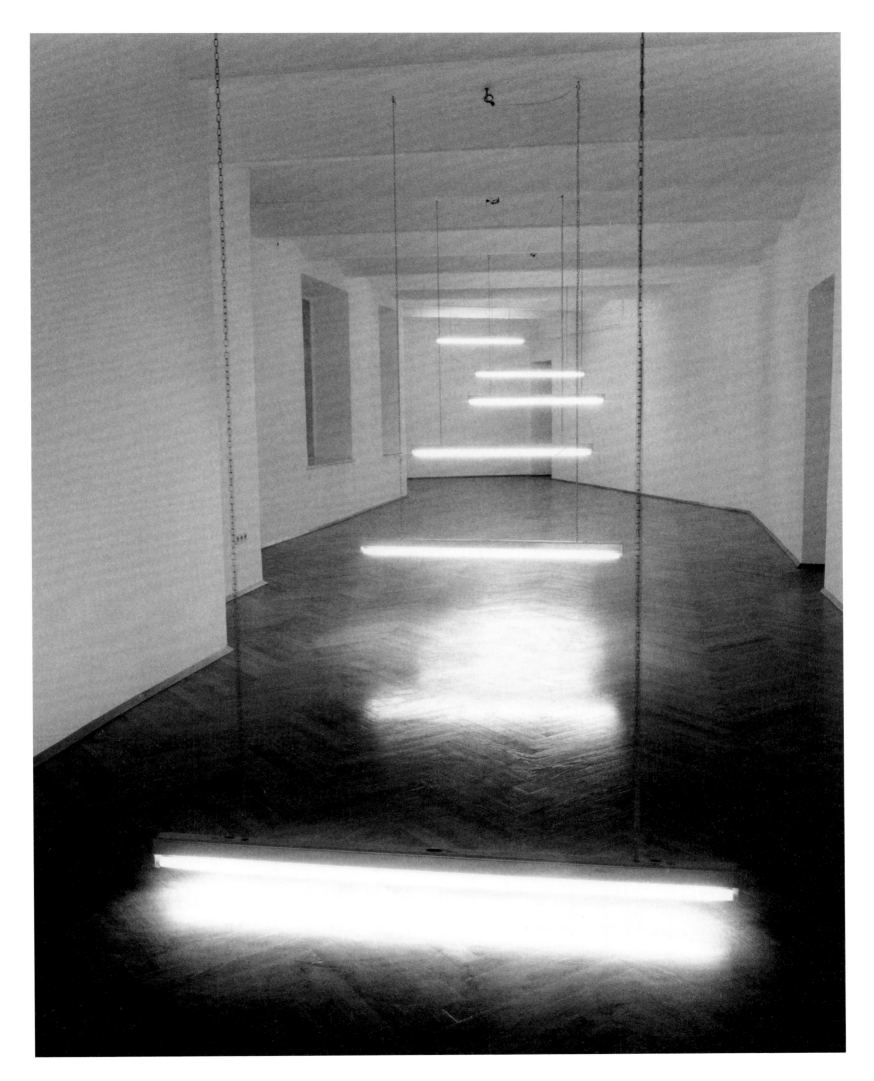

BRIGITTE KOWANZ, *LIGHT STEPS*, 1990/2013

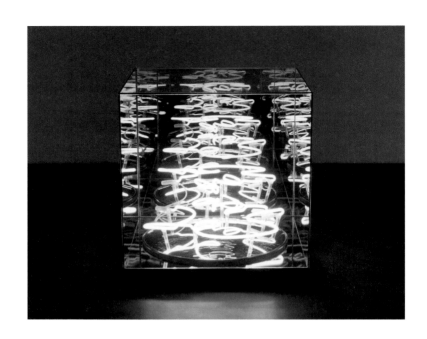

BRIGITTE KOWANZ, *ARISE*, 2008

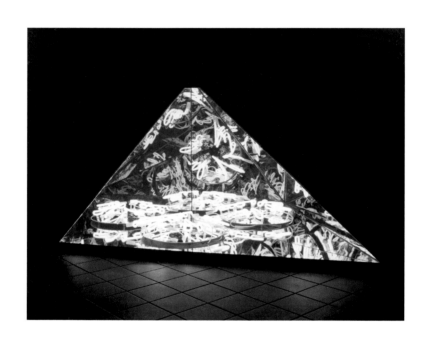

BRIGITTE KOWANZ, *DEDICATED*, 2007

BRIGITTE KOWANZ, *AURA*, 2005

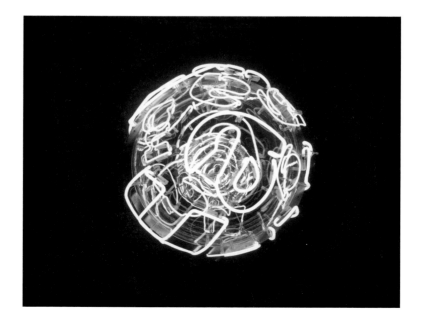

of existing architecture, or of features within it. Further experiments with light using halogen lamps involved modifying the fixtures themselves, so that they projected complex patterns of light and shade onto the walls. Kowanz also explored the rhythmic interplay of light and shadow in projections such as *Depth of Light* (1997), which featured pulsating signal lamps.

Kowanz considers light to be a 'form of language... a carrier of signs and codes'.[1] While she has used actual words and texts in many – mainly neon – sculptures and installations, numerous other works have

BRIGITTE KOWANZ, *COLOURBARS*, 2000

involved the dot-dash configurations of Morse code in some way, often transmitted through the medium of fluorescent tubes or neon elements. As with works incorporating lettering, their underlying message is 'light is what we see', a self-evident truth that is translated into light in a series of works dating from 1994. In the first of these, each letter of the German title *Licht ist was Man sieht* is spelled out in individual glow lamps, and the lights forming each word are plugged into separate distribution sockets. Later versions were not only presented in different languages but also in various other forms of light. A related series of works invokes the speed of light in long sequences of numbers that record the nanoseconds required for light to cover the distance from one end of a neon tube to the other.

Since the late 1990s the multiple ambiguities caused by mirrors and reflections have become a major feature of Kowanz's work, in free-standing sculptures, installations and walk-in environments. In *Lux* (1998, p. 115), an installation involving mirrors, Perspex and halogen lights,

each of the three free-standing elements displays one of the letters of the title, written in Morse code in a sequence of circular and rectangular mirrors. These signals cast shadows behind them and project reflections in front, generating an endless back-and-forth dialogue between light and shade. Explaining that mirrors conduct and intensify light, Kowanz goes on to say: 'I am interested in the way mirrors interact with their surroundings. Mirrors can transmit light, can reflect and bend it, and they can open up spaces and dissolve boundaries.'[2]

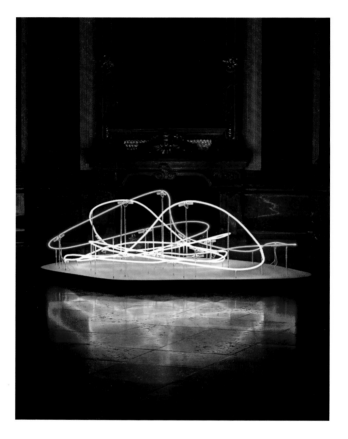

BRIGITTE KOWANZ, *THE ENDLESS FOLD*, 2007

Increasingly, Kowanz has chosen to combine mirrors with neon, which she often uses as a means of writing with light. In *The Endless Fold* (2007), a work created for the Marble Hall of the Upper Belvedere in Vienna, she produced a complex sculpture in which three separate lengths of neon loop around each other. Each of these coils repeats the same encoded sentence: 'Die unendliche Falte ist das Charakteristikum des Barock' ('The Baroque fold unfurls all the way to infinity'). These words, from Gilles Deleuze's study of folding in the thought of the Baroque philosopher Gottfried Leibniz, are 'written' out in the varying lengths of tube between the connectors, and at certain points fold back on themselves. The tripartite, switchback structure is mirrored in its reflective base, and finds further reflections in the hall's marble floor and in its windows. HL

1. Rainer Fuchs, 'Brigitte Kowanz: Manifested Forms', interview with the artist, *Flash Art*, July–September 2010, p. 73.
2. Brigitte Kowanz in conversation with Barbara Willert, in *Brigitte Kowanz: Think Outside the Box*, Museum Ritter, Waldenbuch, 2011.

ANTHONY McCALL

In the early 1970s, Anthony McCall began making films as a means of documenting outdoor performances in which he worked with shifting configurations of small fires in landscape settings. After completing *Landscape for Fire* (1972, p. 126), he found that what interested him was not so much what had occurred in front of the camera, but what happened between the audience and the film at the actual moment of projection. This train of thought led him to embark on his 'solid-light' series.

ANTHONY McCALL, *LINE DESCRIBING A CONE*, 1973; 16MM FILM AND PROJECTOR; DIMENSIONS VARIABLE, ONE CYCLE: 30 MINUTES. INSTALLATION VIEW, ARTISTS SPACE, NEW YORK. IMAGE COURTESY THE ARTIST AND SPRÜTH MAGERS BERLIN LONDON. PHOTO: PETER MOORE © THE ESTATE OF PETER MOORE/VAGA, NYC.

The first, and most famous, of these was *Line Describing a Cone* (1973), which has become a classic of avant-garde cinema. As McCall wrote at the time, the film 'deals with one of the irreducible, necessary conditions of film: projected light. It deals with this phenomenon directly, independent of any other consideration.'[1]

When *Line Describing a Cone* was first shown, it was hailed as a work of cinematic deconstruction. Apart from the fact of being projected in a dark room over a fixed period of time, it overturns all conventions of cinema and reverses normal film behaviour. It consists of a thirty minute

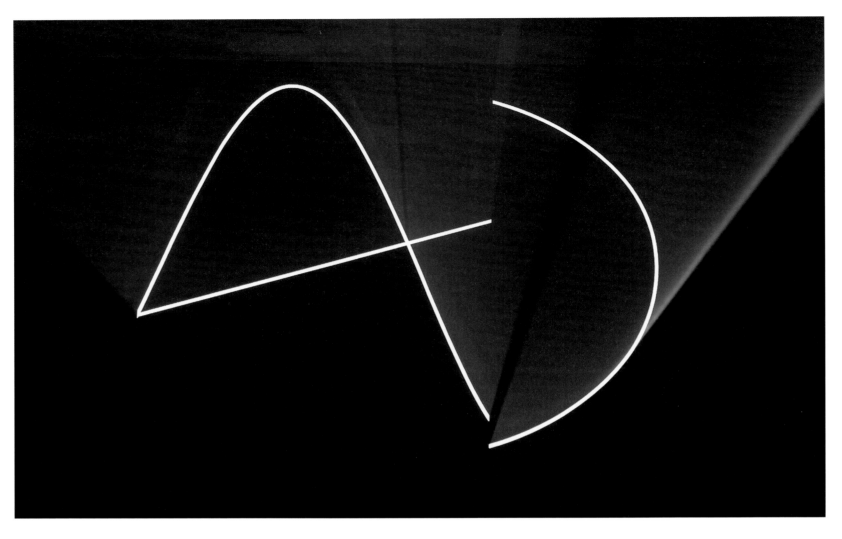

ANTHONY McCALL, *YOU AND I, HORIZONTAL*, 2005

analogue film in which the subject (and substance) is not the projected image but the beam of light that carries it. Starting as a thin ray, the shaft of light gradually widens and unfurls to form a complete, hollow cone that becomes visible by virtue of ambient mist produced by a haze machine, which catches and reflects the projected light.

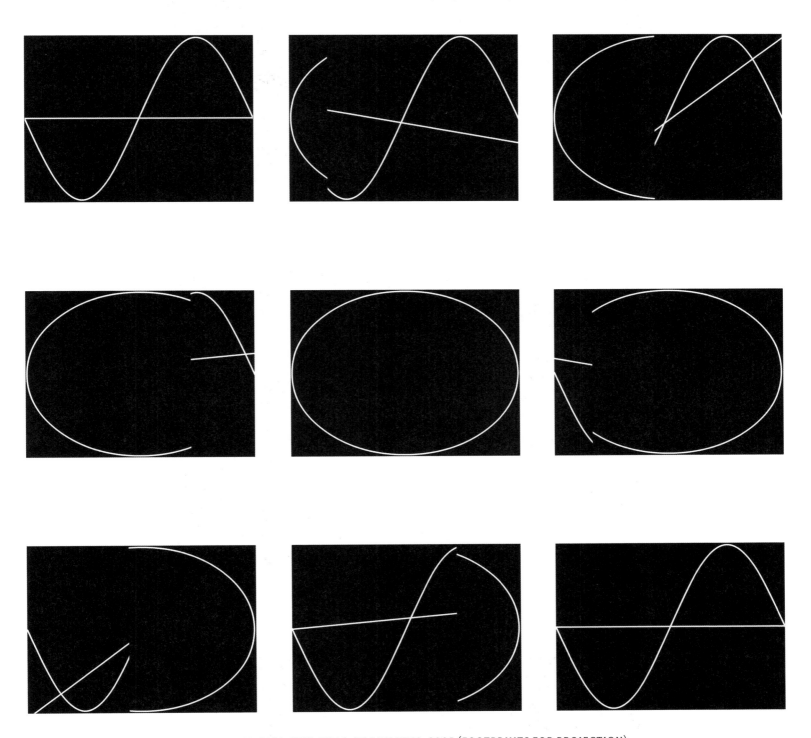

ANTHONY McCALL, *YOU AND I, HORIZONTAL*, 2005 (FOOTPRINTS FOR PROJECTION)

Between 1973 and 75, McCall made seven solid-light works. In these immaterial works, light – which has no solidity – is experienced as a three-dimensional presence involving movement and occupying space and time. Originally, when they were shown in avant-garde film venues, New York lofts and alternative art spaces in the 1970s, their visibility depended on particles of dust in the air. Cigarette smoke was a welcome atmospheric ingredient. Later, when exhibition spaces became cleaner and smoking was no longer allowed, McCall discovered that his

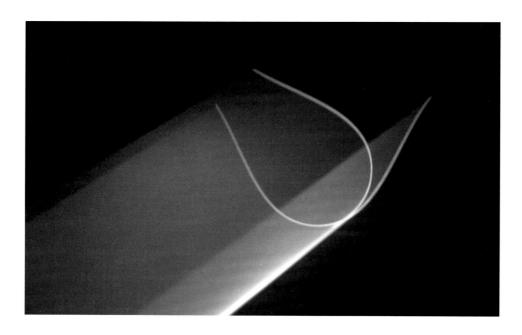

ANTHONY McCALL, *DOUBLING BACK*, 2003. STILLS: 2 MINUTES
30 SECONDS; 7 MINUTES 30 SECONDS; 11 MINUTES 30 SECONDS

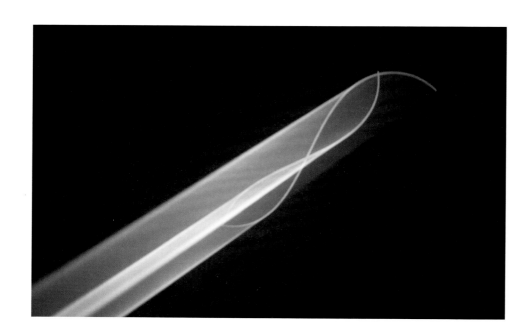

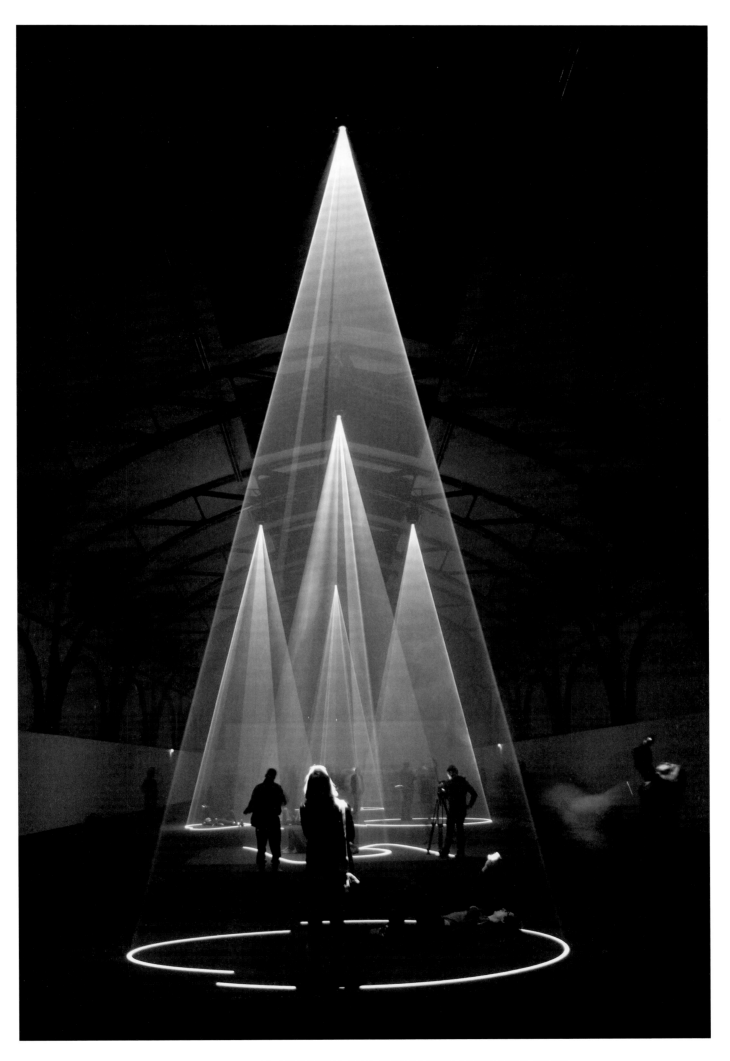

INSTALLATION VIEW, *ANTHONY McCALL: FIVE MINUTES OF PURE SCULPTURE*,
NATIONALGALERIE IM HAMBURGER BAHNHOF, BERLIN, 2012

projected light beams had, as a result, become invisible. For 25 years he stopped making solid-light works. But, after the haze machine became available in the 1990s, McCall initiated a new series, beginning with *Doubling Back* (2003, p. 124), this time using computer algorithms and scripting to produce them rather than traditional film animation.

These digital techniques enabled him to create more complex solid light works like *You and I, Horizontal* (2005, pp. 122, 123), which explore

ANTHONY McCALL, *LANDSCAPE FOR FIRE*, 1972

forms such as ellipses and travelling waves. He also developed a form of transition based on the traditional cinematic 'wipe', which allowed him to maintain two opposing sculptural forms within the same three-dimensional space. The fact that digital projectors could be suspended from the ceiling meant it was possible to orient the solid-light films vertically, something that would have been impractical using 16 mm projections. From 2004 onwards, responding to this possibility, McCall began creating vertical projections, as well as horizontal, which he characterised as 'standing figures'. The new works continue to occupy an ambiguous space between sculpture, cinema, and drawing, but there has also been an unmistakable shift in emphasis. As he puts it: 'over the past few years I've thought of my solid-light works as referring to the body, or as suggesting the idea of reciprocity between bodies'.[2]

1. Anthony McCall, 'Line Describing a Cone and Related Films', *October* 103, Winter, 2003.
2. Charlotte Beaufort and Bertrand Rougé, interview with Anthony McCall (published in French) *La Lumière dans l'Art depuis 1950* (Figures de l'Art No 17), 2009.

FRANÇOIS MORELLET

FRANÇOIS MORELLET, *ACROBATIE N°1*, 2010

Since the early 1960s, François Morellet's sculptures, outdoor and indoor architectural interventions, and ephemeral installations have featured neon and other forms of artificial light. A self-taught artist who worked as an industrialist until 1975, Morellet began his artistic life as a painter. From being almost obsessively interested in abstract geometry he painted endless repetitions of lines, dashes, squares, etc., which formed optically vibrating patterns. He went on to be a founder member of the *Groupe de Recherche d'Art Visuel* (GRAV) in 1960. This group, Morellet recalls, was convinced that the age of painting was over for ever: 'We were passionate about modern materials that hadn't yet been "polluted" by traditional art. We particularly liked anything that could produce movement or light.'[1] He goes on to say, 'neon tubes struck me as an ideal material… because I thought then that they had never been used in art, as I suppose Martial Raysse and Dan Flavin must have thought, too, in those days'.[2]

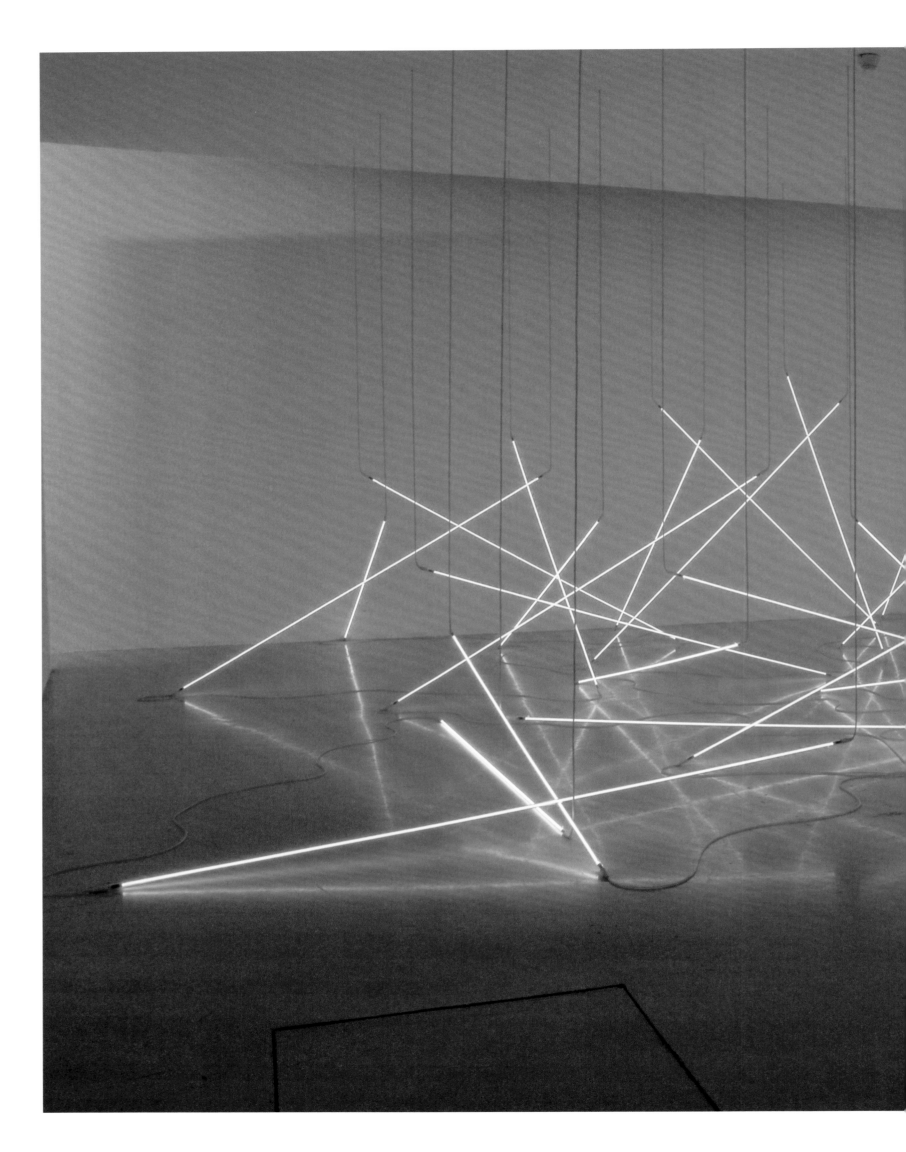

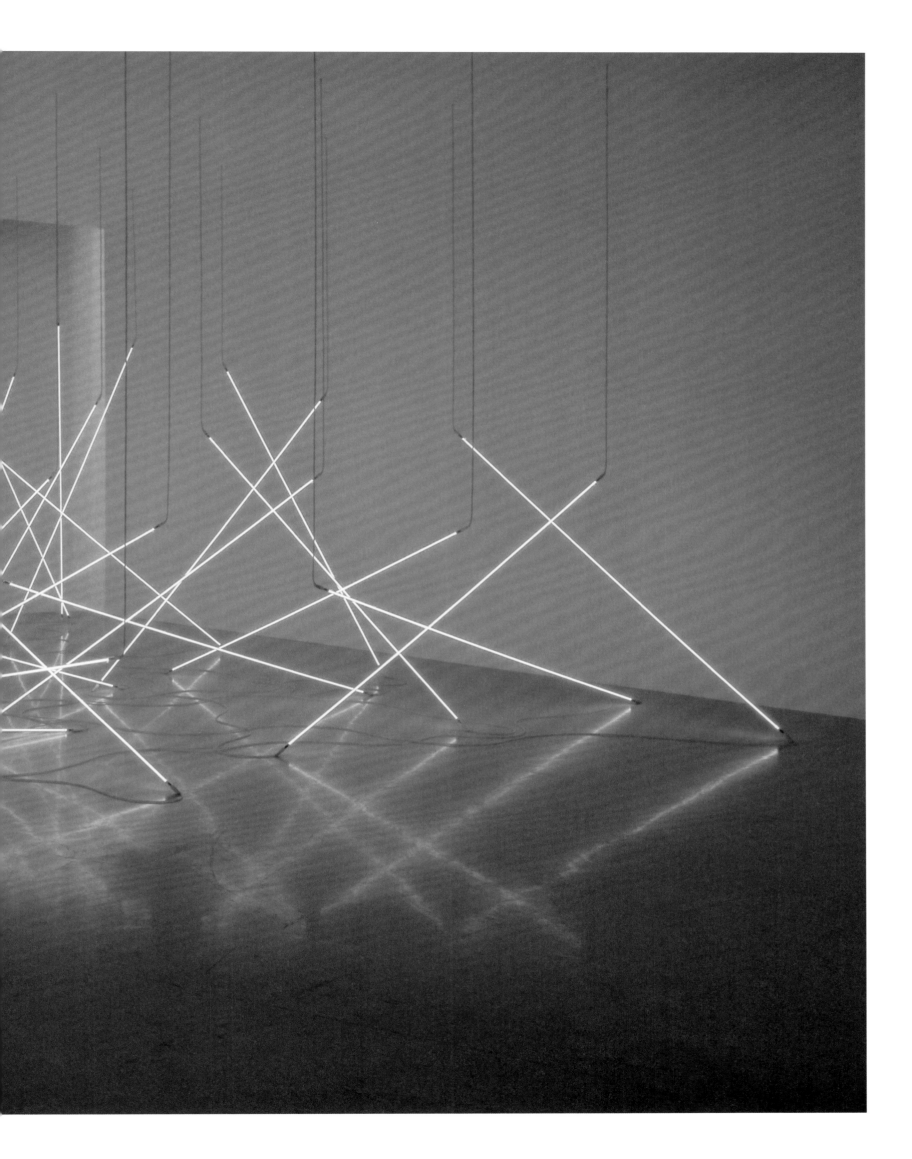

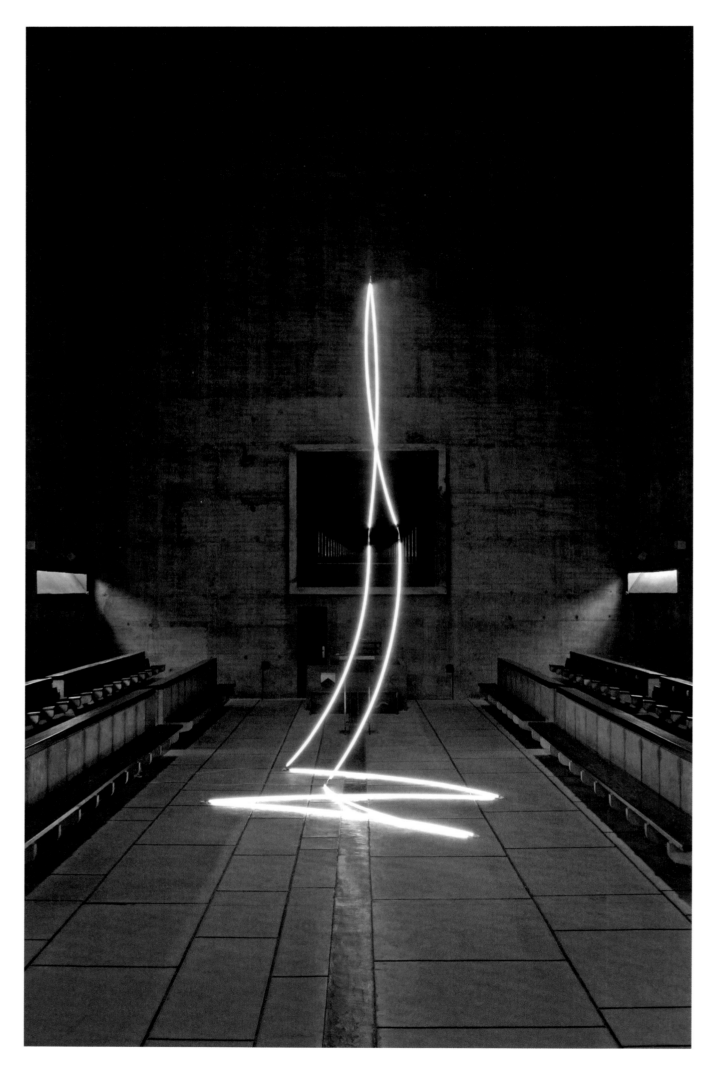

FRANÇOIS MORELLET, *LAMENTABLE*, 2006

During the 1960s, Morellet explored the possibilities of artificial light, especially in relation to optics, rhythm and arbitrary interference. One of his first works using light was *16 lampes – allumage avec 4 rythmes superposes* (1963), a grid of 16 randomly flashing incandescent bulbs, in which each block of four lamps blink simultaneously but at different speeds. This was followed by his fourth work using neon tubes, *Neon 0°–90° – Éclairage avec 4 rythmes interférents* (1965), in which a grid of horizontal and vertical white argon tubes form constantly changing ephemeral shapes and patterns. In both works, the after-image played an important role. Although these, like other works produced at this time, were based on mathematical rules and systems, they produced completely contrary effects: what should be ordered and predictable appears to be haphazard, disrupting expectation and causing visual confusion.

Other works created around this time called for the viewer's active participation. *Reflets dans l'eau déformés par le spectateur* (1964) invited visitors to disturb the surface of a dark pool in which a grid of neon tubes was reflected. The moving water produced unpredictable patterns that continued to change as the water rippled. In various neon works dating from the early 1970s, the sequences of flashing lights were activated by the viewer, either by pushing a button or using dual controls. Most of Morellet's subsequent light works are static, featuring organised groupings of similar types of neon tubes in different configurations. Many of these relate directly to spatial or architectural situations and play with the viewer's perception of space.

In his later work, which he characterises as 'baroque', Morellet abandoned his use of functionally descriptive titles in favour of incongruous titles which, he says, 'free my works from the seriousness that can sometimes be attributed to them and which I detest'.[3] Elaborating on this, he remarks: 'It seems to me that humour, irony, derision and frivolity are the necessary spice to make squares, systems and all the rest of it digestible.' He suggests that the English translation of *Lamentable* (2006, opposite) should be 'pitiful' or 'miserable'. This elegant neon sculpture, which recalls Morellet's first 'fragmented' work, the four-part painting *Arc de cercle brisé* (1954), consists of eight dislocated sections of a circle. These are suspended, one arc dangling from another, on a string fixed to the ceiling. As a result, he says, 'the beautiful circle hangs down in a pitiful way'.[4] HL

1. Alfred Paquement, interview with François Morellet, *CODE COULEUR*, No. 9, January/March 2011.

2. *Ibid.*

3. '"Artworks are picnic sites": François Morellet in Conversation with Gerda Ridler' in *François Morellet: The Squaring of the Square. An Introspective*, Museum Ritter, Waldenbuch, online at http://www.museum-ritter.de/sprache2/n1529515/i1529544.html, accessed 12.9.2012.

4. François Morellet, email to Hayward Gallery, 2012.

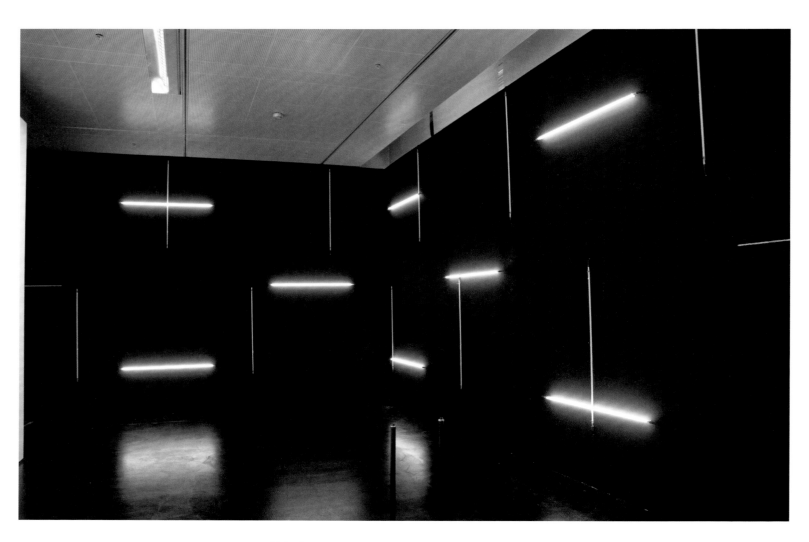

FRANÇOIS MORELLET, *2 TRAMES DE TIRETS 0°–90°*
AVEC PARTICIPATION DU SPECTATEUR, 1971

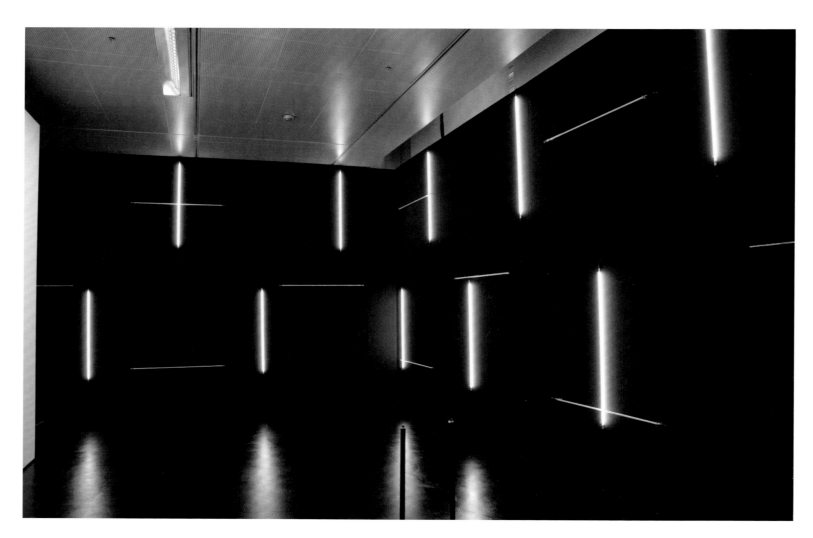

IVÁN NAVARRO

Based in New York since 1997, the Chilean artist Iván Navarro uses light to reinterpret the formal language of Minimalism, celebrating its aesthetics while critiquing what he perceives to be its underlying issues of power and authority. Growing up under the dictatorship of Augusto Pinochet, a period when torture, murder and disappearances were common, for Navarro, Minimal art represented 'a stereotype for

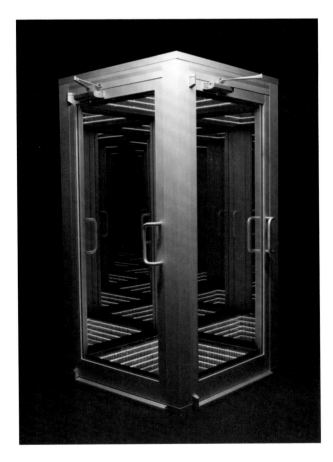

IVÁN NAVARRO, *REALITY SHOW (SILVER)*, 2010

American art… connected with progress and industrialisation'.[1] Alluding to works by American Minimalists and conceptualists such as Dan Flavin, Dan Graham, Ellsworth Kelly and Bruce Nauman, Navarro colours his practice with a distinctively personal hue: in a process that he terms 'metaphorically "dirtying" the purity of industrial [and architectural] forms', he uses light as the analogy for an intellectual illumination that exposes the failure of Modernist utopian ideals.[2]

133

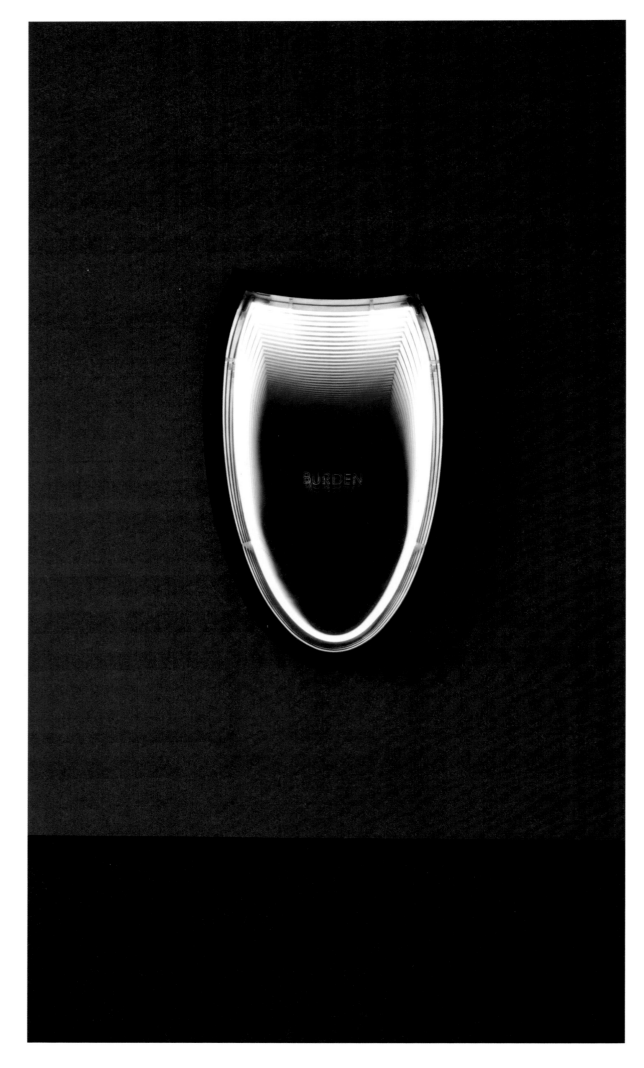

IVÁN NAVARRO, *BURDEN (LOTTE WORLD TOWER)*, 2011

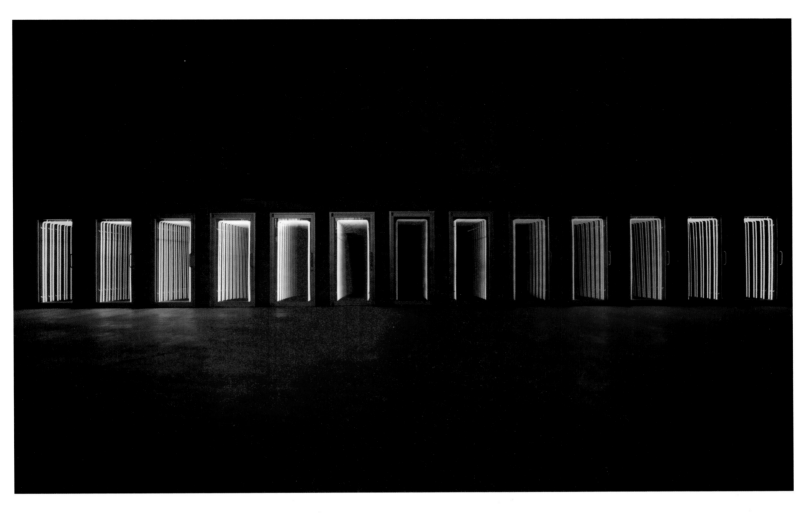

IVÁN NAVARRO, *DEATH ROW*, 2006–9

IVÁN NAVARRO, *NOWHERE MAN I AND VI*, 2009

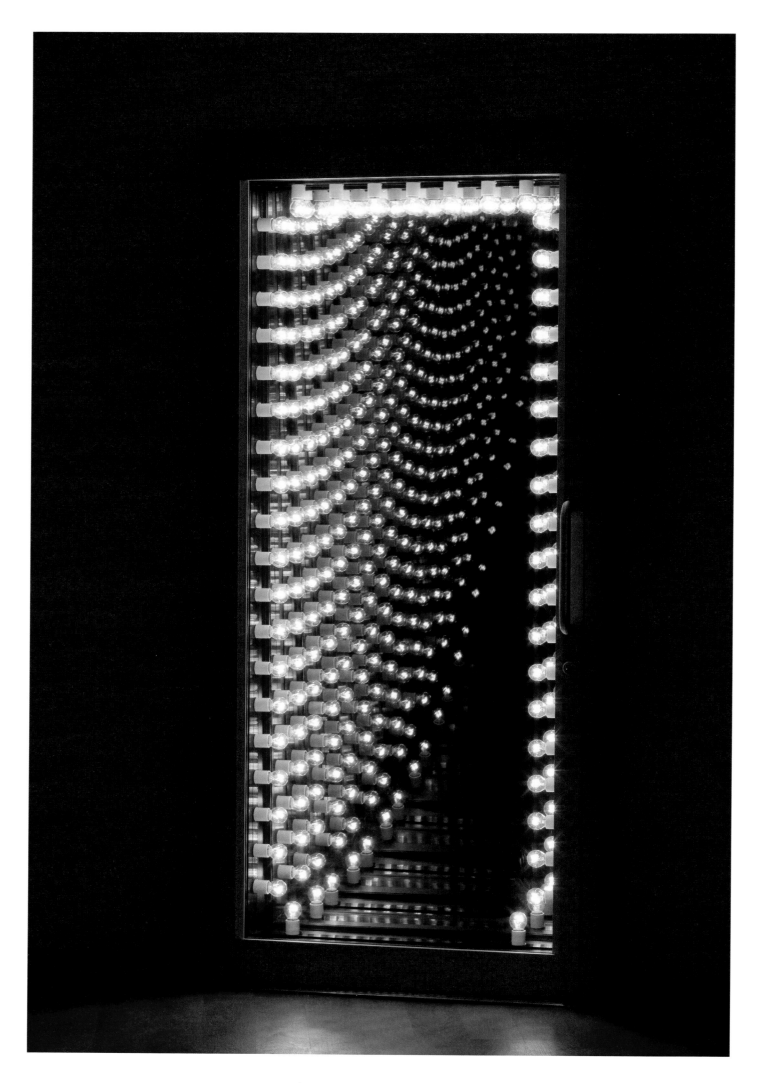

IVÁN NAVARRO, *THE BORDER*, 2007

Through their reference to forms of capital punishment or to social issues, Navarro's titles may evoke a visceral or psychological response; his restrained geometric sculptural installations often provoke vertiginous phenomenological effects.

Navarro utilises fluorescent tubes as construction modules, putting them together like scaffolding to create ordinary objects such as a chair (*Electric Chair*, 2004–5), a wheelbarrow (*Flashlight: I am not from here I am not from there*, 2006) and a shopping trolley (*Homeless Lamp, The Juice Sucker*, 2004–5). In the video that accompanies this last work,

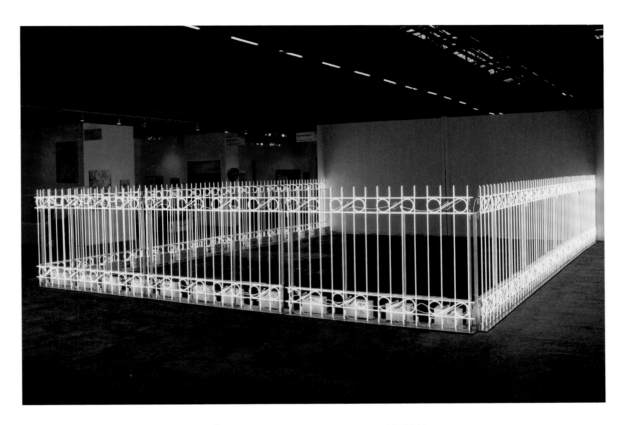

IVÁN NAVARRO, *THE ARMORY FENCE*, 2011

the illuminated shopping trolley pushed through the streets is powered by electricity illegally siphoned from electric points intended for use by facilities workers, calling to mind the containers used by countless urban homeless for their scavenged belongings. Fluorescent stick figures strike poses derived from the pictograms designed by Otl Aicher for the 1972 Olympics in Navarro's series *Nowhere Man* (2009, p. 135). Here, the artist's discovery of the relationship of scale and proportion between the human body and the fluorescent tube became a metaphor for what he refers to as 'the industrialisation of the human body, in which transformation from one kind of energy to another... results in some kind of loss'.[3]

Central to Navarro's work, the notion of threshold is exemplified most visibly in his numerous portals made from door frames, mirrors and lights – either fluorescent tubes or incandescent light bulbs. *Death Row* (2006–9, p. 135) – a series of 13 coloured doors arranged following Ellsworth Kelly's *Spectrum V* (1969) – presents the visitor with tunnels of light, as the framing fluorescent strips are multiplied infinitely by

one-way mirrors. For the artist, this space opened up into the wall of the gallery or museum relates to the building cuts made by Gordon Matta-Clark, with the difference that rather than exposing the structure of the building, they engage the viewer in a situation of frustrated desire. Reminiscent of the interrogation chamber, the one-way mirror places

IVÁN NAVARRO, *ECCO (BRICK)*, 2012

the viewer in the position of the guard, who looks into a space from which he cannot be seen. But the door is locked, and the viewer is unable to penetrate the space. By contrast, *Reality Show (Silver)* (2010, p. 133) presents a cubicle into which the viewer may step to witness the space extending out infinitely in all directions. But here, he or she is the object of the voyeurism of others outside the chamber – isolated in a brightly illuminated glass-walled box that recalls the surveillance mechanisms of television reality shows and the spectacular multi-levelled heights aspired to by contemporary corporate architecture. EM

1. Navarro quoted in Oliver Koerner von Gustorf, 'The Dark Side of Light: Iván Navarro's Emotionally Charged Minimalism', http://db-artmag.com/en/60/feature/ivan-navarros-emotionally-charged-minimalism/, accessed 13 September 2012.
2. Navarro quoted in conversation with Justo Pastor Mellado, 'Politics of Provision' in *Iván Navarro: Threshold*, exh. cat. 53rd Venice Biennale, 2009, p. 55.
3. Navarro quoted in *ibid.*, p. 52.

PHILIPPE PARRENO

The Paris-based artist Philippe Parreno makes work that dialogues
across and between cultural forms, challenging stable subject positions
and notions of linear temporal continuity. Conceptual in its approach,
his practice is based on collaboration through conversations with other
artists, a production model that he first established during the 1980s in
Grenoble, when he began working with Pierre Joseph, Bernard Joisten,
Dominique Gonzales-Foerster and Philippe Perrin. Committed to

PHILIPPE PARRENO, *L'ARTICLE DES LUCIOLES*, 1993

intellectual property sharing, Parreno creates exhibition situations
or circuits where everyone can create his or her own story. He is more
interested in procedures than resolutions, defining art as a process
in which the exhibition is another medium rather than a destination.

Parreno first used light to represent the residue of echoes from
the past in works that play on the role of the gallery in displaying
objects. In 1993, the artist installed a string of LED lights in the garden
of the Villa Arson in Nice. The work's title, *L'Article des Lucioles*, referred
to an article written by Pier Paolo Pasolini in 1975, in which he used the
disappearance of fireflies from Europe in the 1960s as a metaphor for

OVERLEAF: PHILIPPE PARRENO, AN ADAPTATION OF *ORANGE BAY (AFTER GABRIEL
TARDE'S FRAGMENT OF FUTURE HISTORY)*, 2002, AND *SPEECH BUBBLES*, 1997

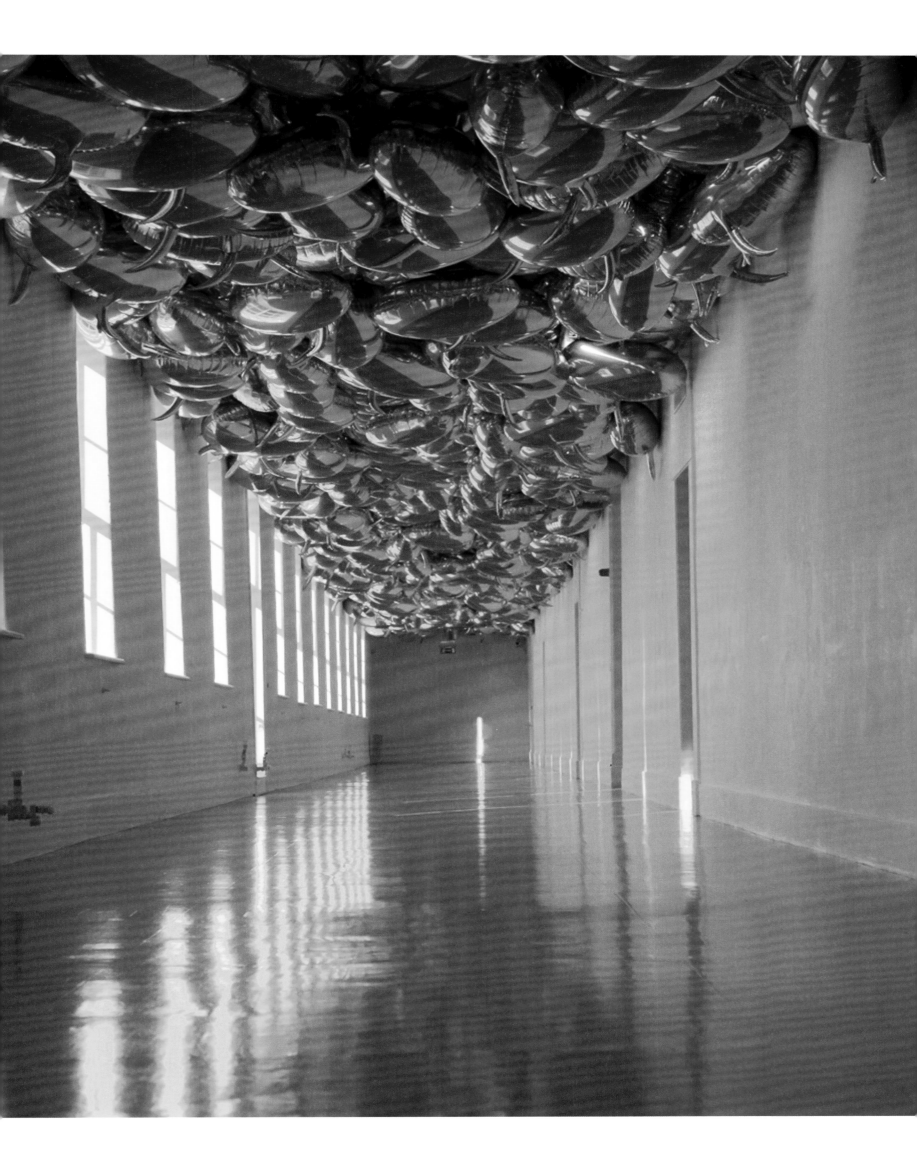

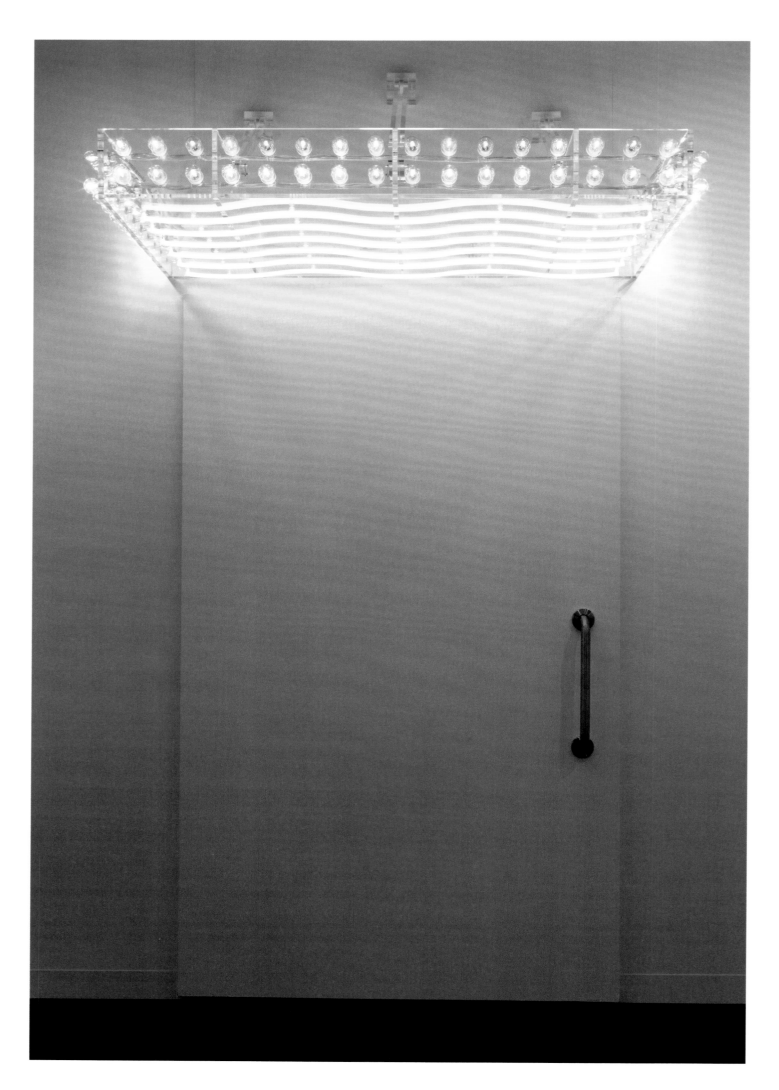

PHILIPPE PARRENO, *MARQUEE*, 2011

the fall of ideology and the rise of mass consumerism. A reproduction of Pasolini's text on display inside the villa was the sole visible manifestation of the work, as the lights, like fireflies, could only be seen at night when the gallery was closed. In *Happy Ending, Stockholm* Parreno installed a lamp on the floor of the Ynglagatan gallery in Stockholm, (2006, overleaf) lighting it by means of a power source hidden beneath the floor. Designed by Eero Saarinen for a hotel that was to have been built on the site of the gallery but was never realised, the lamp evoked this discontinuity with its eerily trailing electrical cord and plug. Another

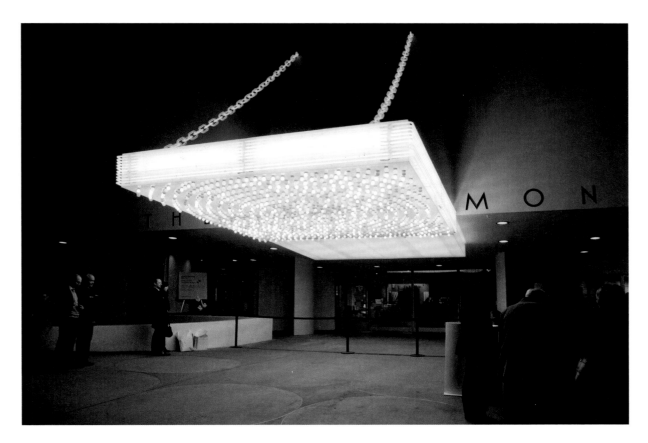

PHILIPPE PARRENO, *MARQUEE, GUGGENHEIM, NY*, 2008

trace is invoked in *Skin of Light* (2001, overleaf) – the outline of the avatar AnnLee drawn in neon tubing. It is part of Parreno's project *No Ghost Just a Shell* (1999–2003), in which he and Pierre Huyghe purchased rights to the Japanese manga character AnnLee from an agency, and invited 16 artists to give the figure identity, filling the empty shell with stories and ideas. In *Skin of Light*, the neon tubing presents the head of AnnLee as a logo, emphasising the ghostly nature of the avatar who lacks real substance, having a merely virtual existence.

Cinema is a significant part of Parreno's practice, both as a subject and a medium. Inspired by the marquees that hang over the entrances to American movie theatres advertising film titles and the stars' names, Parreno began making *Marquees* in 2006, installing them over doorways within gallery spaces or, perhaps most spectacularly, over the front entrance of the Guggenheim Museum, New York, in 2008 for the exhibition *theanyspacewhatever*. Made from acrylic, neon tubes and rows of incandescent bulbs, they are supported by chains or fixtures

that may be illuminated by lines of tiny LEDs. Microcontroller and driver circuitry control the lighting components of the *Marquees*, in some instances causing them to sparkle in random patterns, and in others theatrically dimming down and lighting up in sections, evoking the drama of the cinema without announcing a film. Introducing the space of the exhibition as the stage for an event, the *Marquees* are often placed on the threshold between two empty rooms, emphasizing the role of the visitor as the central protagonist. EM

PHILIPPE PARRENO, *SKIN OF LIGHT*, 2001

PHILIPPE PARRENO, *HAPPY ENDING, STOCKHOLM*, 1995–7

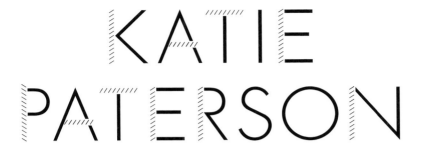

KATIE PATERSON

The Scottish artist Katie Paterson works in collaboration with scientists and engineers to produce conceptual works that dialogue between the Romantic sublime and the ordinary everyday. Investigating the vastness and intangibility of space and time, she employs technology

KATIE PATERSON, *LIGHT BULB TO SIMULATE MOONLIGHT*, 2008 (DETAIL)

to highlight the endless processes of entropy and rebirth to which the cosmos is subject, revealing the intimate connections between things. Her interest in the interplanetary landscape stems from her time living in Iceland, where she was inspired to reflect on the human relationship to the planet and wider space by the immensity and proximity of the sky and the constantly changing light. One of her first major works, *Earth–Moon–Earth (Moonlight Sonata Reflected from the Surface of the Moon)* (2007), sent the first movement of Beethoven's famous Sonata

145

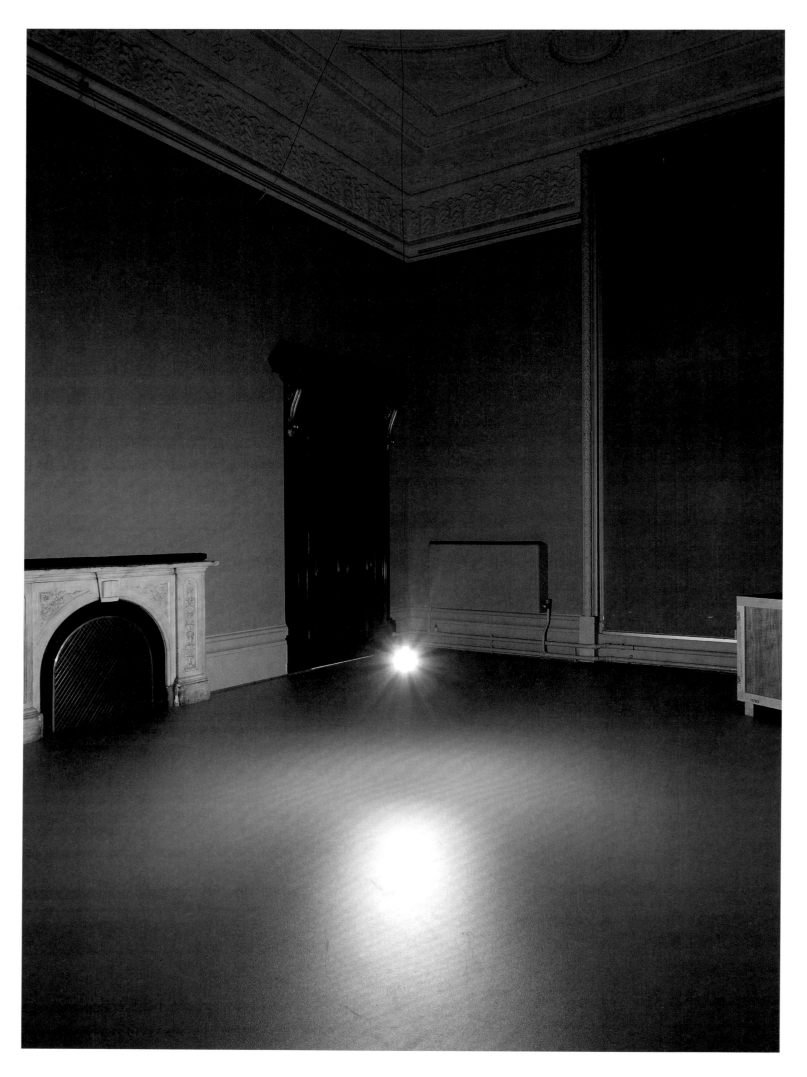

KATIE PATERSON, *LIGHT BULB TO SIMULATE MOONLIGHT*, 2008 (DETAIL)

to the moon and back. Paterson worked with a moonbouncer to transmit the score as Morse code; reflected back to Earth, the radio waves were picked up by a receiver in Sweden. The coded message was then reconstituted as a musical score and programmed for a self-playing grand piano. Not every note survived the journey back and forth into near space, rendering the lunar version of the Sonata more melancholy than the original.

Light bulb to Simulate Moonlight (2008, opposite and p. 145) also evokes the poetic associations of the moon, relating it to human

KATIE PATERSON, *STREETLIGHT STORM*, 2010

mortality. Spectral measurements were taken under the light of a full moon to create incandescent light bulbs that match the moon's light in its colour, temperature and intensity, suffusing the room in which they are installed with a chilly nocturnal glow. In the dim bluish light, a grid of 289 bulbs is displayed as part of the work. This number is based on the average global human life expectancy of 66 years and the fact that each bulb burns for 2,000 hours – one set should provide enough moonlight

to last a lifetime. There would be no moonlight without the light of our sun, and Paterson is equally conscious of the darkness of deep space, which, like death, is ultimately unknowable. *For All the Dead Stars* (2009, previous spread) Paterson contacted astronomers all over the world to map the coordinates of over 27,000 stars that are no longer visible, with points of light that reflect off a large sheet of black, etched steel. An ongoing slide archive, *History of Darkness* (2010), presents images of

KATIE PATERSON, *100 BILLION SUNS*, 2011

darkness from different times and places in the history of the universe, made relevant and precise by their coordinates and distance.

The most powerful emissions of light in the universe are gamma ray bursts, releasing as much energy in one explosion as our sun will emit in its entire ten-billion-year lifespan. Paterson was able to view the evidence of gamma ray bursts that had happened in far-off galaxies more than 11 billion years ago – long before Earth was formed – with the help of astronomers at W. M. Keck Observatory in Hawaii. *100 Billion Suns* (2011) brings the magnitude of these events bathetically down to human level, releasing 3,216 pieces of confetti, colour-coded to match the hues of the 3,216 gamma ray bursts thought to have occurred to date, from a hand-held cannon in a brief explosion of small paper circles. In a similar mapping of macrocosm to microcosm at Whitstable Biennale in 2010, *Streetlight Storm* (p. 147) caused the lights along Deal Pier to flicker in time with lightning strikes that were occurring in locations around the world. Tracked by antennae and transmitted via the Internet, the strikes were translated into subtly oscillating light pulses, reducing the power and the drama of the electrical storms to a more human scale. EM

CONRAD SHAWCROSS

Conrad Shawcross makes sculptures that refer to ideas within philosophy and science, exploiting their dependency on metaphor and allegory for communication. Attracted by failed quests for knowledge and redundant technologies, he uses these as the basis for poetic reinterpretation in the form of hand-made machines and enigmatic static constructions. His sculptures reflect his interest in the two rival metaphors for epistemology: the certainty of science,

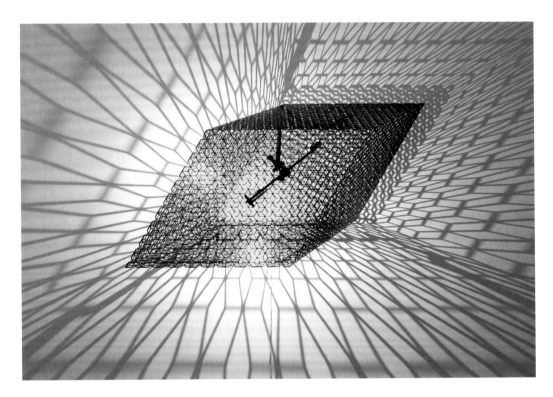

CONRAD SHAWCROSS, *SLOW ARC INSIDE A CUBE V*, 2011

in which knowledge is built on an assumption of solid ground; and an undermining theory, known as Neurath's boat, which posits that there is no certainty in knowledge, but that it is always in flux, like a vessel moving on water. This concept of knowledge as a fluid series of interlocking and interdependent parts is reflected both in the structure of Shawcross's objects and in the way they interweave forms and ideas from different disciplines.

OVERLEAF: CONRAD SHAWCROSS, *SLOW ARC INSIDE A CUBE IV*, 2009

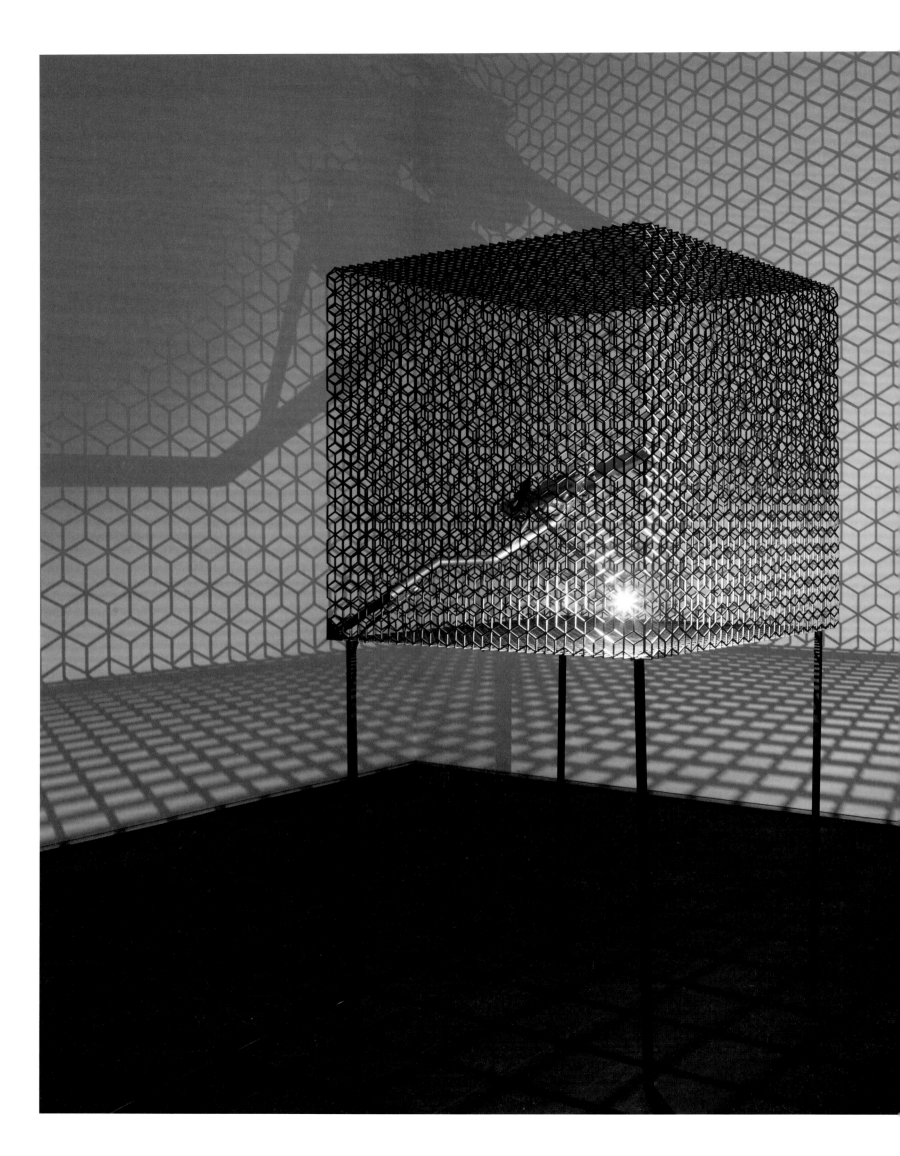

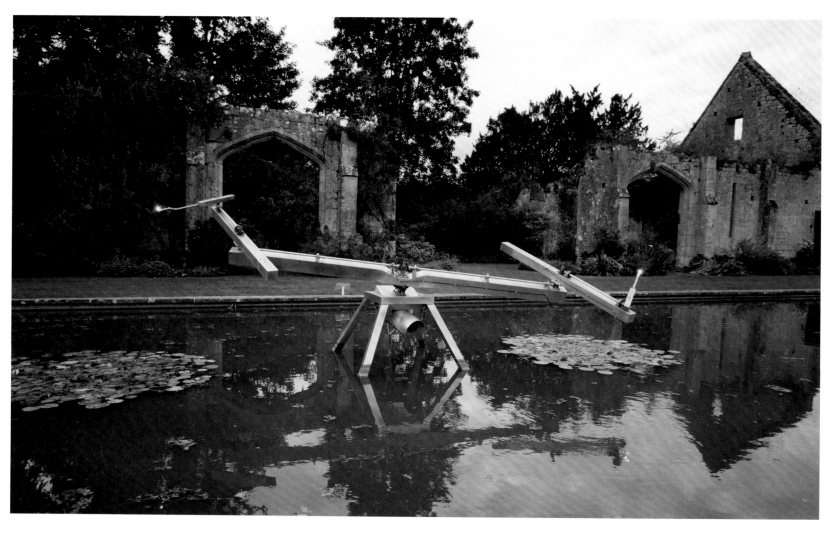

CONRAD SHAWCROSS, *DARK HEART*, 2007

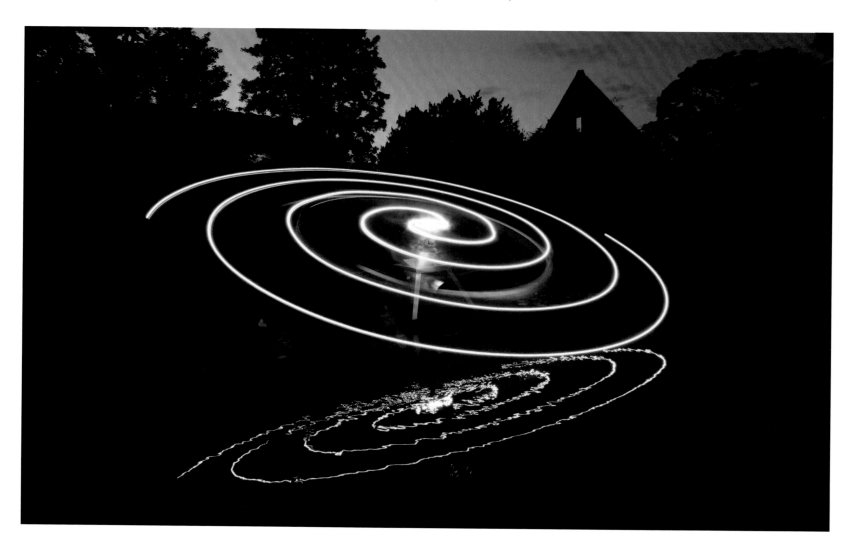

Shawcross's preoccupation with philosophical questions around cosmology, the nature of time, mathematics and harmonics generated his earliest sculptures, all meticulously crafted from wood. Light first appeared in his work in 2003, drawing circles of energy related to both ancient and modern concepts: the theory of harmonic ratios and string theory. Positing that matter is made up of continuously vibrating 'strings'

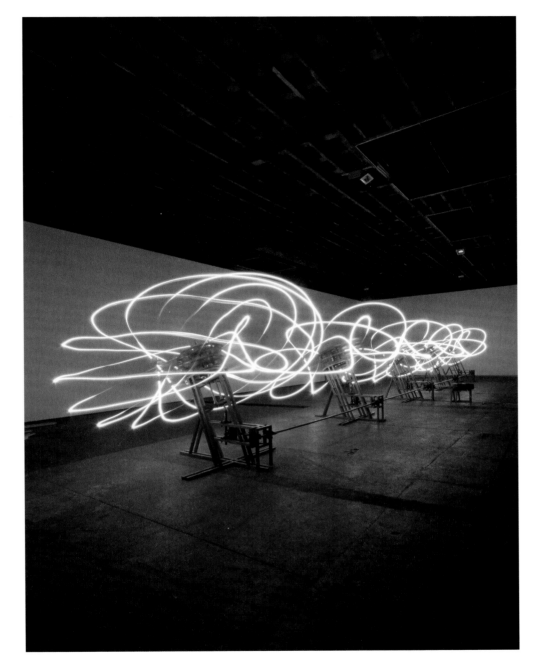

CONRAD SHAWCROSS, *LOOP SYSTEM QUINTET*, 2005

of energy rather than single isolated particles, string theory attempts to unite Einstein's theory of general relativity with quantum mechanics. Developed from this, *Loop System Quintet* (2005) comprises a series of five similar machines made of oak and steel, each drawing a continuous arcing loop of light described by a rotating arm with a bulb on the end that moves at high speed. The velocity and intensity of the light burns its path onto the spectator's retina, revealing the drawn shapes fleetingly. The different 'knots' in space thus described represent visual transcriptions of harmonic chords in the Western octave, an analogy

that Shawcross elaborates further in *The Blind Aesthetic* (2011). Here, a bulb on the end of a mechanical arm fixed to a metal tripod moves through a series of stepped harmonic ratios, drawing a sequence of loops of light in the mathematical form of torus knots. This machine is housed in one chamber of a large bicameral glass box; the other contains a stool facing colourful looping drawings pinned to the dividing wall. The absent inhabitant of this chamber is unable to see anything of the machine's actions on the other side of the wall, only to imagine them through contemplating the line drawings.

Light is always moving in Shawcross's work, but not only at high speed. In a series entitled *Slow Arc Inside a Cube*, begun in 2007, a small bright halogen bulb on the end of an articulated arm travels diagonally,

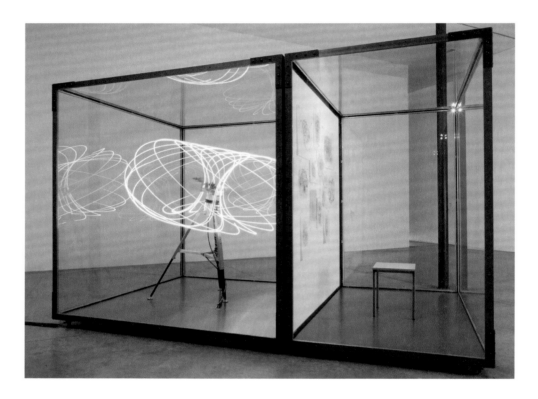

CONRAD SHAWCROSS, *THE BLIND AESTHETIC*, 2011

from one corner inside a mesh cube to its opposite, following the trajectory of a shallow ellipse. The moving light casts gridded shadows onto the walls of the space, which swell and recede as the arm swings slowly back and forth with a sinusoidal speed profile – decelerating to each corner, stopping for an instant and then travelling back toward the centre as though pulled by an invisible gravitational force. The work was inspired by the pioneering scientist Dorothy Hodgkin's description of the X-ray crystallography technique, in which she likened her process of deciphering the complex protein chain of pig insulin to that of trying to work out the structure of a tree by looking only at its shadow. Recalling the allegory of Plato's Cave, in which knowledge is derived from shadows cast by the light of a fire rather than the objects themselves, in *Slow Arc Inside a Cube* the moving light renders the spectator's perception of the surrounding architecture unstable, transforming the certainties of the built world into a space that is in constant flux. EM

JAMES TURRELL

In 1966, while he was a graduate student at the University of California, James Turrell created his first work using pure light. This was a 'cross-corner projection' entitled *Afrum*, in which light projected into the corner of a room seemed to become three-dimensional, forming an illuminated cube which hovered midway between the floor and the ceiling. Soon after this, Turrell left graduate school and rented the Mendota Hotel

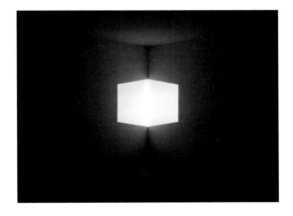

JAMES TURRELL, *AFRUM (WHITE)*, 1966

in Ocean Park, which he turned into a studio for exploring light and the phenomenology of perception. He emptied the rooms, sealed off the windows, closed the doors and painted the walls, ceilings and floors white. Then he began to allow exterior light to enter the space, particularly at night, through various apertures and baffles. Describing this, he says: 'all forms of light were available – the path of the moon, cars, street lights, and shop lights.'[1] By orchestrating the way in which this light was admitted, he was not only able to show what he calls 'the thingness of light', but also to create entirely new perceptual spaces. These experiments, which became known as the *Mendota Stoppages*, marked the beginning of Turrell's lifelong investigation into light and what he refers to as 'the medium of perception'. They included prototypes for his spatially perplexing *Wedgeworks*, in which Turrell induced light to fall across rooms so as to divide the space diagonally, creating apparently tangible shapes.

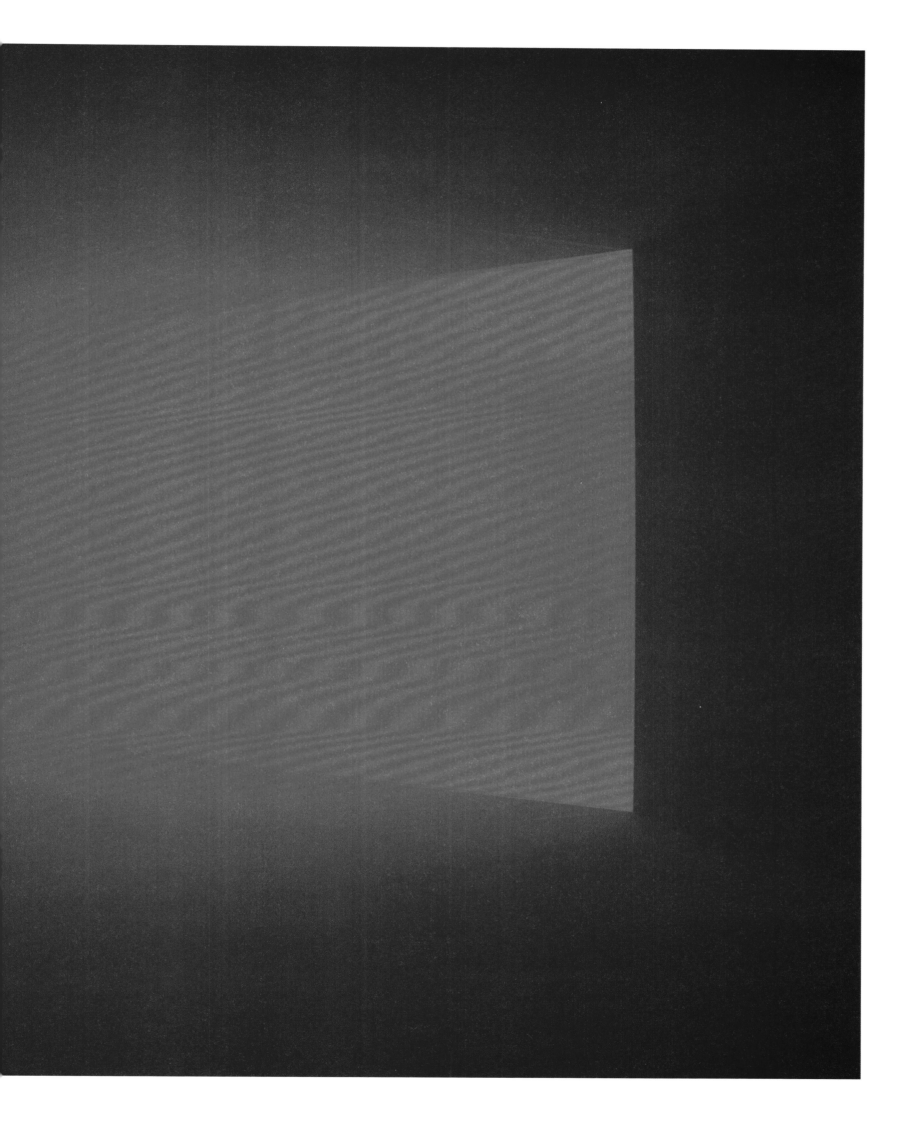

During his time at the Mendota Hotel, Turrell took part in the Art and Technology programme initiated by the Los Angeles County Museum of Art (LACMA). Turrell, who had studied perceptual psychology as an undergraduate, collaborated with Dr Ed Wortz, an experimental psychologist working on developing life-support systems

JAMES TURRELL, *BINDU SHARDS*, 2010

for manned lunar flights. His research had examined the problems of walking on the moon, and how this was affected by the astronaut's perception of space and perspective. Together they studied sensory deprivation, using an anechoic chamber in which sound and light were manipulated. As part of these experiments they produced 'ganzfelds', monochromatic 360° visual fields in which there are no objects, and therefore no perspectives, which the eye can grasp. The effect produced by a ganzfeld is that of an infinite expanse of light which appears to have substance, thickened like mist or fog. Ganzfelds of different types have become an ongoing strand in Turrell's work. He has made them in the form of large-scale walk-in environments, the largest being at the Kunstmuseum in Wolfsburg, where he has created an 11m-high 'space within a space'.

Turrell's continuing investigations into light and perception are concentrated on his Roden Crater project. This immense environmental artwork transforms an extinct volcano into a series of 'light observatories' and 'skyspaces'. Situated at a remote desert location near the Grand Canyon, it has so far taken nearly forty years to plan and construct and is not yet complete. Turrell talks about Roden Crater as 'an eye, something that is itself perceiving.'[2] About his work as a whole he says: 'I want you to sense yourself sensing. To see yourself seeing. To be aware of how you are forming the reality you see.'[3] HL

1. Elaine A. King, 'Into The Light: A Conversation with James Turrell', *Sculpture*, Vol.21, No.9, November 2002.

2. James Turrell, *Occluded Front*, The Museum of Contemporary Art, Los Angeles, 1985 [in *James Turrell*, South Bank Centre, 1993, p.62]

3. Paul Trachtman, 'James Turrell's Light Fantastic', *Smithsonian magazine*, May 2003.

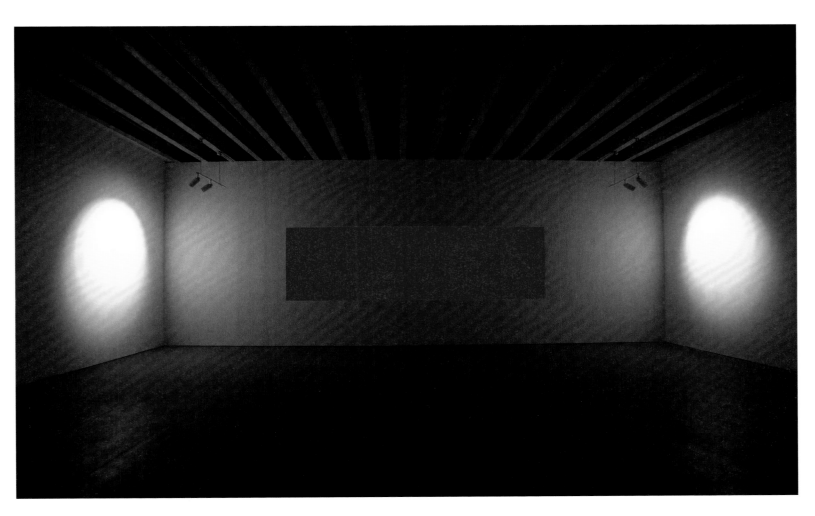

JAMES TURRELL, *GREY DAY*, 1997

JAMES TURRELL, *FLOATER 99*, 2001

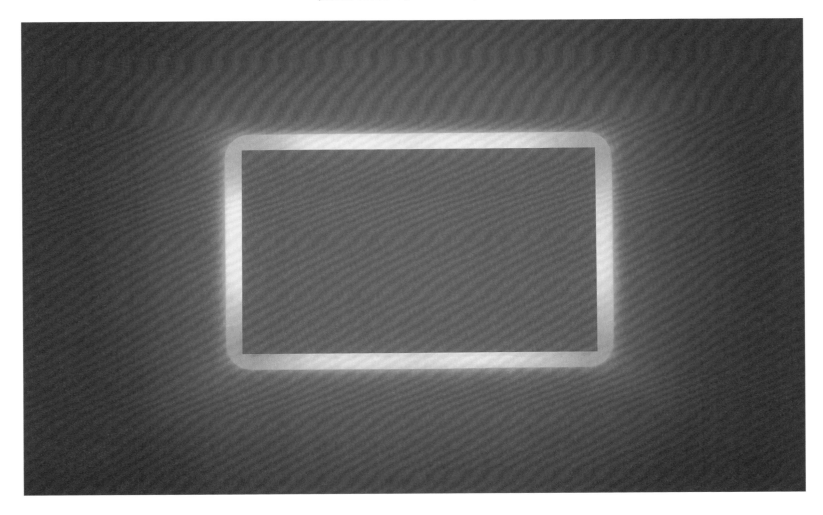

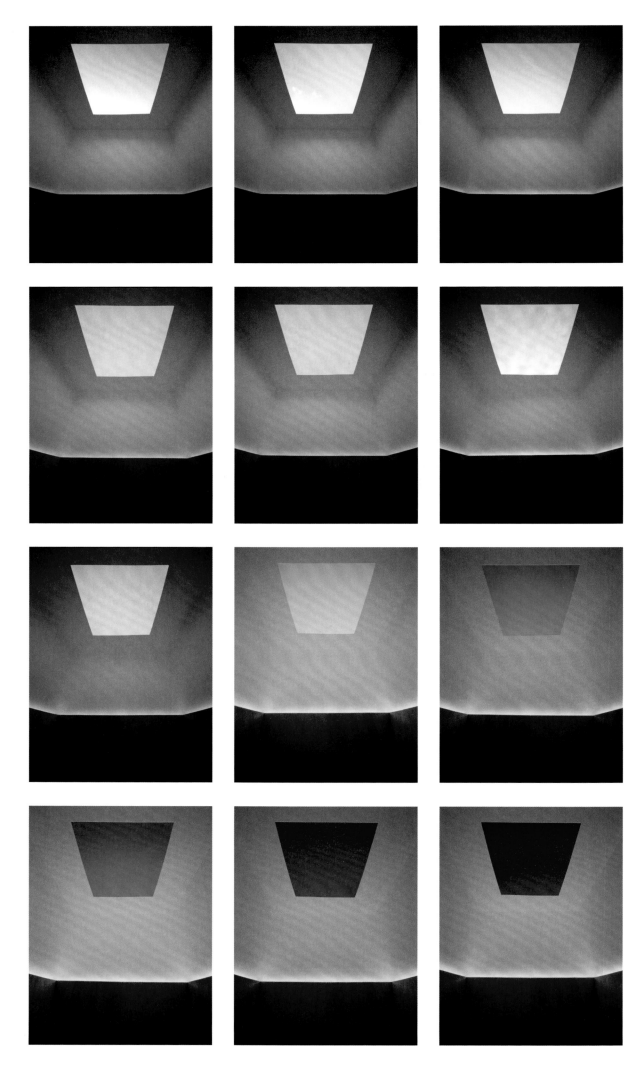

JAMES TURRELL, *AIR MASS*, 1993

LEO VILLAREAL

Based in New York, Leo Villareal works with highly developed software programmes to create perceptual effects using light. His practice is often site-specific, involving specially-designed fixtures installed in building interiors or onto architectural facades. Theatrical in its effects, it fuses elements of Pop Art, Minimalism and the Light and Space movement, utilising cutting-edge digital technology learned at New York University and developed at Interval Research Corporation in Palo Alto, California, in the early 1990s. Villareal created his first light sculpture in 1997,

LEO VILLAREAL, *DIAMOND SEA*, 2007

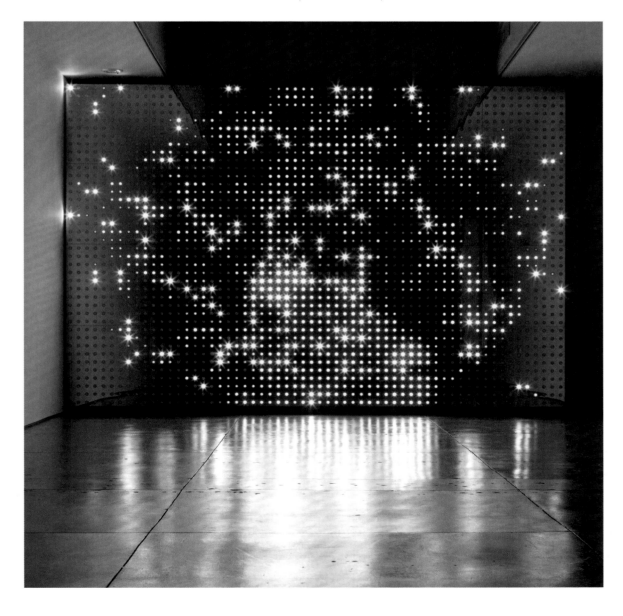

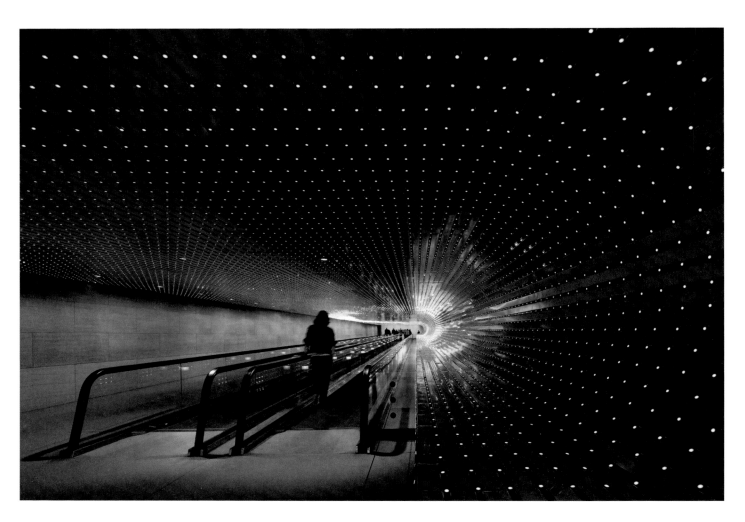

LEO VILLAREAL, *MULTIVERSE*, 2008

LEO VILLAREAL, *COSMOS*, 2012

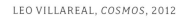

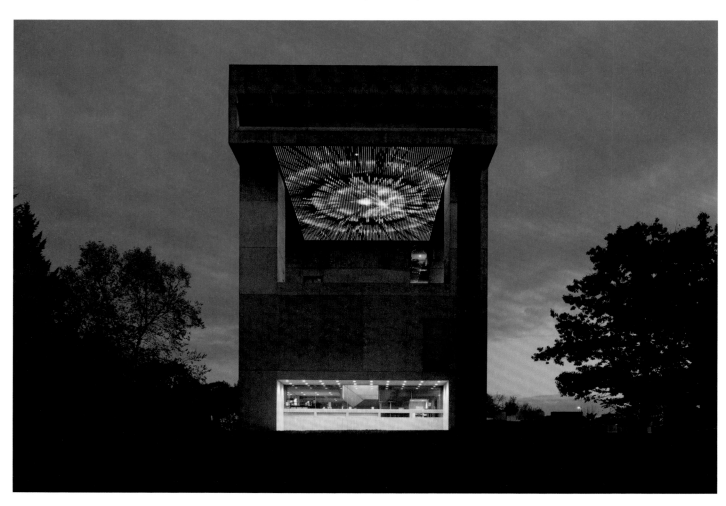

inspired by his experiences at the Nevada counter-culture festival Burning Man. Conceived as a night-time way-finding device for the festival, it featured 16 strobe lights mounted in grid formation that were programmed to go on and off in a pulsing rhythm. The night-time culture of the event, which is based on communal creativity and psychedelic perceptual experience in the vast space of the northern Nevada desert, has contributed significantly to Villareal's art.

Although light is the visible manifestation of Villareal's work, his principal material is computer code. Using simple mathematical formulas he creates sequenced patterns of light that often require an investment of time from the viewer. Works such as *Firmament* (2001) – a series of concentric rings of flickering strobe lights mounted on a darkened ceiling – immerse the viewer in a sensory experience akin to star-gazing in the desert at night, inducing a state of meditative wonderment. Other works have more dazzling effects. *Diamond Sea* (2007, p. 163) presents a grid of glittering white LEDs in an ocean of wall-mounted, mirror-finished stainless steel, providing an abstracted phenomenological version of the vast advertising billboards that flicker endlessly in North American urban landscapes. Villareal began working with LEDs in 2000, challenging their association with the media and consumer culture (emphasized in the work of Jenny Holzer) with a celebration of their potential for pure perceptual pleasure. His installation *Multiverse* (2008, opposite), in the corridor joining the East and West buildings of Washington DC's National Gallery of Art, comprises an assembly of 41,000 LEDs inserted into the aluminium slats that line the ceiling and wall. As visitors travel through the tunnel they are subject to hallucinatory effects created by the streaming pulses of sparkling light that are programmed to run through the LEDs. In another museum intervention, Villareal was commissioned to create an inaugural work for the exterior of the new Tampa Museum of Art in Florida. *Sky (Tampa)* (2010) features hundreds of coloured LEDs that cause the building's west elevation to glow at night in an ever-changing array of intense hues that are reflected in the waterfront below.

The complex software programmes that Villareal writes in collaboration with Information Technology Programming engineers create rules that cause sequential patterns to unfold. He is able to select the more visually compelling sequences and repeat them, while still retaining an element of randomness. For his more painterly works, Villareal covers networks of LEDs with semi-transparent sheets of glass, resulting in areas of diffuse colour that recall the abstractions of colour field painting. In *Field* (2007) and *Threshold (1801K)* (2008, pp. 204–5), thousands of colours in a constantly shifting landscape transmitted through a sheet of glass envelop the viewer in an expansive visual field, creating a rich sensory experience that borders on the sublime. EM

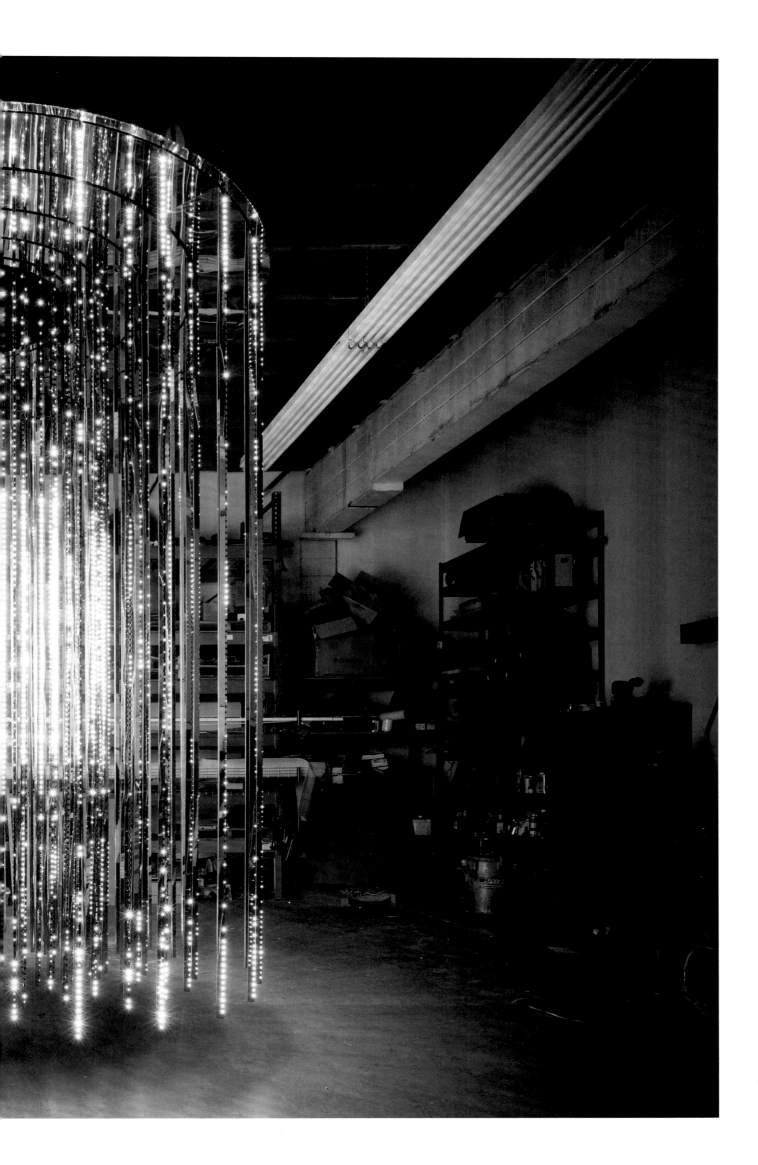

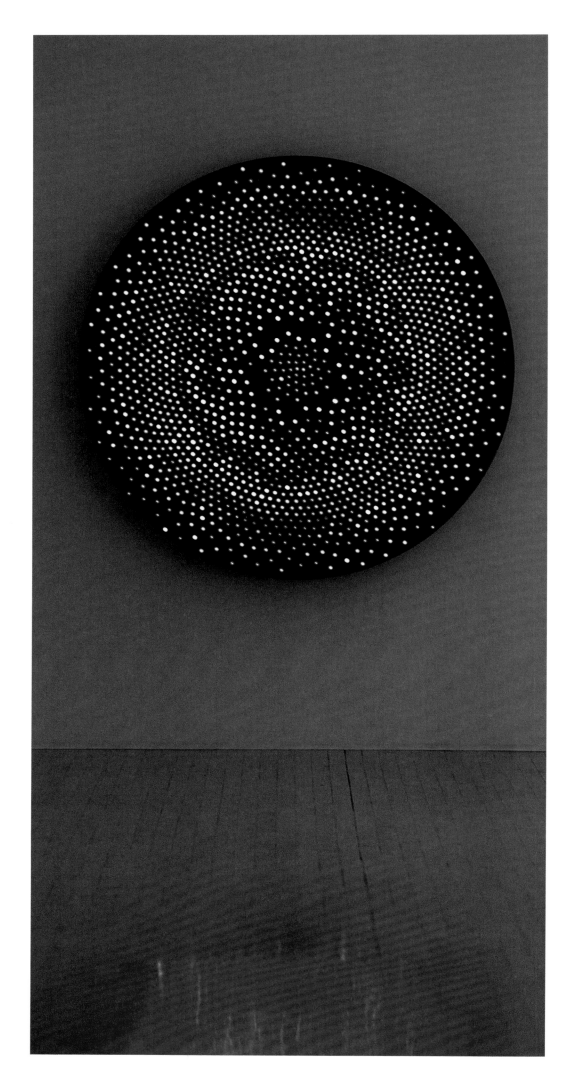

LEO VILLAREAL, *BIG BANG*, 2008

DOUG WHEELER

One of the pioneers of California Light and Space art in the 1960s and 70s, Doug Wheeler creates environmental installations that focus the viewer's perception on a physical experience of space, light and sound. His practice stems from his experiences growing up in Globe, Arizona, where the vast high desert and its dazzling, shimmering light struck him with a visceral intensity. The ways in which features of the landscape such as clouds, volcanoes and mountains activated the empty space and carried sound over long distances affected him deeply. Wheeler's

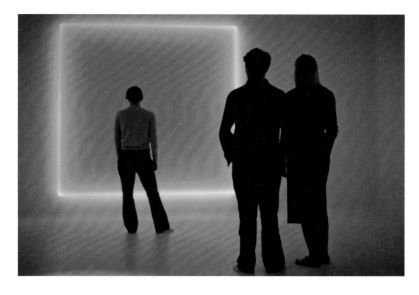

DOUG WHEELER, *RM 669*, 1969

environments aim to recreate these phenomenological effects and enable an experience of light, space and sound that is far more direct than is normally possible.

Wheeler began his artistic career as a painter in the early 1960s, while studying at the Chouinard Art Institute in Los Angeles. Here he began to distil his imagery into minimal emblematic forms that activated the monochromatic fields of his large canvases. He then started creating white paintings that were sprayed with subtle variations of colour and activated by small, highly polished 'chips' of paint that abutted the edges and the corners of the works. In 1964 he was also experimenting with neon light, embedding it along the inside frame of the canvas. Installed with a white floor, these paintings appeared to float on the wall.

By 1965, Wheeler had abandoned canvas to work directly with plastic and light. Early versions of what he calls his 'fabricated paintings' comprise crisp-edged Plexiglas boxes with daylight neon tubing installed around the inside margins. Wheeler sprayed the back of the Plexiglas with a layer of white paint, and painted a narrow border around the front edges with a layer of black followed by several layers of white.

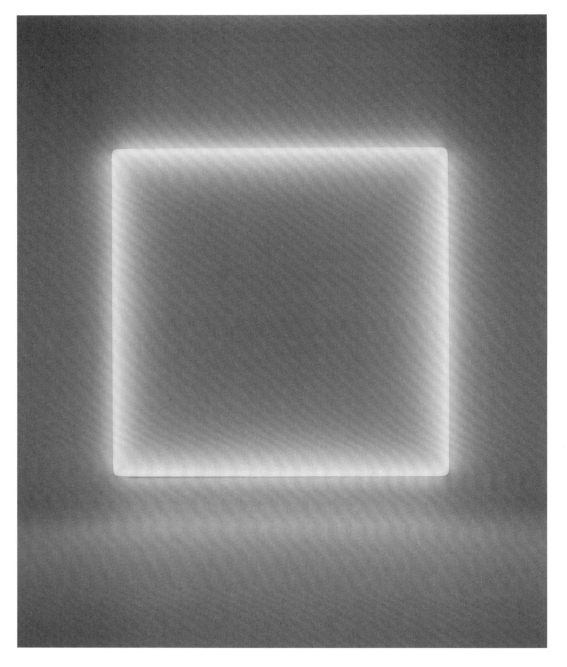

DOUG WHEELER, *UNTITLED*, 1969

This permitted him to control the diffusion of light from the tubes underneath so that it emphasised the edges, at once enhancing and undermining the linear clarity of the traditional picture frame. Hung on the wall like paintings, these large works – such as *Untitled* (1966, opposite) and *Untitled* (1967) exhibited in Wheeler's first solo exhibition at Pasadena Art Museum in 1968 – emanate blue and white light from their translucent sides, casting a soft-edged glow onto the adjoining wall surface that gradually decreases in intensity as it extends away from the painting into the surrounding environment.

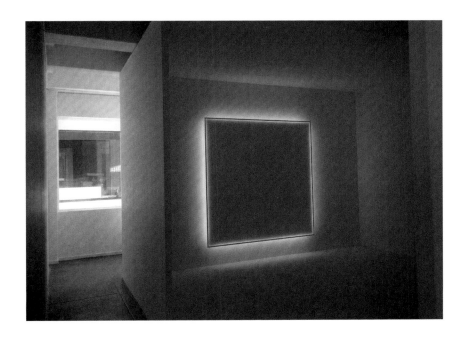

DOUG WHEELER, *UNTITLED*, 1966

The next step was to occupy and transform the space itself.
In 1967 Wheeler began making 'light encasements' – a series of twenty large vacuum-formed acrylic panels with curved edges, sprayed on an inside reflecting panel with subtle variations of white lacquer and encasing neon tubes filled with various types of gas. The space itself now became part of the work, its coved plaster walls, ceiling and floor painted uniform white in order to minimise visible elements of the architecture, causing the encasement itself to dematerialise and the glowing illumination from the central square to 'paint' the surfaces around it with light. The viewer steps into a space in which he or she is enveloped in luminosity; the glowing square on the wall seems to float in space, the void of blue in its centre taking on increasing presence with the viewer's physical proximity.

Wheeler had been experimenting with various kinds of light and phosphorescent paint applied to the existing architecture in his studios

DOUG WHEELER, *49 NORD 6 EST 68 VEN 12 FL*, 2011–2

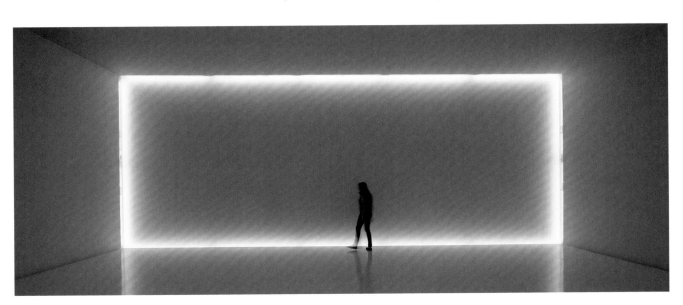

OVERLEAF: DOUG WHEELER, *SA MI 75 DZ NY 12*, 1975/2012

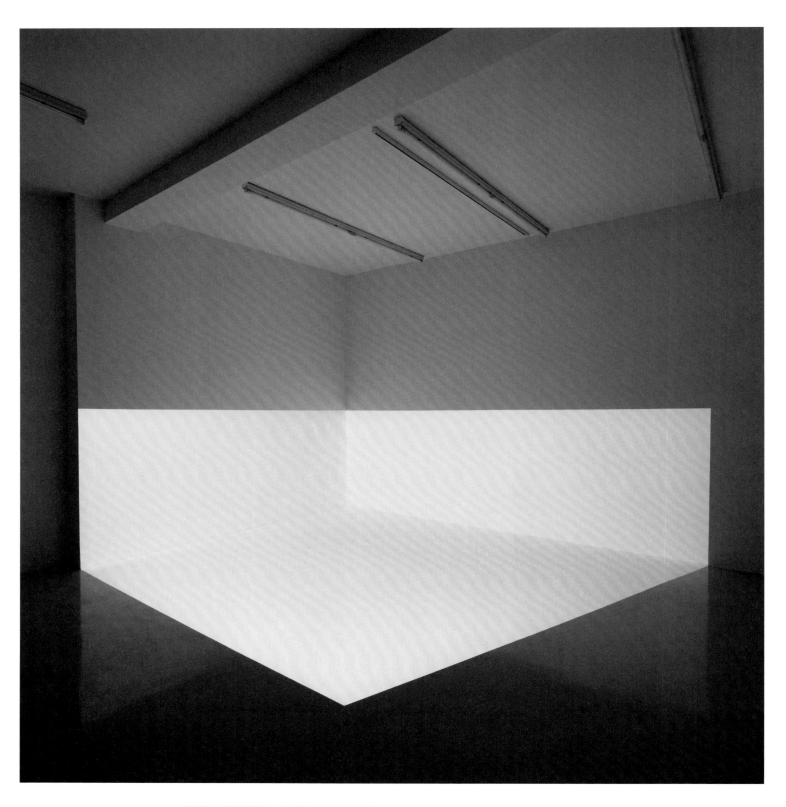

DOUG WHEELER, *49 NORD 6 EST POV LUMINIFEROUS LIGHT VOLUME*, 2011–12

from 1965. For one of his earliest installations, exhibited at the Stedelijk
Museum, Amsterdam, in 1969, Wheeler embedded a neon frame in a
viewing aperture around an existing wall in the museum and stretched
a translucent nylon scrim to create a luminous ceiling that floated above
the room, creating a shimmering atmosphere that seemed to emanate
from the glowing wall of light. In 1975, he exhibited the first of the
complex large-scale works that the artist terms 'continuum atmospheric
environments,' in which the viewer walks through a wall of imperceptibly
changing light into what appears to be an infinite void – a space so
luminous that viewers are unable to fix their eyes on any surface,
evoking a sensation of almost tangible light.

CERITH WYN EVANS

Cerith Wyn Evans's interest in light as a medium for art dates back to the early 1980s, when he first recreated Brion Gysin's iconic *Dreamachine*. Gysin's invention, originally produced in 1962, was a flicker machine constructed from a cylindrical, slotted lightshade mounted on a turntable. Viewed with the eyes closed, the stroboscopic effect of the spinning light was said to induce a state of lucid dreaming and to create 'autonomous movies'. When Wyn Evans remade the *Dreamachine*,

(LEFT) CERITH WYN EVANS, *"DIARY: HOW TO IMPROVE THE WORLD (YOU WILL ONLY MAKE MATTERS WORSE)" CONTINUED 1968, FROM 'M' WRITINGS '67–'72 BY JOHN CAGE,* 2003; (MIDDLE) 'THINGS THAT SPEAK – THE GLASS FLOWERS' BY LORRAINE DASTON, 2007; CHANDELIER (LUCE ITALIA), FLAT SCREEN MONITOR, MORSE CODE UNIT AND COMPUTER; DIMENSIONS VARIABLE, CHANDELIER: 140 X 100 CM. (RIGHT) *'THINGS THAT SPEAK – THE GLASS FLOWERS' BY LORRAINE DASTON*, 2007;

he was a filmmaker, initially assisting Derek Jarman and then making his own short experimental films, which he described as 'sculptures'. In the 1990s he moved away from film and began to focus on sculptures and installations involving other forms of movement and light, including short texts spelled out in neon or with fireworks. He regarded these often cryptic utterances, culled from film, philosophy or literature, as subtitles to a larger, unseen narrative.

In 2000, Wyn Evans began a series of works entitled *Cleave*. The first, *Cleave 00*, was shown at Tate Britain alongside a William Blake exhibition. Its main component consisted of texts by Blake, randomly selected by a computer that translated them into Morse code and transmitted them as light-pulses onto a mirror ball. *Cleave 01*, which

OVERLEAF: CERITH WYN EVANS, *S=U=P=E=R=S=T=R=U=C=T=U=R=E ('TRACE ME BACK TO SOME LOUD, SHALLOW, CHILL, UNDERLYING MOTIVE'S OVERSPILL…')*, 2010

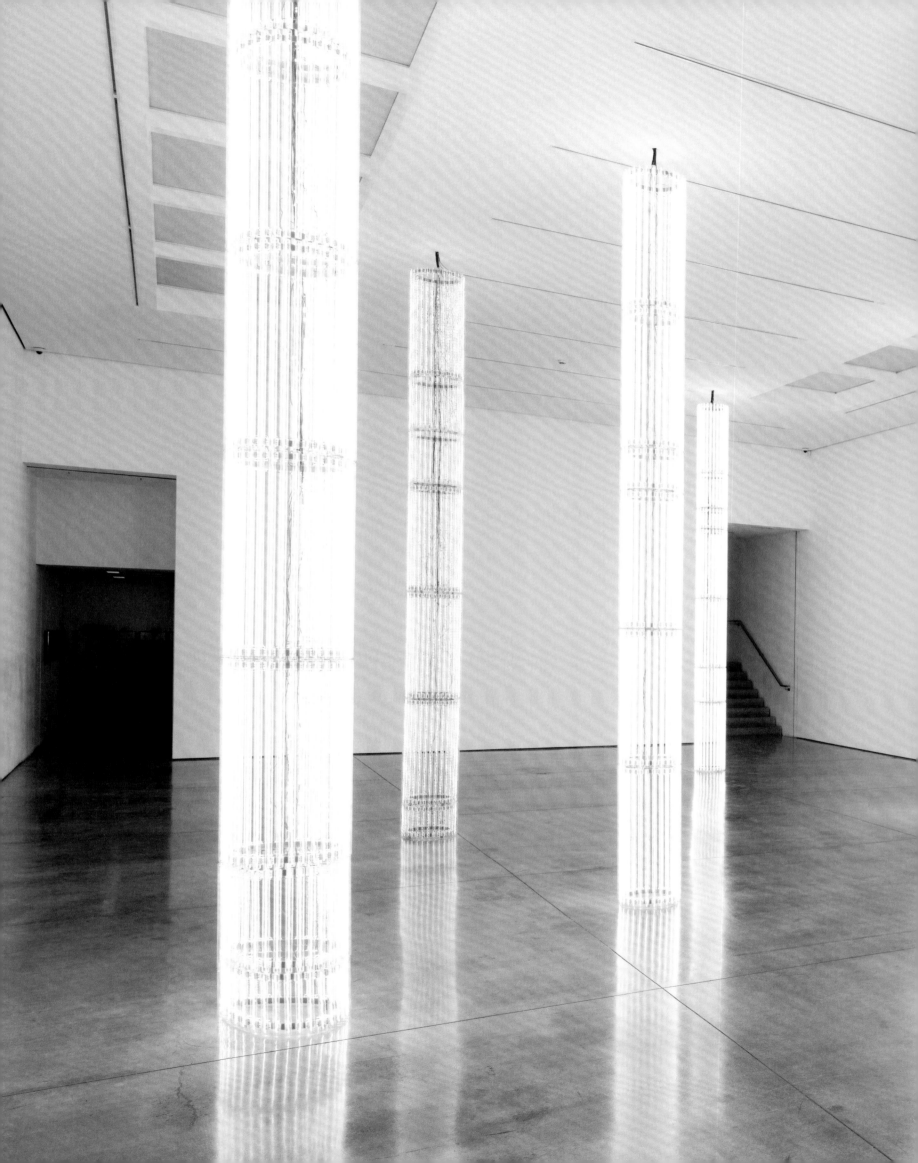

CERITH WYN EVANS, *'TALVINDER, YOU'LL NEVER GUESS, IT'S THE PACIFIC OCEAN, AGAIN.'*, 2007

CERITH WYN EVANS, *EACH BODY DISTRIBUTES…* , 2007

followed in 2001, featured a similar treatment of texts by the filmmaker Pier Paolo Pasolini. In both works, the pulsating light recalls the intense and dazzling effects of *Dreamachine*. But *Cleave 03 (Transmission: Visions of the Sleeping Poet)* (2003, overleaf) was different. Although it, too, featured Morse code, in this case the telegraphic text was beamed up several miles high into the sky by means of a World War II searchlight.

While creating the *Cleave* works, Wyn Evans was also incorporating Morse code in sculptures which took the form of chandeliers, where the texts were transmitted through pulsing incandescent light bulbs. Requisitioning a diverse assortment of chandeliers, all of which had

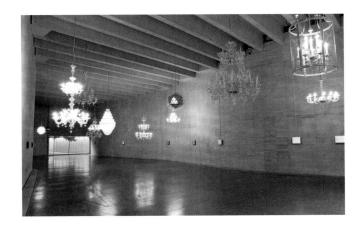

CERITH WYN EVANS, INSTALLATION VIEW, *VISIBLEINVISIBLE*, MUSEO DE ARTE CONTEMPORÁNEO DE CASTILLA Y LEÓN (MUSAC), 2008

different personalities, he programmed them to transmit texts as various as John Cage's *Diary: How to Improve the World (You will only make Matters worse)* and Siegfried Marx's *Astrophotography*, which reveals – amongst other things – the surprising fact that astral bodies identified on photographs as solar systems and galaxies were in fact nothing more than microscopic particles of dust and drifts of dandruff.

The inspiration for these works involving largely indecipherable Morse code came from Wyn Evans's first visit to Japan. Looking out at the lights of Tokyo one night, he had the sense that this spectacle was really 'a synaptic matrix of different dots and bleeps and dashes, none of which I could understand.'[1] In more recent works involving columns of 'architecture lamps' – incandescent bulbs in tubular form – such as *S=U=P=E=R=S=T=R=U=C=T=U=R=E* ('*Trace me back to some loud, shallow, chill, underlying motive's overspill...*') (2010, previous spread), there is no Morse, or any other form of encrypted language. Instead, in *S=U=P=E=R=S=T=R=U=C=T=U=R=E*, the slow sequential lighting up and dimming down of the lamps, and their intermittent brightness and heat, reflects the otherworldliness of the text it is based on, James Merrill's epic poem *The Changing Light at Sandover*, which documents messages dictated by ghostly voices during Ouija séances. HL

1 Cerith Wyn Evans, Testimony given to the International Necronautical Society Second First Committee Hearings: Transmission, Death, Technology, Cubitt Gallery, Saturday 16 November 2002 (text available at http://www.necronauts.org/cubitt_cerith.html)

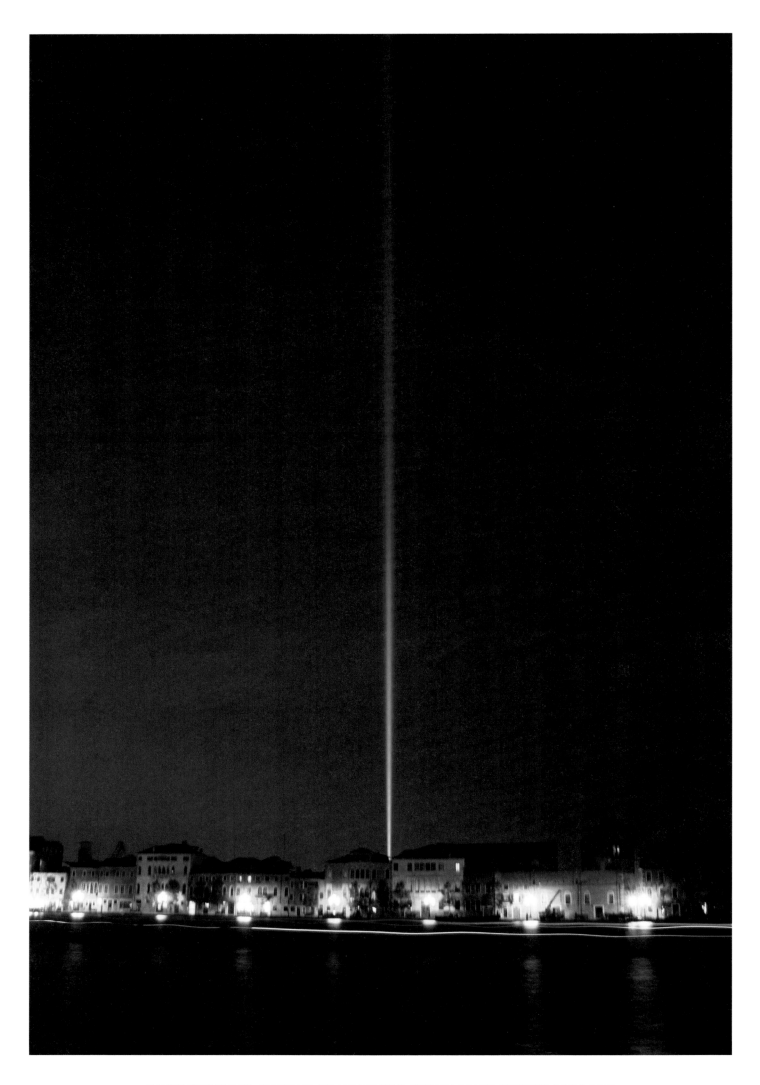

CERITH WYN EVANS, *CLEAVE 03 (TRANSMISSION: VISIONS OF THE SLEEPING POET)*, 2003

LIST OF EXHIBITED WORKS

Measurements are given in centimetres,
height x width x depth.

52

David Batchelor

Magic Hour, 2004/7

Found steel and aluminium lightboxes,
found steel supports, acrylic sheet, fluorescent
light, cable, plugs and plugboards

308 x 206 x 13

Courtesy the artist and Galeria Leme, São Paulo

59, 60–1

Jim Campbell

Exploded View (Commuters), 2011

Custom electronics, 1,152 LEDs, wire and steel

116.8 x 182.9 x 96.5

Courtesy Bryce Wolkowitz Gallery, New York,
and studio of Jim Campbell

66–7, 69

Carlos Cruz-Diez

Chromosaturation, 1965–2013

Three chromocubicles
(fluorescent light with blue, red and green filters)

Dimensions variable

Cruz-Diez Foundation

71

Bill Culbert

Bulb Box Reflection II, 1975

Wooden box, mirror glass,
lightbulbs and electrical cable

33 x 32 x 31

Laurent Delaye Gallery

77

Olafur Eliasson

Model for a timeless garden, 2011

Water, pumps, nozzles, stainless steel,
wood, foam, plastic, strobe lights, wall
mounts and control unit

120 x 960 x 162

PinchukArtCentre Collection

84

Fischli and Weiss

Son et Lumière (Le rayon vert), 1990

Flashlight, turntable, plastic cup and adhesive tape

16 x 25 x 40

Courtesy Sprüth Magers Berlin London

87

Dan Flavin

the nominal three (to William of Ockham), 1963

Daylight fluorescent light

Height: 244

Stephen Flavin, courtesy of David Zwirner, New York

89

Dan Flavin

*untitled (to the "innovator" of
Wheeling Peachblow)*, 1966–8

Daylight, yellow and pink fluorescent light

244 x 244, across a corner

Stephen Flavin, courtesy of David Zwirner, New York

93

Ceal Floyer

Throw, 1997

Theatre light and metal gobo (no. 8136)

Dimensions variable

Courtesy the artist and Lisson Gallery, London

99

Nancy Holt

Holes of Light, 1973

Two 650W quartz lamps,
polyurethane board and pencil

442 x 609.6 x 823

The artist, courtesy Haunch of Venison

106

Jenny Holzer

MONUMENT, 2008

Nine double-sided, semicircular electronic LED signs: red and white diodes on front and back. Nine double-sided, semicircular electronic LED signs: red and blue diodes on front, blue and white diodes on back. Text: U.S. government documents

Hayward Gallery installation: 400.9 x 146.7 x 73.3; each element: 13.4 x 146.7 x 14.8

Courtesy Sprüth Magers Berlin London

109

Ann Veronica Janssens

Rose, 2007

Installation with spotlights and artificial haze

Dimensions variable

Private Collection

117

Brigitte Kowanz

Light Steps, 1990/2013

Fluorescent lamps

Dimensions variable

The artist, courtesy Häusler Contemporary, München/Zürich; Galerie Krobath, Wien/Berlin; Galerie Nikolaus Ruzicska, Salzburg; Bryce Wolkowitz Gallery, New York. Supported by Zumtobel Lighting

122, 123

Anthony McCall

You and I, Horizontal, 2005

Solid-light installation: computer, QuickTime movie file, video projector and haze machines

Dimensions variable; running time: 50 minutes

Courtesy the artist and Sprüth Magers Berlin London

130

François Morellet

Lamentable, 2006

Eight blue neon tubes, electric cables and two transformers

Dimensions variable

Courtesy the artist and Annely Juda Fine Art

133

Iván Navarro

Reality Show (Silver), 2010

LED, aluminium door frames, mirrors, one-way mirrors, wood and electric energy

234 x 114.5 x 114.5

Courtesy the artist and Galerie Daniel Templon, Paris

134

Iván Navarro

Burden (Lotte World Tower), 2011

Neon, wood, paint, Plexiglas, mirror, one-way mirror and electric energy

172.1 x 106.7 x 16.5

Courtesy Paul Kasmin Gallery

—

Iván Navarro

The Hayward Fence, 2013

Neon, aluminium and electric energy

228 x 1144

Courtesy the artist and Paul Kasmin Gallery

142

Philippe Parreno

Marquee, 2011

Transparent acrylic glass, neon tubes, lightbulbs, converters, controller and cables

20 x 165 x 90

Catherine and Jean Madar Collection, courtesy Esther Schipper, Berlin

145, 146

Katie Paterson

Light bulb to Simulate Moonlight, 2008

Set of 289 lightbulbs with halogen filament, frosted coloured shell, 28W, 4500W

Dimensions variable

Scottish National Gallery of Modern Art, Edinburgh. Purchased 2011.

152-3

Conrad Shawcross

Slow Arc inside a Cube IV, 2009

Mechanised system, steel, light
aluminium and motors

180 x 90 x 90

Courtesy the artist and Victoria Miro Gallery, London

158-9

James Turrell

Wedgework V, 1974

Fluorescent light, fibre optic

Dimensions variable

Abstract Select Ltd

166-7

Leo Villareal

Cylinder II, 2012

White LEDs, mirror-finished stainless steel,
steel, custom software and electrical hardware

373.4 x 294.6 x 294.6

Courtesy the artist and GERING & LóPEZ GALLERY, NY

#

Doug Wheeler

Untitled, 1969

Sprayed lacquer on vacuum-formed
Plexiglas and white UV neon light

232.5 x 232.5 x 5.7

Stiftung Museum Kunstpalast, Düsseldorf

#

Cerith Wyn Evans

S=U=P=E=R=S=T=R=U=C=T=U=R=E
('Trace me back to some loud, shallow, chill,
underlying motive's overspill...'), 2010

Mixed media

Dimensions variable

Courtesy the artist and White Cube

LIGHT READING

David Rosenberg, (ed.), *Le Néon Dans L'Art Des Années 1940 à Nos Jours*, exh. cat., La maison rouge, Archibooks, Paris, 2012. Texts by David Rosenberg, Luis de Miranda and Antoine de Galbert.

Robin Clark (ed.), *Phenomenal: California Light, Space, Surface*, exh. cat., University of California Press, Berkeley, 2011. Texts by Michael Auping, Robin Clark, Stephanie Hanor, Adrian Kohn and Dawna Schuld.

Elizabeth Hamilton and Alma Ruiz (eds), *Suprasensorial: Experiments in Light, Color, and Space*, exh. cat., The Museum of Contemporary Art (MOCA), Los Angeles, 2010. Text by Alma Ruiz.

Mattias Wagner K and Bettina Reichmuth (eds), *Biennale fur Internationale Lichtkunst: Open light in private spaces*, exh. cat., Revolver Publishing, Berlin, 2010. Texts by Matthias Wagner K and Sabine Schirdewahn.

Max Hollein and Martina Weinhart (eds), *OP ART*, exh. cat., Schirn Kunsthalle Frankfurt, Buchhandlung Walther König, Cologne, 2007. Texts by Frances Follin, Max Hollein, Claus Pias and Martina Weinhart.

Bice Curiger (ed.), *The Expanded Eye: Stalking the Unseen*, exh. cat., Kunsthaus Zürich, Hatje Cantz, Ostfildern, 2006. Texts by Ina Blom, Bice Curiger, Kurt W. Forster, Diedrich Diederichsen, Al Rees and Rüdiger Wehner.

Eleonore Espargiliere, Alice Motard, Pascal Rousseau and Eva Witzel (eds), *ON/OFF*, exh. cat., Casino Luxembourg – Forum d'art contemporain, Fonds régional d'art contemporain de Lorraine, Metz, Saarlandmuseum, Saaarbrücken, 2006. Texts by Guillaume Désanges, Béatrice Josse, Enrico Lunghi, Ralph Melcher and Pascal Rousseau.

Gregor Jansen and Peter Weibel (eds), *Light art from artificial light: Light as a Medium in 20th and 21st Century Art*, Hatje Cantz, Ostfildern, 2006. Texts by Andreas F. Beitin, Thomas Beth and Jörn Müller-Quade, Dietmar Elger, Gregor Jansen, Friedrich A. Kittler, Günther Leising, Light Technology Institute, Vanessa Joan Müller, Frank Popper, Wolfgang Schivelbusch, Sara Selwood, Pete Sloterdijk, Stephan von Wiese, Peter Weibel, Yvonne Ziegler and Daniela Zyman.

John B. Ravenal, *Artificial Light: New Light-based Sculpture and Installation Art*, VCUarts Anderson Gallery, Richmond, 2006. Texts by Paula R. Feldman and Kathleen Forde.

Amnon Barzel and Consuelo de Gara (eds), *Light Art*, exh. cat., Targetti Light Art Collection, Skira Editore, Milan, 2005. Texts by Amnon Barzel, Consuelo De Gara, Paolo Targetti and Stella Targetti.

Karl Ganser, Uwe Rüth, Axel Sedlack and Michael Schwarz (eds.), *Zentrum für International Lichtkunst Unna – Die Sammlung/Centre for International Light Art Unna – The Collection*, Buchhandlung Walther König, Cologne, 2004. Texts by Werner Kolter, Uwe Rüth and Christa Thoben.

Chrissie Iles (ed.), *Into the Light: The Projected Image in American Art 1964–1977*, exh. cat., Whitney Museum of American Art, Abrams Inc., New York, 2001. Texts by Chrissie Iles and Thomas Zummer.

Light Pieces, 05.02–26.03.2000, exh. cat., Casino Luxembourg – Forum d'art contemporain, Luxembourg, 2000. Texts by Joëlle Moyne, Margarida Santos and Pierre van Tieghem.

Jan Butterfield, *The Art of Light + Space*, 'modern art movements' series, Abbeville Press, New York, 1993.

Johan Jansen and Aline Skrochowski (eds.), *Art in Light*, exh. cat., Museum fur Verkehr und Technik, Berlin, 1985. Texts by Johan Jansen and Otto Lührs.

Frank Popper (ed.), *KunstLichtKunst*, exh. cat., Stedelijk van Abbemuseum, Eindhoven, 1966. Text by Frank Popper.

Robert M. Doty, *Light: Object and Image*, exh. cat., Whitney Museum of American Art, New York, NY, 1968.

DAVID BATCHELOR

b. 1955, Dundee, Scotland.
Lives and works in London, England.

Selected Solo Exhibitions

Magic Hour, Gemeentemuseum Den Haag, 2012.

Big Rock Candy Fountain, Archway Station, London, 2010.

Chromophilia, Paço Imperial, Rio de Janeiro, 2010.

Unplugged (Remix), Talbot Rice Gallery, The University of Edinburgh; touring to Wilkinson Gallery, London, 2007.

Ten Silhouettes, Gloucester Road Station, London, 2005.

Shiny Dirty, Ikon Gallery, Birmingham, 2004.

Electric Colour Tower, Sadler's Wells Theatre, London, 2000.

Polymonochromes, Henry Moore Institute, Leeds, 1997.

Serial Colour, Curtain Road Arts, London, 1995.

Selected Group Exhibitions

Lumiere, various venues, Durham, 2011.

The Shape of Things to Come, Saatchi Gallery, London, 2011.

Kaleidoscopic Revolver, Han Ji Yun Contemporary Space, Beijing, 2009.

Folkestone Triennial, 2008.

Color Chart: Reinventing Color, 1950 to Today, The Museum of Modern Art (MoMA), New York, NY, 2008; touring to Tate Liverpool, 2009.

Extreme Abstraction, Albright-Knox Art Gallery, Buffalo, NY, 2005.

Contrabandistas de Imágenes, Museo de Arte Contemporaneo, Faculdad de Artes, Universidad de Chile, Santiago, 2005.

26th Bienal de São Paulo, 2004.

Days Like These: Tate Triennial of Contemporary Art, Tate Britain, London, 2003.

British Art Show 5, Scottish National Gallery of Modern Art (SNGMA), Edinburgh; touring to Southampton City Art Gallery; Centre for Visual Art, Cardiff; Ikon Gallery, Birmingham, 2000.

Fact and Value, Charlottenberg Palace, Copenhagen, 2000.

POSTMARK: An Abstract Effect, SITE Santa Fe, NM, 1999.

Selected Bibliography

David Batchelor: Found Monochromes, Vol. 1, 1–250, Ridinghouse, London, 2010. Interview with Jonathan Rée.

David Batchelor (ed.), *Colour*, 'Documents of Contemporary Art' series, Whitechapel Art Gallery, London, MIT Press, Boston, 2008.

Unplugged, exh. cat., Talbot Rice Gallery, Edinburgh, 2007.

Jonathan Watkins (ed.), *David Batchelor: Shiny Dirty*, exh. cat., Ikon Gallery, Birmingham, Lars Müller Publishers, Zürich, 2004. Texts by David Batchelor, Richard Noble and Clarrie Wallis.

Chromophobia, Reaktion Books, London, 2000.

JIM CAMPBELL

b. 1956, Chicago, IL, USA.
Lives and works in San Francisco, CA, USA.

Selected Solo Exhibitions

Jim Campbell: Exploded View, Museum of the Moving Image, Astoria, NY, 2011.

Jim Campbell: Home Movies, UC Berkeley Art Museum and Pacific Film Archive, CA, 2008.

Wavelengths, Museum of the Moving Image, Astoria, NY, 2004.

Maryland Institute of Contemporary Art, 2004.

Data and Time, Nagoya City Art Museum, 2002.

Contemporary Configurations, Santa Cruz Museum of Art & History at the McPherson Center, CA, 2001.

Transforming Time: Electronic Works 1990–1999, ASU Art Museum, Nelson Fine Arts Center, Tempe, AZ, 1999.

Memory, Reflection and Transformation: Reactive Works by Jim Campbell, Art Center College of Design, Pasadena, CA, 1997; touring to San José Museum of Art, CA, 1998.

Hallucination, Fresno Art Museum, CA, 1991.

Selected Group Exhibitions

Marking Time, Museum of Contemporary Art Australia, Sydney, 2012.

Rewriting Worlds, Fourth Moscow Biennale of Contemporary Art, 2011.

Walking + Falling: Jim Campbell, Chris Marker and Eadweard Muybridge, Vancouver Art Gallery, 2011.

Paradise Lost, Istanbul Museum of Modern Art, 2011.

Blink! Light, Sound and the Moving Image, Denver Art Museum, CO, 2011.

Watch This! New Directions in the Art of the Moving Image, Smithsonian American Art Museum, Washington, DC, 2010.

LIKENESS, Mattress Factory, Pittsburgh, PA, 2009.

Living Room, National Gallery of Canada, Ottawa, 2008.

Closed Circuit: Video and New Media at the Metropolitan, The Metropolitan Museum of Art, New York, NY, 2007.

Busan Biennale, Busan Metropolitan Art Museum, 2002.

Whitney Biennial, Whitney Museum of American Art, New York, NY, 2002.

Serious Games, Barbican Art Gallery, London, 1997.

Press/Enter: Between Seduction and Disbelief, The Power Plant, Toronto, 1995.

Facing the Finish, San Francisco Museum of Modern Art (SFMOMA), CA, 1992.

Selected Bibliography

Steve Deitz (ed.), *Jim Campbell: Material Light*, Hatje Cantz, Ostfildern, 2010. Texts by Richard Grusin, John G. Hanhardt, Robert R. Riley and Richard Shiff.

Sarah King (ed.), *Quantizing Effects: The Liminal Art of Jim Campbell*, exh. cat., Site Santa Fe, NM, 2005.

Jim Campbell: Time and Data, exh. cat., Wood Street Galleries, Pittsburgh, PA, 2001.

Jim Campbell: Transforming Time: Electronic Works 1990–1999, exh. cat., Arizona State University Art Museum, Tempe, AZ, 1999.

BILL CULBERT

b. 1935, Port Chalmers, New Zealand.
Lives and works in London, UK, and Provence, France.

Selected Solo Exhibitions

Bill Culbert: Groundworks, Govett-Brewster Art Gallery, New Plymouth, 2008.

Light Wine Things: Photographs and Installations by Bill Culbert, Millennium Art Gallery, Blenheim, 2003; touring to Dunedin Public Art Gallery, 2004; Te Manawa Art Gallery, Palmerston North, 2005; and Whangarei Art Museum, 2005.

Lightworks: Recent Work by Bill Culbert, City Gallery, Wellington, 1997; touring to Govett-Brewster Art Gallery, New Plymouth, 1998; and Dunedin Public Art Gallery, 1998.

Bill Culbert: entre chien et loup – Afterdark, Les Coopérateurs, Fonds régional d'art contemporain (FRAC) Limousin, Limoges, 1994–5; touring to Musée des Beaux-Arts, Mulhouse, 1995.

Bill Culbert: Sculptures in Light, Cornerhouse, Manchester, 1987.

Bill Culbert: New Work, Institute of Contemporary Art (ICA), London, 1986.

Bill Culbert and Liliane Lijn: Beyond Light, Serpentine Gallery, London, 1976–7; touring to D.L.I. Gallery, Durham, 1977; Bradford Industrial Museum, 1977; Mappin Art Gallery, Sheffield, 1977; and Walker Art Gallery, Liverpool, 1977.

William Culbert: Recent Paintings, Commonwealth Institute Art Gallery, London, 1961.

Selected Group Exhibitions

Op Art, Schirn Kunsthalle Frankfurt, 2007.

High Tide: New Currents in Art from Australia and New Zealand, Zachęta Narodowa Galeria Szutki, Warsaw, 2006; touring to Contemporary Art Centre, Vilnius, 2006.

The Sixties Art Scene in London, Barbican Art Gallery, London, 1993.

Headlands: Thinking Through New Zealand Art, Museum of Contemporary Art, Sydney, 1992; touring to National Art Gallery, Wellington, 1992.

The Readymade Boomerang: Certain Relations in 20th Century Art, 8th Biennale of Sydney, Art Gallery of New South Wales and the Museum of Contemporary Art, Sydney, 1990.

Electra (Electricity and Electronics in the Art of the XXth Century), Museé d'Art Moderne de la Ville de Paris, 1983–4.

The Sculpture Show: Fifty Sculptors at the Serpentine and the South Bank, Hayward Gallery and Serpentine Gallery, London, 1983.

Multiples: The First Decade, Philadelphia Museum of Art, 1971.

New Zealand Painting 1965, Auckland City Art Gallery, 1965.

1st Commonwealth Biennale of Abstract Art, Commonwealth Institute, London, 1963.

Armagh Street Group, Canterbury School of Art, Christchurch, 1955.

Selected Bibliography

Ian Wedde, *Bill Culbert: Making Light Work*, Auckland University Press, 2009.

Bill Culbert: Light Wine Things, exh. cat., Millennium Art Gallery, Blenheim, 2003. Texts by William McAloon and Kyla McFarlane.

Lightworks: Bill Culbert, exh. cat., City Gallery Wellington, 1997. Texts by Yves Abrioux, Christina Barton, Francis Pound and Lara Strongman.

Frederic Paul (ed.), *Bill Culbert: entre chien et loup – Afterdark*, exh. cat., FRAC Limousin, Limoges, 1994. Texts by Yves Abrioux, Olivier Blanckart and Frédéric Paul.

Bill Culbert: Zum, exh. cat., Städtische Galerie im Lenbachhaus, Munich, 1990. Text by Maribel Königer.

Bill Culbert: Selected Works 1968–1986, exh. cat., Institute of Contemporary Arts, London, in association with Orchard Gallery, Londonderry, Cornerhouse, Manchester, and Victoria Miro Gallery, London, 1986. Texts by Stephen Bann and Simon Cutts.

Bill Culbert 1973–1984: Extant Work and Sources, Coracle Press, London, 1984.

CARLOS CRUZ-DIEZ

b. 1923, Caracas, Venezuela.
Lives and works in Paris, France.

Selected Solo Exhibitions

Carlos Cruz-Diez: Circumstance and Ambiguity of Color, Ningbo Museum of Art; touring to Jiangsu Provincial Art Museum, Nanjing, and Henan Museum, Zhengzhou, 2012.

Carlos Cruz-Diez: El color en el espacio y en el tiempo, Museo de Arte Latinoamericano de Buenos Aires (MALBA) – Fundación Constantini, 2011.

Carlos Cruz-Diez: Color in Space and Time, The Museum of Fine Arts, Houston (MFAH), TX, 2011.

Environment Chromaticinterferences: Interactive Space by Carlos Cruz-Diez, Guangdong Museum of Art, 2010.

Venezuelan Pavilion, XXV Bienal de São Paulo, 2002.

Cruz-Diez: El Color Autónomo, Museo de Arte Moderno de Bogotá, 1998.

Fisicromías. Cromocinetismo. Carlos Cruz-Diez: Artista Venezolano, Museo de Arte Moderno, Mexico City, 1976.

Venezuelan Pavilion, 31st Venice Biennale, 1962.

Carlos Cruz-Diez: Obras de 1949 al 55, Museo de Bellas Artes, Caracas, 1955.

12 Gouaches de Carlos Cruz-Diez, Centro Venezolano-Americano, Caracas, 1947.

Selected Group Exhibitions

Suprasensorial: Experiments in Light, Color, and Space, Hirshhorn Museum and Sculpture Garden, Washington, DC, 2012.

Op Art, Schirn Kunsthalle Frankfurt, 2007.

Beyond Geometry: Experiments in Form 1940s to 70s, Los Angeles County Museum of Art (LACMA), CA, 2004.

Heterotopías: Medio Siglo Sin-lugar, 1918–1968, Museo Nacional Centro de Arte Reina Sofía, Madrid, 2000.

Otero, Cruz-Diez, Soto: Tres maestros del abstraccionismo en Venezuela y su proyección internacional, Galería de Arte Nacional, Caracas, 1994.

Light and Movement, Museum of Contemporary Art Australia, Sydney, 1993.

Art in Latin America, Hayward Gallery, London, 1989.

Forty Years of Modern Art 1945–1985, Tate Gallery, London, 1985.

L'Oeil en Action, Le Centre Pompidou, Paris, 1978.

Lumière et Mouvement, Musée d'Art Moderne de la Ville de Paris, 1966.

The Responsive Eye, The Museum of Modern Art (MoMA), New York, NY, 1965.

Le Mouvement, Stedelijk Museum, Amsterdam; touring to Moderna Museet, Stockholm, and Louisiana Museum of Modern Art, Humlebaek, 1961.

Selected Bibliography

Carlos Cruz-Diez: Color in Space and Time, exh. cat., Museum of Fine Arts, Houston, Yale University Press, New Haven and London, 2011. Texts by Hector Olea and Mari Carmen Ramirez.

Carlos Cruz-Diez in conversation with Ariel Jiménez, Fundación Cisneros/Coleccion Patricia Phelps de Cisneros, New York, 2010.

Carlos Cruz-Diez, *Cruz-Diez: Reflection on Color*, Fundación Juan March, Madrid, 2009.

Carlos Cruz-Diez: Color Happens, exh. cat., Fundación Juan March, Madrid, 2009. Text by Osbel Suarez.

Carlos Cruz-Diez: (In)formed by Color, exh. cat., Americas Society, New York, 2009. Texts by Alexander Alberro, Estrellita Brodsky and Carlos Cruz-Diez.

OLAFUR ELIASSON

b. 1967, Copenhagen, Denmark.
Lives and works in Copenhagen, Denmark,
and Berlin, Germany.

Selected Solo Exhibitions

Your Emotional Future, Pinchuk Art Centre, Kiev, 2011.

Olafur Eliasson: Your chance encounter, 21st Century Museum of Contemporary Art, Kanazawa, 2009–10.

Olafur Eliasson: The nature of things, Fundació Joan Miró, Barcelona, and Fontana d'Or – Centro Cultural Caixa de Girona, 2008.

Take your time: Olafur Eliasson, San Francisco Museum of Modern Art (SFMOMA), CA, 2007.

The light setup: Olafur Eliasson, Lunds Konsthall, and Malmö Konsthall, 2005–6.

Olafur Eliasson: Your light shadow, Hara Museum of Contemporary Art, Tokyo, 2005.

Colour memory and other informal shadows, Astrup Fearnley Museet, Oslo, 2004.

The blind pavilion, Danish Pavilion, 50th Venice Biennale, 2003.

The weather project, The Unilever Series, Tate Modern, London, 2003.

Chaque matin je me sens différent, chaque soir je me sens le même, Musée d'Art Moderne de la Ville de Paris, 2002.

Projects 73: Olafur Eliasson; Seeing yourself sensing, The Museum of Modern Art (MoMA), New York, NY, 2001.

Thoka, Kunstverein Hamburg, 1995.

Selected Group Exhibitions

The Future Archive, n.b.k. (Neuer Berliner Kunstverein), 2012.

Common Ground, Venice Biennale: 13th International Architecture Exhibition, 2012.

Danser sa vie, Le Centre Pompidou, Paris, 2011–2.

Revolutions – forms that turn, 16th Biennale of Sydney, 2008.

Il Tempo del Postino, Manchester International Festival, 2007.

Space for Your Future, Museum of Contemporary Art, Tokyo, 2007–8.

Ecstasy: In and About Altered States, Museum of Contemporary Art (MoCA), Los Angeles, CA, 2005–6.

Utopia Station, 50th Venice Biennale, 2003; touring to Haus der Kunst, Munich, 2004–5.

Sitings: Installation Art 1969–2002, MoCA, Los Angeles, CA, 2003–4.

d'APERTutto, 48th Venice Biennale, 1999.

Nuit blanche – scènes nordiques: Les années 90, Musée d'Art Moderne de la Ville de Paris; touring to Reykjavik Art Museum; Bergen Kunstmuseum; Porin Taidemuseo and Göteborgs Konstmuseum, 1998.

Every Day, 11th Biennale of Sydney, 1998.

On Life, Beauty, Translations and Other Difficulties, 5th International Istanbul Biennial, 1997.

Declining and becoming, Manifesta 1, Kunsthal Rotterdam, 1996.

Selected Bibliography

Anna Engberg-Pedersen (ed.), *Studio Olafur Eliasson: An Encyclopedia*, Taschen GmBH, Cologne, 2012.

Caroline Eggel (ed.), *Olafur Eliasson: Your Chance Encounter*, Lars Müller Publishers, Baden, 2010.

Madeleine Grynsztejn (ed.), *Take Your Time: Olafur Eliasson*, exh. cat., San Francisco Museum of Modern Art, Thames & Hudson, London, 2007. Text by Mieke Bal.

Olafur Eliasson (ed.), *Olafur Eliasson: Your Engagement has Consequences – On the Relativity of Your Reality*, exh. cat., Lars Müller Publishers, Baden, 2006.

Holger Broeker (ed.), *Olafur Eliasson: Your Lighthouse; Works with Light 1991–2004*, exh. cat., Hatje Cantz Verlag, Ostfildern, 2004. Texts by Holger Broeker, Jonathan Crary, Richard Dawkins, Annelie Lütgens and Gijs van Tuyl.

Angeline Scherf (ed.), *Chaque matin je me sens différent; chaque soir je me sens le même*, exh. cat., Musée d'Art Moderne de la Ville de Paris, 2002.

Daniel Birnbaum, Madeleine Grynsztejn and Michael Speaks (eds.), *Olafur Eliasson*, Phaidon Press, London, 2002.

Peter Weibel (ed.), *Olafur Eliasson: Surroundings Surrounded; Essays on Space and Science*, exh. cat., Neue Galerie am Landesmuseum Joanneum Graz, ZKM Center for Art and Media Karlsruhe, The MIT Press, Cambridge, MA/London, 2001.

Olafur Eliasson, exh. cat., Kunsthalle Basel, Schwabe & Co. AG, Verlag und Druckerei, Basel/Muttenz, 1997. Texts by Jonathan Crary and Madeleine Schuppli.

FISCHLI AND WEISS

David Weiss b. 1946, Zürich, Switzerland; d. 2012.
Peter Fischli b. 1952, Zürich, Switzerland.
Lives and works in Zürich, Switzerland.

Selected Solo Exhibitions

Peter Fischli David Weiss: Questions, the Sausage Photographs, and a Quiet Afternoon, The Art Institute of Chicago, IL, 2011.

Are Animals People?, Museo Nacional Centro de Arte Reina Sofia, Madrid, 2009.

Flowers & Questions: A Retrospective, Tate Modern, London, 2006–7; touring to Kunsthaus Zürich, 2007: and Musée d'Art Moderne de la Ville de Paris, 2007.

Visible World, Museu d'Art Contemporani de Barcelona (MACBA), 2000; touring to Fundação Serralves, Porto, 2001.

Peter Fischli and David Weiss: In a Restless World, Walker Art Center, Minneapolis, MN, 1996; touring to Institute of Contemporary Art (ICA), Philadelphia, PA, 1996–7; Wexner Center for the Arts, Columbus, OH, 1997; San Francisco Museum of Modern Art (SFMOMA), CA, 1997; The Institute of Contemporary Art (ICA), Boston, 1997–8; and Kunstmuseum-Wolfsburg, 1998.

Swiss Pavilion, 46th Venice Biennale, 1995.

Peter Fischli / David Weiss, Le Centre Pompidou, Paris, 1992.

Fischli and Weiss, Museum of Contemporary Art (MoCA), Los Angeles, CA, 1988; touring to MIT List Visual Arts Center, Massachusetts Institute of Technology, Cambridge, MA, 1987.

Peter Fischli / David Weiss, Kunsthalle Basel, 1985.

Selected Group Exhibitions

Ghosts in the Machine, New Museum, New York, 2012.

10000 Lives, Gwangju Biennale, 2010.

Waiting for Video: Works from the 1960s to Today, The National Museum of Modern Art, Tokyo, 2009.

Revolutions – forms that turn, Biennale of Sydney, 2008.

Utopia Station, 50th Venice Biennale, 2003.

Moving Pictures, Solomon R. Guggenheim Museum, New York, NY, 2002–3.

Restaging the Everyday: Recent Work by Beat Streuli and Fischli/Weiss, San Francisco Museum of Modern Art (SFMOMA), CA, 2001–2.

Maisons/Häuser: Carsten Höller. Rosemarie Trockel. Peter Fischli David Weiss, Musée d'Art Moderne de la Ville de Paris, 1999.

Thomas Demand, Olafur Eliasson, Peter Fischli David Weiss, Biennale of Sydney, 1998.

Double Take: Collective Memory and Current Art, Hayward Gallery, London, 1992; touring to Kunsthalle Wien, 1993.

Skulptur. Projekte Münster, 1987.

Documenta VIII, Kassel, 1987.

An International Survey of Recent Painting and Sculpture, The Museum of Modern Art (MoMA), New York, NY, 1984.

Saus und Braus, Museum Strauhof, Zürich, 1980.

Selected Bibliography

Ingvild Goetz and Karsten Löckemann (eds), *Peter Fischli, David Weiss*, exh. cat., Hatje Cantz Verlag, Ostfildern, 2010. Texts by Ingvild Goetz, Karsten Löckemann, Rainald Schumacher, Stephan Urbaschek and Katharina Vossenkuhl.

Bice Curiger (ed.), *Fischli Weiss: Flowers & Questions – A Retrospective*, exh. cat., Tate Publishing, London, 2006.

Peter Fischli David Weiss, 'Contemporary Artists' series, Phaidon Press, London, 2005. Texts by Arthur C. Danto, Robert Fleck and Beate Soentgen.

Laurence Bossé and Boris Groys, *Peter Fischli and David Weiss*, Musée d'Art Moderne de la Ville de Paris, Buchhandlung Walther König, Cologne, 1999.

Peter Fischli and David Weiss: In a Restless World, exh. cat., Walker Art Center, Minneapolis, MN, Distributed Art Publishers, Inc., 1996. Texts by Elizabeth Armstrong, Arthur C. Danto and Boris Groys.

DAN FLAVIN

b. 1933, New York, NY, USA.
d. 1996 New York, NY, USA.

Selected Solo Exhibitions

Dan Flavin: Lights, Museum moderner Kunst Stiftung Ludwig Wien (MUMOK), 2012–3.

Dan Flavin: Constructed Light, The Pulitzer Foundation for the Arts, St. Louis, MO, 2008.

Dan Flavin: A Retrospective, National Gallery of Art, Washington, DC, 2004–5; touring to Modern Art Museum of Fort Worth, TX, 2005; Museum of Contemporary Art (MCA), Chicago, IL, 2005; Hayward Gallery, London, 2006; Musée d'Art Moderne de la Ville de Paris, 2006; Pinakothek der Moderne, Munich, 2006–7; Los Angeles County Museum of Art (LACMA), CA, 2007.

Dan Flavin: lichinstallaties/light installations, Stedelijk Museum, Amsterdam, 1986.

'monuments' for V. Tatlin from Dan Flavin, 1964–1983, Temporary Contemporary at The Museum of Contemporary Art (MOCA), Los Angeles, CA, 1984; touring to Corcoran Gallery of Art, Washington, DC, 1984; CAPC, Musée d'art contemporain de Bordeaux, 1985; and Rijksmuseum Kröller-Müller, Otterlo, 1985–6.

Dan Flavin: installations in fluorescent light, Scottish National Gallery of Modern Art, Edinburgh, 1976.

Zeichnungen, Diagramme, Druckgraphik 1972 bis 1975 und zwei Installationen in fluoreszierendem Licht von Dan Flavin, Kunstmuseum Basel, 1975.

Fünf Installationen in fluoreszierendem Licht von Dan Flavin, Kunsthalle Basel, 1975.

fluorescent light, etc. from Dan Flavin, National Gallery of Canada, Ottawa, 1969; touring to Vancouver Art Gallery, 1969; and Jewish Museum, New York, NY, 1970.

dan flavin: fluorescent light, Green Gallery, New York, NY, 1964.

Selected Group Exhibitions

Color Chart: Reinventing Color, 1950 to Today, The Museum of Modern Art (MOMA), New York, NY, 2008; touring to Tate Liverpool, 2009.

A Minimal Future? Art as Object 1958–1968, MOCA, Los Angeles, CA, 2004.

The American Century, Art and Culture 1900–2000, Part II: 1950–2000, Whitney Museum of American Art, New York, NY, 1999–2000.

American Art in the Twentieth Century: Painting and Sculpture, 1913–1993, Martin-Gropius-Bau, Berlin; touring to Royal Academy of Arts and the Saatchi Gallery, London, 1993.

L'Art conceptuel, une perspective, Musée d'Art Moderne de la Ville de Paris, 1989–90.

Transformations in Sculpture: Four Decades of American and European Art, Solomon R. Guggenheim Museum, New York, NY, 1985–6.

Skulptur: Matisse, Giacometti, Judd, Flavin, Andre, Long, Kunsthalle Bern, 1979.

Documenta IV, Kassel, 1968.

American Sculpture of the Sixties, LACMA, CA, 1967; touring to Philadelphia Museum of Art, PA, 1967.

Current Art, Institute of Contemporary Art (ICA), Philadelphia, PA, 1965.

Selected Bibliography

Rainer Fuchs and Karola Kraus (eds.), Dan Flavin: Lights, exh. cat., Hatje Cantz Verlag, Ostfildern, 2012.

Corinna Theirolf and Johannes Vogt, Dan Flavin: Icons. Thames & Hudson, London, 2009.

Jeffrey Weiss (ed.), Dan Flavin: New Light, Yale University Press, New Haven and London, National Gallery of Art, Washington, DC, 2006.

Tiffany Bell and Michael Govan (eds), Dan Flavin: The Complete Lights, 1961–1996, exh. cat., Yale University Press, New Haven and London, Dia Art Foundation, New York, NY, 2004.

Dan Flavin: The Architecture of Light, exh. cat., Solomon R. Guggenheim Museum, New York, NY, 1999. Texts by Tiffany Bell, Frances Colpitt, Jonathan Crary, Michael Govan, Joseph Kosuth, Michael Newman, J. Fiona Ragheb and Brydon E. Smith.

fluorescent light, etc., from Dan Flavin / lumiére fluorescente, etc., par Dan Flavin, exh. cat., National Gallery of Canada, Ottawa, 1969. Texts by Brydon Smith, Mel Bochner and Donald Judd.

CEAL FLOYER

b. 1968, Karachi, Pakistan.
Lives and works in Berlin, Germany.

Selected Solo Exhibitions

DHC/ART Foundation for Contemporary Art, Montréal, 2011.

Ceal Floyer: Works on Paper, Centre of Contemporary Art (CCA), Tel Aviv, 2011.

Ceal Floyer: Auto Focus, Museum of Contemporary Art North Miami (MOCA), FL, 2010.

Palais de Tokyo, Paris, 2009.

Ceal Floyer: Show, KW Institute for Contemporary Art, Berlin, 2009.

Museo d'Arte Contemporanea Donna Regina (MADRE), Naples, 2008–9.

Ceal Floyer: Construction, Museum Haus Esters, Kunstmuseen Krefeld, 2007.

The Power Plant, Toronto, 2006.

Ikon Gallery, Birmingham, 2001.

Kunsthalle Bern, 1999.

Tramway Project Room, Glasgow, 1996.

Selected Group Exhibitions

Triumphant Carrot: The Persistence of Still Life, Contemporary Art Gallery (CAG), Vancouver, 2010.

The Quick and the Dead, Walker Art Center, Minneapolis, MN, 2009.

Making Worlds, 53rd Venice Biennale, 2009.

Just Another Kind of Rendezvous, Künstlerhaus Bremen, 2006.

6th Shanghai Biennale, 2006.

Five Billion Years, Swiss Institute, New York, NY, 2004.

Tempo, The Museum of Modern Art (MoMA), New York, NY, 2002.

Mirror's Edge, Bild Museet, Umeå, 1999–2000; touring to Vancouver Art Gallery, 2000; Castello di Rivoli, Turin, 2000; and Tramway, Glasgow, 2001.

Trace, Tate Liverpool, Liverpool Biennial, 1999.

Richard Wentworth's Thinking Aloud, Kettles Yard, Cambridge, 1998–9; touring to Cornerhouse, Manchester, 1999; and Camden Arts Centre, London, 1999.

Every Day, 11th Biennale of Sydney, 1998.

Material Culture: The Object in British art of the 80's and 90's, Hayward Gallery, London, 1997.

British Art Show 4, touring to various venues in Manchester, Edinburgh and Cardiff, 1995.

Fast Forward, Institute of Contemporary Art (ICA), London, 1994.

Selected Bibliography

Bonnie Clearwater, Ceal Floyer: Auto Focus, exh cat., Museum of Contemporary Art, North Miami, FL, 2010.

Mario Codognato, Ceal Floyer, Mondadori Electa, Milan, 2008.

Marianne Torp and Angela Rosenberg, Ceal Floyer, exh. cat., X-Rummet Statens Museum for Kunst, Copenhagen, 2002.

Jeremy Millar and Jonathan Watkins, Ceal Floyer, exh. cat., Ikon Gallery, Birmingham, Cornerhouse Publications, Manchester, 2001.

Bernhard Fibicher (ed.), Ceal Floyer, exh. cat., Kunsthalle Bern, 1999.

Heike Dander (ed.), Ceal Floyer, exh. cat., Künstlerhaus Bethanien, Berlin, 1998. Texts by Michael Archer and Gerrit Gohlke.

Ina Blom and Sylvia Martin, Ceal Floyer: Construction, exh. cat., Verlag für Moderne Kunst, Nuremberg, 2007.

Ceal Floyer, untitled artist's book, Imprint 93, London, 1996.

NANCY HOLT

b. 1938, Worcester, MA, USA.
Lives and works in Galisteo, NM, USA.

Selected Solo Exhibitions

Nancy Holt: Sightlines, Miriam and Ira D. Wallach Art Gallery, Columbia University in the City of New York, NY, 2010; touring to Badischer Kunstverein, Karlsruhe, 2011; Graham Foundation, Chicago, IL, 2011; Tufts University Art Gallery, Medford, MA, 2012; Santa Fe Arts Institute, NM, 2012; and Utah Musem of Fine Arts, 2012–3.

Le Musée d'Art Comtemporain, Marseilles, 1994.

Montpellier Cultural Arts Center, Laurel, MD, 1989.

Flow Ace Heating, Ace Gallery (formerly Flow Ace Gallery), Los Angeles, CA, 1985.

Detroit Institute of Arts, MI, 1980.

Carnegie Institute, Pittsburgh, PA, 1980.

Cineprobe (solo presentation of *Underscan*), The Museum of Modern Art (MoMA), New York, NY, 1979.

Young American Filmmakers' Series, (solo presentation of *Revolve*), Whitney Museum of American Art, New York, NY, 1977.

Mirrors of Light II, Walter Kelly Gallery, Chicago, IL, 1974.

Mirrors of Light I, Bykert Gallery, New York, NY, 1974.

Holes of Light, LoGiudice Gallery, New York, NY, 1973.

Locators with Mirrors, Gallery of Visual Arts, University of Montana, Missoula, MT, 1972.

Fine Arts Center, University of Rhode Island, Kingston, RI, 1972.

Selected Group Exhibitions

Ends of the Earth: Land Art to 1974, The Museum of Contemporary Art (MOCA), Los Angeles, CA, 2012; touring to Haus der Kunst, Munich, 2012–3.

Land Art, Hamburger Bahnhof, Museum für Gegenwart, Berlin, 2011–2.

1969, MoMA PS1, Long Island City, NY, 2009–10.

A Stake in the Mud, A Hole in the Reel. Land Art's Expanded Field 1968–2008, Museo Tamayo Arte Contemporáneo, Mexico City; touring to multiple venues, 2008.

Decoys, Complexes, and Triggers: Feminism and Land Art in the 1970s, SculptureCenter, Long Island City, NY, 2008.

Time Frame, MoMA PS1, New York, NY, 2006.

The Big Nothing, Institute of Contemporary Art (ICA), University of Pennsylvania, Philadelphia, PA, 2004.

Century City: Art and Culture in the Modern Metropolis, Tate Modern, London, 2001.

Afterimage: Drawing Through Process, MOCA, Los Angeles, CA; touring to Contemporary Arts Museum Houston (CAMH), TX, 2000

Home Screen Home, Witte de With Center for Contemporary Art, Rotterdam, 1998.

Mapping, MoMA, New York, NY, 1994.

Making Their Mark: Women Artists Move into the Mainstream, 1970–85, Cincinnati Art Museum, OH; touring to New Orleans Museum of Art (NOMA), LA; Denver Art Museum, CO; and Pennsylvania Academy of Fine Arts, Philadelphia, 1989.

Porkkana – kokoelma: nykytaiteen museon puolesta, KIASMA Museum of Contemporary Art, Helsinki, 1988.

Whitney Biennial, Whitney Museum of American Art, New York, NY, 1981.

Probing the Earth: Contemporary Land Projects, Hirshhorn Museum and Sculpture Garden, Washington, DC, 1977.

Video Art, Institute of Contemporary Art (ICA), Boston, MA, 1974.

Selected Bibliography

Ben Tufnell (ed.), *Nancy Holt : Photoworks*, exh. cat., Haunch of Venison, London, 2012.

Alena J. William (ed.), *Nancy Holt: Sightlines*, University of California Press, Berkley, CA, 2011.

JENNY HOLZER

b. 1950, Gallipolis, OH, USA.
Lives and works in New York, NY, USA.

Selected Solo Exhibitions

DHC/ART Foundation for Contemporary Art, Montreal, 2010.

Jenny Holzer: PROTECT PROTECT, Museum of Contemporary Art (MCA), Chicago, IL, 2008–9; touring to Whitney Museum of American Art, New York, NY, 2009; and BALTIC Centre for Contemporary Art, Gateshead, 2010.

XX, MAK, Vienna, 2007.

TRUTH BEFORE POWER, Kunsthaus Bregenz, 2004.

Neue Nationalgalerie, Berlin, 2001.

United States Pavilion, 49th Venice Biennale, 1990; touring to Städtische Kunsthalle, Düsseldorf; Louisiana Museum, Humlebaek, 1991; Albright–Knox Art Gallery, Buffalo, NY: and Walker Art Center, Minneapolis, MN.

Solomon R. Guggenheim Museum, New York, NY, 1989.

Jenny Holzer: Laments 1988–89, Dia Art Foundation: Chelsea, New York, NY, 1989–90.

Jenny Holzer: Signs, Des Moines Art Center, IA, 1986–7; touring to Aspen Art Museum, CO, 1987; Artspace, San Francisco, CA, 1987; Museum of Contemporary Art (MCA), Chicago, IL, 1987; and MIT List Visual Arts Center, Cambridge, MA, 1987.

Investigations 3: Jenny Holzer, Institute of Contemporary Art (ICA), University of Pennsylvania, Philadelphia, PA, 1983.

Jenny Holzer Painted Room: Special Project P.S.1, Institute for Art and Urban Resources at P.S.1, Long Island City, NY, 1978.

Selected Group Exhibitions

This Will Have Been: Art, Love & Politics in the 1980s, MCA Chicago, IL, 2012; touring to Walker Art Center, Minneapolis, MN, 2012; and Institute of Contemporary Art (ICA), Boston, MA, 2012–3.

Into Me/Out of Me, MoMA PS1, Long Island City, NY, 2006; touring to Kunst-Werke Institute for Contemporary Art, Berlin, 2007.

Read My Lips: Jenny Holzer, Barbara Kruger, Cindy Sherman, National Gallery of Australia, Canberra, 1998.

Objects for the Ideal Home: The Legacy of Pop Art, Serpentine Gallery, London, 1991.

Art & Pub: Art et Publicité 1890–1990, Le Centre Pompidou, Paris, 1990.

High & Low: Modern Art and Popular Culture, The Museum of Modern Art (MoMA), New York, NY, 1990; touring to The Art Institute of Chicago, IL, 1990–91; and The Museum of Contemporary Art (MOCA), Los Angeles, CA, 1991.

A Forest of Signs: Art in the Crisis of Representation, MOCA, Los Angeles, CA, 1989.

From the Southern Cross, A View of World Art c.1940–88, 7th Biennale of Sydney, Art Gallery of New South Wales and Pier 2/3, Sydney; touring to National Gallery of Victoria, Melbourne, 1988.

L'Époque, La Mode, La Morale, La Passion, Musée National d'Art Moderne, Le Centre Pompidou, Paris, 1987.

Whitney Biennial, Whitney Museum of American Art, New York, NY, 1983.

Selected Bibliography

Jenny Holzer: PROTECT PROTECT, exh. cat., Hatje Cantz Verlag, Ostfildern, 2008. Text by Benjamin H. D. Buchloh, Joan Simon and Elizabeth A. T. Smith.

Jenny Holzer, exh. cat., Guggenheim Museum Publications and Harry N. Abrams, Inc. New York, 2004. Text by Diane Waldeman.

Jenny Holzer: TRUTH BEFORE POWER, exh. cat., Kunsthaus Bregenz, 2004. Text by Maurice Berger, Thomas Blanton, Henri Cole, Sherman Kent and Eckhard Schneider.

Jenny Holzer–Neue Nationalgalerie Berlin, exh. cat., The American Academy in Berlin, Neue Nationalgalerie Berlin, 2001. Text by Henri Cole and Angela Schneider.

David Joselit, Renata Salecl and Joan Simon, *Jenny Holzer*, 'Contemporary Artists' series, Phaidon Press Ltd, London, 1996.

Noemi Smolik (ed.), *Jenny Holzer: Writing*, Cantz Verlag, Schriften, 1990.

Jenny Holzer: The Venice Installation, exh. cat., Albright-Knox Gallery, Buffalo, NY, 1992. Text by Michael Auping.

ANN VERONICA JANSSENS

b. 1956, Folkestone, UK.
Lives and works in Brussels, Belgium.

Selected Solo Exhibitions

18th Biennale of Sydney, 2012.

Oscar, IKON Gallery, Birmingham, 2012.

Ann Veronica Janssens: Serendipity, WIELS Centre d'Art Contemporain, Brussels, 2009.

8'26", MAC Galeries Contemporaines des Musées de Marseille, 2003–4.

Licht und Farben, Kunsthalle Bern, 2003.

Rouge 106, Bleu 132, Musée d'Orsay, Paris, 2003.

IKON Gallery, Birmingham, 2002.

Light Games, Neue Nationalgalerie, Berlin, 2001.

Horror Vacui (with Michel François), Belgian Pavilion, 48th Venice Biennale, 1999.

Museum van Hedendaagse Kunst Antwerpen (MuHKA), 1997.

Salle Altenloh, Musée d'Art Moderne, Brussels, 1987.

Selected Group Exhibitions

Void if removed: Concrete Erudition 4, Le Plateau, FRAC Ile-de-France, Paris, 2011.

Universal Code: Art and Cosmology in the Information Age, The Power Plant, Toronto, 2009.

Ecstasy: In and About Altered States, Museum of Contemporary Art (MOCA), Los Angeles, CA, 2005–6.

Aux Origines de l'abstraction (1800–1914), Musée d'Orsay, Paris, 2003.

The World on its Head, San Francisco Art Institute (sfai), CA, 2001.

Audible Light, Modern Art Oxford, 2000.

Stimuli, Witte de With Center for Contemporary Art, Rotterdam, 1999–2000.

Every Day, 11th Biennale of Sydney, 1998.

On Life, Beauty, Translations and Other Difficulties, 5th International Istanbul Biennale, 1997.

Inside the Visible, an Elliptical Traverse of 20th Century Art in, of and from the Feminine, The Institute of Contemporary Art (ICA), Boston, MA, 1994; touring to National Museum of Women in the Arts, Washington, DC, 1994; Whitechapel Art Gallery, London, 1996; and Art Gallery of Western Australia, Perth, 1997.

Confrontationes, Museo Espanol de Arte Contemporaneo (now Museo Reina Sofia), Madrid, 1990.

Lauréat de La jeune Peinture Belge, Palais des Beaux-Arts, Brussels, 1979.

Selected Bibliography

Michel François, *Ann Veronica Janssens: Are You Experienced?*, Base Publishing, Brussels, 2009.

8'26", exh. cat., Musée d'Art Contemporain de Marseille, 2004. Texts by Henri Claude Clousseau, Nathalie Ergino, Anne Pontégnie and Pascal le Thorel-Daviot.

Hans Theys, *Ann Veronica Janssens: The Gliding Gaze*, exh. cat., Middelheim Museum, Antwerp, 2003.

Mieke Bal (ed.), *Ann Veronica Janssens: Lichtspiel*, exh. cat., Berliner Künstler Programm DAAD, Kunstverein München, 2001.

Ann Veronica Janssens, exh. cat., MuHKA, Antwerp, 1997 .

BRIGITTE KOWANZ

b. 1957, Vienna, Austria.
Lives and works in Vienna, Austria.

Selected Solo Exhibitions

Cut a Long Story Short, Borusan Contemporary, Istanbul, 2012–3.

What Next, Häusler Contemporary, Munich, 2012.

Think Outside the Box, Museum Ritter, Waldenbuch, 2011–2.

Now I See, Museum moderner Kunst Stiftung Ludwig Wien (MUMOK), 2010.

Intervention: Brigitte Kowanz, Oberes Belvedere, Vienna, 2007–8.

VO_LUMEN, Kunsthalle Krems, 2007.

Zentrum für Internationale Lichtkunst Unna (ZKM), 2005.

See it now, Galerie aller Art, Remise Bludenz, 2001; touring to Schloss Hardenberg, Velbert, 2002.

Universität für angewandte Kunst Wien, 1998.

Architekturforum Tirol, Innsbruck, 1996.

Wiener Secession, 1993.

Salzburger Kunstverein, 1990.

Selected Group Exhibitions

Néon: Who's afraid of red yellow and blue?, la maison rouge – foundation antoine de galbert, Paris, 2012.

Austria Davaj!, Österreiches Museum für angewandte Kunst (MAK) Vienna, 2011.

Genau+anders: Mathematik in der Kunst von Dürer bis Sol LeWitt, MUMOK, Vienna, 2008.

Signaal, Centrum Kunstlicht in de Kunst, Eindhoven, 2008.

Lichtkunst aus Kunstlicht, ZKM, Karslruhe, 2005–6.

ein-leuchten, Museum der Moderne, Salzburg, 2004.

Austrian Contemporary Art, Architecture and Design, Shanghai Art Museum, 2001.

Art in Central Europe 1949–1999, MUMOK, Vienna, 1999–2000; touring to Fundació Joan Miró, Barcelona, 2000; John Hansard Gallery, Southampton, 2000; and Národní Galerie V Praze, 2001.

Secession: A Century of Artistic Freedom, Wiener Secession, 1998.

29'-0"/East, Doug Aitken, Ernst Caramelle, Brigitte Kowanz, Kirsten Mosher, Glen Seator, Erwin Wurm, The New York Kunsthalle, NY, 1996.

Intervenciones en el espacio/Interventions in the Space, Museo de Bellas Artes, Caracas, 1995.

Austrian Vision, Centre Cultural de la Fundación 'La Caixa', Madrid, 1994.

19th Bienal de São Paolo, 1987.

12th Biennale de Paris, 1982.

Selected Bibliography

Beate Ermacora (ed.), Brigitte Kowanz – in light of light, exh. cat., Moderne Kunst Nürnberg, 2012. Texts by Beate Ermacora and Gregor Jansen.

Brigitte Kowanz: Now I See, exh. cat., MUMOK, Vienna, 2010. Texts by Riccardo Caldura, Rainer Fuchs, Edelbert Köb, Peter Weibel and Anton Zeilinger.

Brigitte Kowanz: Intervention, ad infinitum, exh. cat., Belvedere, University of Applied Arts, Vienna, 2007. Texts by Meinhard Rauchensteiner and Eva Maria Stadler.

Brigitte Kowanz: more L978T, Universität für angewandte Kunst, Vienna, 2006. Texts by Gerald Bast, Markus Brüderlin, Rainer Fuchs and Christian Reder.

Wolfgang Häusler (ed.), Brigitte Kowanz: Another time another place, exh. cat., Häusler Contemporary, Munich, 2002. Texts by Christa Häusler, Jan Tabor and Sabine B. Vogel

Wolfgang Häusler (ed.), Brigitte Kowanz: Time-Light – Lightspace, Hatje-Cantz Verlag, Ostfildern, 2001. Text by Rainer Fuchs.

L.I.W.M.S. – Licht ist was man sieht, exh. cat., Triton Verlag, Vienna, 1997. Texts by Rainer Fuchs and Rainer Metzger.

Brigitte Kowanz, exh. cat., Wiener Secession, 1993. Texts by Ecke Bonk, Christian Kravagna and Sabine B. Vogel.

Brigitte Kowanz, Noema Verlag, Salzburg, 1990. Text by Helmut Draxler.

ANTHONY McCALL

b. 1946, St Paul's Cray, UK.
Lives and works in New York, NY, USA.

Selected Solo Exhibitions

Anthony McCall: Five Minutes of Pure Sculpture, Hamburger Bahnhof, Berlin, 2012.

Nu/Now: Anthony McCall, Moderna Museet, Stockholm, 2010.

Anthony McCall: Breath [the vertical works], HangarBicocca, Milan, 2009.

Anthony McCall: Elements for a Retrospective, Musée départemental d'art contemporain de Rochechouart, 2007; touring to Serpentine Gallery, London, 2007–8; and Utzon Center, Aalborg, 2008.

Museum für Moderne Kunst (MMK) Frankfurt am Main, 2005.

Long Film for Four Projectors, Tate Britain, London, 2004.

Anthony McCall: les films de lumière solide, Le Centre Pompidou/La maison rouge – foundation antoine de galbert, Paris, 2004.

Musée Nationale d'Art Moderne, Paris, 1976.

Anthony McCall: Solid Light Films, Collective for Living Cinema and Film Forum, New York, NY, 1974.

Solid Figures: Anthony McCall, Museum of Modern Art, Oxford, 1974.

Selected Group Exhibitions

Ends of the Earth: Land Art to 1974, The Museum of Contemporary Art (MOCA), Los Angeles, CA, 2012; touring to Haus der Kunst, Munich, 2012–3.

Off the Wall, Museu de Arte Contemporânea de Serralves, Porto, 2011.

The Cinema Effect: Illusion, Reality, and the Moving Image, Hirshhorn Museum and Sculpture Garden, Smithsonian Institution, Washington, DC, 2008; touring to Fundació La Caixa, Barcelona, 2011.

Whitney Biennial, Whitney Museum of American Art, New York, NY, 2004.

Eyes, Lies & Illusions, Hayward Gallery, London, 2004.

Into the Light: The Projected Image in American Art 1964–1977, Whitney Museum of American Art, New York, NY, 2001; touring to The Cleveland Museum of Art, OH, 2002; and Fundacão Centro Cultural de Belém (CCB), Lisbon, 2004.

X-Screen: The Expanded Screen: Actions and Installations of the Sixties and Seventies, Museum moderner Kunst Stiftung Ludwig Wien (MUMOK), 2003–4.

L'Art et la Vie 1952–1994, Le Centre Pompidou, Paris, 1995.

Documenta VI, Kassel, 1977.

Where Are You Standing?, 2nd Venice Biennale, 1976.

Photography into Art, Camden Arts Centre, London, 1972.

A Survey of the Avant-Garde in Britain, Gallery House, London, 1972.

Selected Bibliography

Henriette Huldisch and Udo Kittelmann (eds), Anthony McCall: Five Minutes of Pure Sculpture, exh. cat., Buchandlung Walther König, Cologne, 2012. Text by Noam Elcott.

Serena Cattaneo Adorno (ed.), Breath [The Vertical Works], exh. cat., Hangar Bicocca, Carraini, Milan, 2009. Text by Hal Foster.

Olivier Michelon, Anthony McCall: Elements for a Retrospective 1972–1979/2003 –, exh. cat., Monografik Editions, Paris, 2007.

Nathalie Ergino (ed.), Anthony McCall, exh. cat., Institut d'Art Contemporain, Villeurbanne, 2006. Texts by Nathalie Ergino and Philippe-Alain Michaud.

Christopher Eamon (ed.), Anthony McCall: The Solid Light Films and Related Works, Northwestern University Press and New Art Trust, Evanston, IL, Steidl, Göttingen, 2005. Texts by Branden W. Joseph and Jonathan Walley.

Helen Legg (ed.), Anthony McCall: Film Installations, exh. cat., Mead Gallery, University of Warwick, 2004. Texts by George Baker and Lisa Le Feuvre.

FRANÇOIS MORELLET

b. 1926, Cholet, France.
Lives and works in Cholet and Paris, France.

Selected Solo Exhibitions

François Morellet – Réinstallations, Le Centre Pompidou, Paris, 2011.

François Morellet: oeuvres de la collection, Musée d'Art contemporain de Lyon (MAC Lyon), 2007.

François Morellet: Blow up 1952–2007, quand j'étais petit je ne faisais pas grand, Musée d'Art Moderne de la Ville de Paris, 2007.

Encres et Lumières, La Cohue, Musée des Beaux-arts de Vannes, 1999.

François Morellet: Dessins et Tableaux blancs des années 1980, Musée de Grenoble, 1991.

Stedelijk Museum, Amsterdam, 1986.

Morellet, Le Centre Pompidou, Paris, 1986.

François Morellet: Systèmes, Albright-Knox Art Gallery, Buffalo, NY, 1984; touring to Musée d'art contemporain de Montréal, 1984; The Brooklyn Museum, New York, NY, 1985; and Center for the Fine Arts (now Miami Art Museum), Miami, FL, 1985.

Musée d'Art Moderne de la Ville de Paris, 1977.

François Morellet: Bilder und Lichtobjekte, Neue Nationalgalerie, Berlin, 1977–8.

Paintings 1953/57, Néons 1973, Leicester Art Gallery, 1974; touring to Museum of Modern Art, Oxford; Southampton City Art Gallery; National Museum of Wales, Cardiff; Scottish National Gallery of Modern Art, Edinburgh; Ferens Art Gallery, Hull; Graves Art Gallery, Sheffield; Liang Art Gallery, Newcastle; City Museum and Art Gallery, Birmingham; and Kunsthalle Bielefeld.

Morellet in Van Abbe, Van Abbemuseum, Eindhoven, 1971.

Selected Group Exhibitions

Ghosts in the Machine, New Museum, New York, NY, 2012.

Color Chart: Reinventing Color, 1950 to Today, The Museum of Modern Art (MOMA), New York, 2008; touring to Tate Liverpool, 2009.

Beyond Geometry: Experiments in Form, Los Angeles County Museum of Art (LACMA), CA, 2004.

Passions privées, Musée d'Art Moderne de la Ville de Paris, 1995.

La ville, art et architecture en Europe 1870–1983, Le Centre Pompidou, Paris, 1994.

Skulptur. Projekte in Münster 1987, 1987.

Kinetics, Hayward Gallery, London, 1970.

Lumière et Mouvement, Musée d'Art Moderne de la Ville de Paris, 1967.

The Responsive Eye, MOMA, New York, NY, 1945; touring to City Art Museum of St Louis, MO, 1945; Seattle Art Museum, WA, 1945; and The Pasadena Art Museum, CA, 1965.

Documenta III, Kassel, 1964.

Selected Bibliography

Alfred Pacquement, *François Morellet – Réinstallations*, exh. cat., Le Centre Pompidou, Paris, 2011.

Serge Lemoine, *François Morellet*, Flammarion, Paris, 2011.

François Morellet: Blow-up 1952–2007: Quand j'étais petit, j'en faisais pas grand, exh. cat., Musée d'Art Moderne de la Ville de Paris, 2007.

François Morellet 1926–2006 etc... Récentes Fantaisies, exh. cat., Musée des Beaux-Arts d'Angers, Monografik Editions, Paris, 2006. Texts by Christine Besson and Patrick Le Nouëne.

IVAN NÁVARRO

b. 1972, Santiago, Chile.
Lives and works in New York, NY, USA.

Selected Solo Exhibitions

Iván Navarro: Fluorescent Light Sculptures, Frost Museum of Art, Miami, FL, 2012.

Nacht und Nebel, Fondazione VOLUME!, Rome, 2012.

Heaven or Las Vegas, SCAD Museum of Art, Savannah, GA, 2012.

Tierra de Nadie, Centro de Arte Caja de Burgos (CAB), 2010.

Threshold, Chilean Pavillion, 53rd Venice Biennale, 2009.

Homeless Lamp, The Juice Sucker, Fabric Workshop and Museum (FWM), Philadelphia, PA, 2008.

Monuments for D. Flavin, Roebling Hall, Brooklyn, NY, 2004.

Blade runner, Gasworks Studios, London, 2002.

Camping day, PUC, Santiago, 1996.

Selected Group Exhibitions

Neon – Who's afraid of red, yellow and blue?, La maison rouge, fondation antoine de galbert, Paris; MACRO, Rome, 2012.

Prospect 2, International Art Biennial, New Orleans, IL, 2011.

HomelessHome, Museum on the Seam, Jerusalem, 2010.

When We Build, Let Us Think That We Build Forever, BALTIC Centre for ContemporaryArt, Gateshead, 2007–8.

Petroliana, 2nd Moscow Biennale of Contemporary Art, Moscow Museum of Modern Art (MMOMA), 2007.

The Disappeared/Los Desaparecidos, North Dakota Museum of Art, Grand Forks, ND; Museo del Barrio, New York, NY, 2006–7.

Trace, Whitney Museum of American Art, New York, NY, 2006.

Don Quijote, Witte de With, Center for Contemporary Art, Rotterdam, 2006

Light Art from Artificial Light, Zentrum für Kunst und Medientechnologie (ZKM) Museum Für Neue Kunst, Karlsruhe, 2005–6.

The Selected Files, El Museo del Barrio, New York, 1999.

Young art in Chile (1986–1996), the ice fields, Museo Nacional de Bellas Artes, Santiago, 1997.

The things and its attributes (Mario and Iván Navarro), Galería Gabriela Mistral, Santiago, 1996.

Selected Bibliography

Tierra de nadie, exh. cat., Centro de Arte Caja de Burgos, 2010. Text by Tatiana Flores.

Anne Ellegood, *Iván Navarro: Threshold*, Edizioni Charta Srl, Milan, 2009.

Iván Navarro: Nowhere Man, exh. cat., Towner, Eastbourne, 2009. Texts by Katie M. Kitamura, Sanna Moore and Matthew Rowe.

Iván Navarro: We Are The Future, exh. cat., Moscow Biennale of Contemporary Art, 2007.

John B. Ravenal, *Iván Navarro*, galerie Daniel Templon, Paris, 2007 (French).

PHILIPPE PARRENO

b. 1964, Oran, Algeria.
Lives and works in Paris, France.

Selected Solo Exhibitions

Fondation Beyeler, Riehen, 2012.

Serpentine Gallery, London, 2010–11.

Philippe Parreno: May, Kunsthalle Zurich, 2009.

Musée national d'Art moderne – Le Centre Pompidou, Paris, 2009.

Briannnnnn & Ferryyyyyy, collaboration with Liam Gillick, Vamiali's, Athens, 2005; touring to Kunsthalle Zurich, 2006.

Fade Away, Kunstverein München, 2004.

Sky of The Seven Colors, Center for Contemporary Art (CCA) Kitakyushu, 2003.

El sueno de una cosa, Museet Project, Moderna Museet, Stockholm, 2001; Portikus Museum, Frankfurt, 2002.

Alien Season, Musee d'Art Moderne de la Ville de Paris, 2002.

No Ghost Just a Shell, collaboration with Pierre Huyghe, Kunsthalle Zürich, 2002; touring to San Francisco Museum of Modern Art (SFMoMA), 2002–3; Institute of Visual Culture, Fitzwilliam Museum, Cambridge, 2002–3 and Van Abbemuseum, Eindhoven 2003.

No Ghost Just a Shell: Anywhere Out of the World, Air de Paris; touring to Schipper & Krome, Berlin, 2000.

La nuit des heros, Salle Garance, Le Centre Pompidou, Paris; FRAC Poitou–Charente, Angoulême, 1994.

Selected Group Exhibitions

Ghosts in the Machine, New Museum, New York, 2012.

The Puppet Show, Institute of Contemporary Art, Philadelphia, PA, 2008; touring to Santa Monica Museum of Art, CA, 2008; Contemporary Arts Museum, Houston, TX, 2009 and Frye Art Museum, Seattle, WA, 2009.

Theanyspacewhatever, Guggenheim Museum, New York, NY, 2008–9.

Universal Experience: Art, Life and the Tourist's Eye, Museum of Contemporary Art Chicago (MCA), 2005.

No Ghost Just a Shell, Institute of Visual Culture, Cambridge, 2002; reinvented for San Francisco MoMA, CA; Kunsthalle Zürich; Van Abbemuseum, Eindhoven; and others, 2002–2005.

Utopia Station, 50th Venice Biennale, 2003; touring to Haus der Kunst, Munich, 2003–4.

Let's Entertain, Walker Art Center, Minneapolis, MN; touring to Portland Art Museum, OR; Le Centre Pompidou, Paris; Museo Rufino Tamayo, Mexico City; and Miami Art Museum, FL, 2000.

L'Autre, Biennale de Lyon, 1997.

Traffic, CAPC Bordeaux, 1996 (with Maurizio Cattelan).

APERTO, 45th Venice Biennale, 1993.

L'Amour de l'Art, Biennale d'Art Contemporain, Lyon, 1991.

Selected Bibliography

Maria Lind, *Philippe Parreno*, Sternberg Press, Berlin, 2010

Parreno, exh. cat., Irish Museum of Modern Art (IMMA), Dublin, 2010. Texts by Enrique Juncosa, Christine Macel and Karen Marta.

Philippe Parreno: Films 1987–2010, exh. cat., Buchhandlung Walther König, Cologne, 2010. Texts by Nicolas Bourriaud, Dorothea von Hantelmann and Hans Ulrich Obrist.

Johan Olander, *Philippe Parreno: Parade?*, JRP Ringier, Zurich, 2009.

Philippe Parreno/Hans Ulrich Obrist, 'Conversation' series, Buchhandlung Walther König, Cologne, 2008.

Pierre Huyghe and Philippe Parreno, *No Ghost Just a Shell*, Buchhandlung Walther König, Cologne, 1999.

KATIE PATERSON

b. 1981, Glasgow, Scotland.
Lives and works in Berlin, Germany.

Selected Solo Exhibitions

Inside this Desert, BAWAG Contemporary, Vienna, 2012.

FOCUS: Katie Paterson, The Modern Art Museum of Fort Worth, TX, 2012.

Continuum, James Cohan Gallery, New York, NY, 2011.

Streetlight Storm, with Turner Contemporary, Margate, and Whitstable Biennale, 2010.

Albion, London, 2008.

Encounters: Katie Paterson, Modern Art Oxford, 2008.

Langjökull, Snæfellsjökull, Solheimajökull, ROOM, London, 2008.

Selected Group Exhibitions

Light & Landscape, Storm King ArtCenter, Mountainville, NY, 2012.

Marking Time, Museum of Contemporary Art, Sydney, 2012.

Exposure: Matt Keegan, Katie Paterson, Heather Rasmussen, The Art Institute of Chicago, IL, 2011.

Constellations, Cornerhouse, Manchester, 2011.

Space. About a Dream, Kunsthalle Wien, 2011.

Cage Mix, BALTIC, Gateshead, 2010.

Systematic, Zabludowicz Collection, London, 2010.

PERFORMA 09, New York, NY, 2009.

Altermodern: Tate Triennial 2009, Tate Britain, London, 2009.

Life-forms, Bonniers Konsthall, Stockholm, 2009.

Universal Code, The Power Plant, Toronto, 2009.

ARTfutures, Bloomberg Space, London, 2008.

Selected Bibliography

Katie Paterson: Earth–Moon–Earth, with Modern Art Oxford, 2008.

CONRAD SHAWCROSS

b. 1977, London, UK.
Lives and works in London, UK.

Selected Solo Exhibitions

Conrad Shawcross: The Nervous Systems (Inverted), MUDAM, Luxembourg, 2012.

Protomodel: Five Interventions, Science Museum, London, 2011–2.

Projections of the Perfect Third, Turner Contemporary, Margate, 2011.

Conrad Shawcross: Control, Location One, New York, NY, 2009.

The Fireplace Project, East Hampton, NY, 2009.

The Collection, Siobhan Davies Dance Studio, London, 2009.

Light Perpetual, Jenaer Kunstverein, 2008.

Conrad Shawcross: The Steady States, The New Art Gallery Walsall and Walker Art Gallery, Liverpool, 2005–6.

Conrad Shawcross: Continuum, The Queen's House, National Maritime Museum (NMM), London, 2004–5.

The Nervous Systems, Entwistle Gallery, London, 2003.

Selected Group Exhibitions

Metamorphosis: Titian 2012, National Gallery, London, 2012.

Set Design for Royal Opera House/Wayne McGregor, Royal Opera House, London, 2012.

Mondes Inventés, Mondes Habités, MUDAM, Luxembourg, 2011.

The Knowledge, Gervasuti Foundation, 54th Venice Biennale, 2011.

Light – Part I, Paradise Row, London, 2011.

ShadowDance, Kunsthal in Amersfoort (KAdE), 2010.

3rd Moscow Biennale of Contemporary Art, 2009.

A Duck for Mr. Darwin, BALTIC Centre for Contemporary Art, Gateshead; touring to Mead Art Gallery, Warwick, 2009.

Beyond Measure: conversations across art and science, Kettle's Yard, Cambridge, 2008.

Rendez-vous, Musee d'art Contemporain de Lyon (MAC), 2008.

Manifesta 5, Donostia-San Sebastian, 2004.

New Blood, The Saatchi Gallery, London, 2004.

New Contemporaries 2001, Camden Arts Centre, London; touring to Northern Gallery for Contemporary Art, Sunderland, 2001.

Selected Bibliography

Chord, Conrad Shawcross, exh. cat., Measure, London, 2009. Texts by George Hooper, Ed Humphreys, Robin Mackay and Helen Sumpter.

Conrad Shawcross: The Steady States, exh. cat., National Museums & Galleries on Merseyside, 2005. Texts by Andrea Bellini and Jenny Uglow.

Conrad Shawcross: No Such Thing as One, exh. cat., Victoria Miro Gallery, London, 2006. Text by Brooke McGowan.

JAMES TURRELL

b. 1943, Los Angeles, CA, USA.
Lives and works in Flagstaff, AZ, USA.

Selected Solo Exhibitions

Garage Center for Contemporary Culture, Moscow, 2011.

James Turrell: Alta (White), Le Centre Pompidou, Paris, 2006.

National Gallery of Art, Washington, DC, 2002.

James Turrell: Spirit and Light, The Brown Foundation Gallery, Contemporary Art Museum Houston (CMAH), TX, 1998.

James Turrell: Where Does the Light in Our Dreams Come From?, The Museum of Modern Art, Saitama, 1997; touring to Nagoya City Museum, 1998; and Setagaya Art Museum, Tokyo, 1998.

Hayward Gallery, London, 1993.

Musée d'art contemporain (MAC) Lyon, 1992.

Occluded Front: James Turrell, The Temporary Contemporary, Museum of Contemporary Art (MOCA), Los Angeles, CA, 1985.

James Turrell: Three Installations, Musee d'Art Moderne de la Ville de Paris, 1983–4.

Whitney Museum of American Art, New York, NY, 1980.

Stedelijk Museum, Amsterdam, 1976.

Pasadena Art Museum, CA, 1967.

Selected Group Exhibitions

Phenomenal: California Light, Space, Surface, Museum of Contemporary Art San Diego, CA, 2011–2.

ILLUMInations, 54th Venice Biennale, 2011.

ColorForms, Hirshhorn Museum and Sculpture Garden, Smithsonian Institution, Washington, DC, 2010–2.

Light Art from Artificial Light, ZKM – Museum für Neue Kunst, Karlsruhe, 2005–6.

Devices of Wonder, The J. Paul Getty Museum, Los Angeles, CA, 2001–2.

Open Ends, The Museum of Modern Art (MoMA), New York, NY, 2000–1.

Regarding Beauty: A View of the Late 20th Century, Hirshhorn Museum and Sculpture Garden, Smithsonian Institution, Washington, DC, 2000.

Sunshine & Noir, Art in Los Angeles 1960–1997, Louisiana Museum of Modern Art, Humlebæk, 1997; touring to Kunstmuseum Wolfsburg, 1998; Castello di Rivoli – Museo d'Arte Contemporaneo, Turin, 1998; and Armand Hammer Museum of Art and Culture Center (now Hammer Museum), Los Angeles, CA, 1998.

Individuals: A Selected History of Contemporary Art, 1945–1986, The Temporary Contemporary, MOCA, Los Angeles, USA, 1986–8.

Art and Technology, Los Angeles County Museum of Art (LACMA), CA, 1968.

Selected Bibliography

James Turrell: Geometry of Light, exh. cat., Hatje Cantz Verlag, Ostfildern, 2009. Texts by Gernot Böhme, Julian Heynen, Agostino De Rosa, Ursula Sinnreich and Gerhard Buurman, Christian Weber and Max Rheiner.

James Turrell: The Wolfsburg Project, exh. cat., Hatje Cantz Verlag, Ostfildern, 2009. Texts by Richard Andrews, Markus

Brüderlin, Esther Barbara Kirschner, Annelie Lütgens and Peter Weber.

James Turrell: A Life in Light, exh. cat., Somogy Publishing, Paris, 2006. Texts by Andrew Graham-Dixon, Michael Hue-Williams and Jeremy Newton.

James Turrell: Infinite Light, exh. cat., Scottsdale Museum of Contemporary Art, AZ, 2001. Texts by Valerie Vadala Homer, Debra L. Hopkins and Robert E. Knight.

James Turrell: Spirit and Light, exh. cat., Contemporary Arts Museum Houston (CMAH), TX, 1998. Texts by Lynn M. Herbert and John H. Lienhard.

Mark Holborn (ed.), *James Turrell: Air Mass*, exh. cat., The South Bank Centre, London, 1993.

James Turrell, *Batten: An Installation*, MIT Press, Cambridge, MA, 1983.

Barbara Haskell, *James Turrell: Light and Space*, Whitney Museum of American Art, New York, NY, 1981.

b. 1967, Albuquerque, NM, USA.
Lives and works in New York, NY, USA.

Selected Solo Exhibitions

Leo Villareal: Volume, GERING & LÓPEZ GALLERY, New York, NY, 2011.

Leo Villareal: Animating Light, San José Museum of Art, CA, 2010–1; touring to Nevada Museum of Art, Reno, NV, 2011; Nerman Museum of Contemporary Art, Overland Park, KS, 2011; Telfair Museum of Art, Savannah, GA, 2012; and Madison Museum of Contemporary Art, WI, 2012.

Leo Villareal: Recent Works, Tampa Museum of Art, FL, 2010.

Leo Villareal: New Work, Conner Contemporary Art, Washington, DC, 2008.

Galería Javier López, Madrid, 2005.

Leo Villareal: Supercluster, MoMA PS1, Long Island City, NY, 2004.

Sandra Gering Gallery, New York, NY, 2002.

Selected Group Exhibitions

Altered States, Norton Museum of Art, West Palm Beach, FL, 2011.

Sensory Crossovers: Synesthesia in American Art, Albuquerque Museum of Art and History, NM, 2011.

That Was Then... This is Now, MoMA PS1, Long Island City, NY, 2008.

Digital Stories, Centro Galego de Arte Contemporánea (CGAC), Santiago, 2007.

All Digital, Museum of Contemporary Art Cleveland, OH, 2006.

Extreme Abstraction, Albright-Knox Art Gallery, Buffalo, NY, 2005.

Visual Music, Hirshhorn Museum and Sculpture Garden, Smithsonian Institution, Washington, DC, and the Museum of Contemporary Art (MOCA), Los Angeles, CA, 2005.

Fiction.Love Ultra New Vision in Contemporary Art, Museum of Contemporary Art, Taipei, 2004

Winter Light, Socrates Sculpture Park, Long Island City, NY, 2003.

Synth, White Columns, New York, NY, 2001.

Rooms for Listening, CCA Wattis Institute for Contemporary Arts, San Francisco, CA, 2000.

Selected Bibliography

Margo A. Crutchfield, *Leo Villareal: All Digital*, exh. cat., Museum of Contemporary Art Cleveland, OH, 2006.

Leo Villareal, exh. cat., Hatje Cantz Verlag, Ostfildern, San Jose Museum of Art, CA, 2010. Texts by Sarah Douglas Hart, Stephen B. Johnson, Joanne Northrup, Michael Rush and Mark Van Proyen.

b. 1939, Globe, AZ, USA.
Lives and works in Santa Fe, NM, USA.

Selected Solo Exhibitions

FRAC Lorraine, Metz, 2012.

"Upside Down": Les Arctiques (exhibition design & installation), Musée du Quai Branly, Paris , 2008; touring to The Menril Collection, Houston, TX, 2011.

RM669 (installation), The Museum of Contemporary Art (MOCA), Los Angeles, CA, 1984.

MLJ81 (installation), Centro internazionale di Sperimentazioni artistiche 'Marie-Louise Jeanneret', Boissano, 1981.

Salvatore Ala Gallery, Milan, 1975.

Luminiferous Space, artist's studio, Venice, CA, 1971.

Douglas Wheeler: Licht-Bilder, Galerie Schmela, Düsseldorf, 1970.

Ace Gallery, Venice, CA, 1969.

Pasadena Art Museum (now Norton Simon Museum of Art), CA, 1968.

Selected Group Exhibitions

Phenomenal: California Light, Space, Surface, Museum of Contemporary Art San Diego, CA, 2011–2.

Time & Place: Los Angeles 1957–1968, Moderna Museet, Stockholm, 2008–9; touring to Kunsthaus Zürich (as *Hot Spots: Rio de Janeiro/Milano – Torino/Los Angeles 1956–1969*), 2009.

Sitings: Installation Art 1969–2002, MOCA, Los Angeles, CA, 2003–4.

Singular Forms (Sometimes Repeated): Art from 1951 to the Present, Solomon R. Guggenheim Museum, New York, NY, 2004..

Beyond Geometry: Experiments in Form, Los Angeles County Museum of Art (LACMA), CA, 2004.

Sunshine & Noir, Art in Los Angeles 1960–1997, Louisiana Museum of Modern Art, Humlebæk, 1997; touring to Kunstmuseum Wolfsburg, 1998; Castello di Rivoli – Museo d'Arte Contemporaneo, Turin, 1998; and Armand Hammer Museum of Art and Culture Center (now Hammer Museum), Los Angeles, CA, 1998.

Individuals: A Selected History of Contemporary Art, 1945–1986, MOCA, Los Angeles, CA, 1986.

Painting and Sculpture in California: The Modern Era, San Francisco Museum of Art, CA, 1976; touring to National Collection of Fine Arts, Washington, DC, 1977.

Ambiente/Arte dal futurismo alla body art, United States Pavillion, 37th Venice Biennale, 1976.

Larry Bell, Robert Irwin, Doug Wheeler, Tate Gallery, London, 1970.

Kompas IV: West Coast U.S.A., Stedelijk Museum, Amsterdam; Stedelijk van Abbemuseum, Eindhoven, 1969.

Robert Irwin/Doug Wheeler, Fort Worth Community Art Center Museum, TX, 1969.

Selected Bibliography

John Coplans, *Doug Wheeler*, exh. cat., Pasadena Art Museum, CA, 1968.

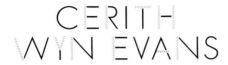

CERITH WYN EVANS

b. 1958, Llanelli, Wales, UK.
Lives and works in London, UK.

Selected Solo Exhibitions

De La Warr Pavilion, Bexhill-on-Sea, 2012.

Bergen Kunsthall, 2011.

A=P=P=A=R=I=T=I=O=N (with Throbbing Gristle), Tramway, Glasgow, 2009.

Inverleith House, Edinburgh, 2009.

...visibleinvisible, Museo de Arte Contemporáneo de Castilla y León (MUSAC), 2008.

...in which something happens all over again for the very first time, ARC, Musée d´Art Moderne de la Ville de Paris, 2006; touring to Stadtische Galerie im Lenbachhaus und Kunstbau München, 2006–7.

Cerith Wyn Evans: take my eyes and through them see you, Institute of Contemporary Arts (ICA), London, 2006.

Cerith Wyn Evans: Thoughts unsaid, now forgotten, MIT List Visual Arts Center, Cambridge, MA, 2004.

Art Now, Tate Britain, London, 2000.

Deitch Projects, New York, NY, 1997.

...And Then I 'Woke Up, London Filmmakers Co-op, London, 1980.

Selected Group Exhibitions

Neon: Who's afraid of red, yellow and blue?, La maison rouge – fondation antaine de galbert, Paris, 2012.

Rewriting Worlds, 4th Moscow Biennale of Contemporary Art, 2011.

Secret Societies: To Know, To Dare, To Will, To Keep Silence, Schirn Kunsthalle Frankfurt, 2011; touring to musée d'art contemporain de Bordeaux (CAPC), 2011–2.

Contemplating the Void: Interventions in the Guggenheim Museum, Solomon R. Guggenheim Museum, New York, NY, 2010.

In the Between, 11th Istanbul Biennial, 2009.

How to Improve the World, Hayward Gallery, London, 2006.

Tate Triennial 2006: New British Art, Tate Britain, London, 2006.

Utopia Station, 50th Venice Biennale, 2003; touring to Haus der Kunst, Munich, 2003–4.

Documenta XI, Kassel, 2002.

British Art Show 5, touring to various venues in Edinburgh, Southampton, Cardiff and Birmingham, 2000.

Material Culture, Hayward Gallery, London, 1997.

Life/Live, Musée d'Art Moderne de la Ville de Paris; touring to Centro Cultural de Belém, Lisbon, 1996.

Image and Object in Current British Art, Le Centre Pompidou, Paris, 1990.

The New Art, Tate Gallery, London, 1983.

Selected Bibliography

Cerith Wyn Evans:...visibleinvisible, exh. cat., Hatje Cantz Verlag, Ostfildern, 2008. Texts by Daniel Birnbaum and Octavio Zaya.

Cerith Wyn Evans: Bubble Peddler, exh. cat., Kunsthaus Graz, Buchhandlung Walther König, Cologne, 2007. Texts by Adam Budak, Mark Cousins, Jonathan Crary, Martin Prinzhorn and Jan Verwoert.

Cerith Wyn Evans: In Which Something Happens All Over Again For The Very First Time, exh. cat., Lenbachhaus München, Buchhandlung Walther König, Cologne, 2006. Texts by Susanne Gaensheimer and Molly Nesbit.

Cerith Wyn Evans: "Cerith Wyn Evans", exh. cat., Frankfurter Kunstverein, Lukas & Sternberg, New York, NY, 2004. Texts by Juliane Rebentisch, Andreas Spiegl and Jan Verwoert.

Thoughts unsaid, now forgotten..., exh. cat., MIT List Visual Art Center, Cambridge, MA, 2004. Text by Bill Arning.

Jennifer Higgie, *Cerith Wyn Evans*, exh. cat., Camden Arts Centre, London, 2004.

Cerith Wyn Evans: In Girum Imus Nocte et Consumimur Igni, exh. cat., Centre for Contemporary Art Kitakyushu, Korinsha Press, Kyoto, 1998.

LIST OF ILLUSTRATED WORKS

The publisher has made every effort to contact all copyright holders. If proper acknowledgement has not been made, we ask copyright holders to contact the publisher. All works of art are © the artist unless otherwise stated. Likewise, all images are courtesy the artist unless otherwise stated.

Frontispiece

Doug Wheeler, *Untitled*, 1969; sprayed lacquer on vacuum-formed Plexiglas and white UV neon light ; 232.5 x 232.5 x 5.7 cm. Image courtesy David Zwirner, New York.

Light Art: An Immaterial Material, Cliff Lauson

p. 16, James Turrell, *Shanta, Red*, 1968; projection work; dimensions variable. Image from private collection, courtesy Michael Hue-Williams.

p. 17, Lucio Fontana, *Luce spaziale*, 1951. Installation view, Honor Staircase, IX Triennale di Milano. © Lucio Fontana/SIAE/DACS, London 2012. Image courtesy Archivio Fotografico © La Triennale di Milano. Photo: Aragozzini.

p. 19, Dan Flavin, *untitled (to you, Heiner, with admiration and affection)*, 1973; green fluorescent light; modular units, each 122 x 122 cm, length variable; CL no 333. © 2012 Stephen Flavin/Artists Rights Society (ARS), New York and DACS, London. Image courtesy David Zwirner, New York.

p. 25, Olafur Eliasson, *Your rainbow panorama*, 2006–11. Installation view, ARoS Århus Kunstmuseum. Image courtesy Studio Olafur Eliasson.

p. 26, Bruce Nauman, *Manipulating a Fluorescent Tube*, 1969; black-and-white video; 62 minutes. Video still. © 2012 Bruce Nauman/Artists Rights Society (ARS), New York and DACS, London. Image courtesy Electronic Arts Intermix (EAI), New York.

p. 29, Frontispiece from Jules Verne, *The Green Ray*, Pierre-Jules Hetzel, Paris, 1882. Image courtesy Photos 12/Alamy.

Vision Made Visible, Anne Wagner

p. 32, László Moholy-Nagy, *Untitled*, 1925; gelatin silver print (photogram); 33.4 x 26.6 cm. © Hattula Moholy-Nagy/DACS 2012. Image © 2012. Digital image, The Museum of Modern Art, New York/Scala, Florence.

p. 33, László Moholy-Nagy, *Light-Space-Modulator*, 1922–30 (reconstruction 1970); chrome-plated steel, aluminium, Plexiglas and wood. Installation view, Bauhaus-Archiv, Berlin, 1973. © Hattula Moholy-Nagy/DACS 2012. Image courtesy akg-images/ullstein bild.

p. 35, Nancy Holt, *Vision*. From Lucy Lippard, *c.7,500*, 1973. Image courtesy Haunch of Venison, London. Licensed by DACS, London.

p. 36 t, Nancy Holt, *Holes of Light*, 1973; 650W quartz lights, polyurethane board and pencil; 4.3 x 8.2 x 6.1 m. Installation view, LoGiudice Gallery, New York. Image courtesy Haunch of Venison, London. Photo: Richard Landry. Licensed by DACS, London.

p. 36 b, Nancy Holt, *Holes of Light*, 1973 (detail); 650W quartz lights, polyurethane board and pencil; 4.3 x 8.2 x 6.1 m. Installation view, LoGiudice Gallery, New York. Image courtesy Haunch of Venison, London. Photo: Richard Landry. Licensed by DACS, London.

p. 38, Philippe Parreno, *Marquee, Guggenheim, NY*, 2008; acrylic, steel, LEDs, and incandescent, fluorescent, and neon lights; front section: 503.6 x 489 x 58.4 cm; back section: 479.4 x 364.5 x 40.6 cm. Installation view, Solomon R. Guggenheim Museum, New York. Image courtesy the artist and The Solomon R. Guggenheim Foundation, New York. Photo: Kristopher McKay.

p. 39, Anthony McCall, *Line Describing a Cone*, 1973; 16mm film and projector; dimensions variable, one cycle: 30 minutes. Installation view (during the 24th minute), Musée départemental d'art contemporain Rochechouart, 2007. Image courtesy the artist and Sprüth Magers Berlin London. Photo: Freddy le Saux.

p. 40, Olafur Eliasson, *The weather project*, 2003; monofrequency lights, projection foil, haze machines, mirror foil, aluminium and scaffolding; 26.7 x 22.3 x 155.4 m. Installation view, Turbine Hall, Tate Modern, London. Image courtesy Studio Olafur Eliasson. Photo: Jens Ziehe.

From Symbol to Substance: The Technologies of Light, Philip Ball

p. 42, Additive (left) and subtractive (right) methods of colour combination. Image courtesy Universal Images Group Limited/Alamy.

p. 43, J.M.W. Turner, *Light and Colour (Goethe's Theory) – the Morning after the Deluge – Moses Writing the Book of Genesis*, 1843; oil on canvas; 78.7 x 78.7 cm. Image © Tate, London, 2012.

p. 44, Diagram showing the electromagnetic spectrum. Frequency (in metres) is shown along the top of the diagram, with visible light indicated by bands on the spectrum at centre-right. Image courtesy Equinox Graphics/Science Photo Library.

p. 47 t, A carbon filament lamp of the type invented by Thomas Alva Edison, 1879. Image © Science Museum/Science & Society Picture Library.

p. 47 b, Katie Paterson, *Light bulb to Simulate Moonlight*, 2008. Bulbs in production, OSRAM factory, Nové Zámky. Photo © MJC.

p. 48, Working Geissler tube, c. 1988. Image © Science Museum/Science & Society Picture Library.

p. 49, Blue-coloured LEDs, 2012. Image courtesy Shutterstock.

p. 50, Flexible organic LED (OLED) lighting. Developed by Holst Centre, Eindhoven

David Batchelor

p. 52, *Magic Hour*, 2004/7; found steel and aluminium lightboxes, found steel supports, acrylic sheet, fluorescent lights, cable and plugboards; 308 x 276 x 50 cm. Photo: David Batchelor.

p. 53, *Slugfest 2*, 2012; found steel and aluminium objects, and neon; dimensions variable. Photo: David Batchelor.

pp. 54–5, *Barrier (front and back)*, 2003; found steel and aluminium lightboxes, found steel supports, acrylic sheet, fluorescent lights, cable and plugboards; 285 x 267 x 25 cm. Installation view, 38 Langham Street, London. Photo: David Batchelor.

p. 56, *Spectrum of Brick Lane*, 2003; found steel and aluminium lightboxes, found steel supports, acrylic sheet, fluorescent lights, cable and plugboards; 1,510 x 91 x 30 cm. Installation view, *Days Like These*, Tate Britain Triennial of Contemporary Art, London. Floor work: Jim Lambie, *Zobop*, 1999–2003; © the artist, courtesy Sadie Coles HQ, London. Image © Tate, London.

p. 57, *Eyemobile*, 2008; plastic sunglasses, anglepoise lamp, motor, bracket and plinth; 185 x 30 x 78 cm. Photo: David Batchelor.

p. 58, *Idiot Stick 1*, 2000; plastic bottles and fluorescent light; 183 x 10 x 8 cm. Photo: David Batchelor.

Jim Campbell

p. 59 t + b, *Exploded View (Commuters)*, 2011; 1,152 LEDs, custom electronics, wire and steel; 182.9 x 116.8 x 96.5 cm. Image courtesy Sarah Christianson.

pp. 60–1, *Exploded View (Commuters)*, 2011 (detail); 1,152 LEDs, custom electronics, wire and steel; 182.9 x 116.8 x 96.5 cm. Image courtesy Sarah Christianson.

p. 63 t to b, *Motion and Rest 1*, 2001; 768 LEDs and custom electronics; 73.7 x 55.9 cm. *Motion and Rest 5*, 2002; 768 LEDs and custom electronics; 73.7 x 55.9 cm. *Motion and Rest 2*, 2002; 768 LEDs and custom electronics; 73.7 x 55.9 cm.

p. 64 t + b, *Exploded Views*, 2011; 2,880 LEDs, custom electronics, wire and steel; 4.9 x 6.1 x 3.4 m. Installation view, San Francisco Museum of Modern Art (SFMoMA). Image courtesy Sarah Christianson.

Carlos Cruz-Diez

pp. 66–7, *Chromosaturation*, 2008. Installation view, *Carlos Cruz-Diez: (In) Formed by Color*, Americas Society's Art Gallery, New York. Image courtesy Atelier Cruz-Diez Paris.

p. 68 t, *Performance 'Chromatiques'*, 2011. Museum of Fine Arts (MFAH), Houston, TX. Image courtesy Atelier Cruz-Diez Paris.

p. 68 b, *Performance Chromatique*, 2008. Installation view, *Color! - Die Farbe in der Konkreten Kunst*, Galerie Konkret Martin Wörn, Sulzburg. Image courtesy Atelier Cruz-Diez Paris.

p. 69, *Chromosaturation*, 2010. Installation view, *Suprasensorial: Experiments in Light, Color, and Space*, The Museum of Contemporary Art (MOCA), Los Angeles. Image courtesy Atelier Cruz-Diez Paris.

p. 70, *Cromoprisma aleatorio*, 1975; translucid Plexiglas, dichroic reflectors, movement sensors and approach sensors; 300 x 60 x 60 cm. Installation view, *Cruz-Diez: El artista y la ciudad*, Palacio de la Gobernación del Distrito Federal (Federal District Government Palace), Caracas. Image courtesy Atelier Cruz-Diez Paris.

Bill Culbert

p. 71, *Bulb Box Reflection II*, 1975; wooden box, mirror glass, lightbulb and electrical cable; 33 x 32 x 31 cm. Image © Bill Culbert and Laurent Delaye Gallery. Photo: Matthew Hollow.

p. 72 t to b, *Light Field Blaze (Carpet), phase I*, 1968; fabric mesh, lightbulbs, electrical cable, timer and switch; 274 x 274 cm. *Light Field Blaze (Carpet), phase II*, 1968; fabric mesh, lightbulbs, electrical cable, timer and switch; 274 x 274 cm. *Light Field Blaze (Carpet), phase III*, 1968; fabric mesh, lightbulbs, electrical cable, timer and switch; 274 x 274 cm. Image © Bill Culbert and Laurent Delaye Gallery.

p. 73, *Small Glass Pouring Light*, 1979; black-and-white photograph; 19 x 19 cm. Image © Bill Culbert and Laurent Delaye Gallery.

p. 74, *Outline*, 1970; perspex, lightbulbs and electrical cable; 30 x 30 x 30 cm. Installation view, Serpentine Gallery, London, 1976–7. Image © Bill Culbert and Laurent Delaye Gallery.

p. 75, *An Explanation of light*, 1984; fluorescent tubes, glazed 'French' doors and electrical cable; whole: 240 x 240 cm; tubes: 61 x 240 cm. Installation view, Serpentine Gallery, London. Image © Bill Culbert and Laurent Delaye Gallery.

p. 76, *Pacific Flotsam*, 2007 (detail); plastic containers, fluorescent tubes and electrical cable; 500 x 900 cm. Installation view, Govett-Brewster Art Gallery, New Plymouth, 2008. Image © Bill Culbert and Govett-Brewster Art Gallery. Photo: Bryan James.

Olafur Eliasson

p. 77, *Model for a timeless garden*, 2011; water, pumps, nozzles, stainless steel, wood, foam, plastic, strobe lights, wall mounts and control unit; 160 x 970 x 100 cm. Installation view, Pinchuk Art Centre, Kiev, 2011. Image courtesy Studio Olafur Eliasson. Photo: Dimitry Baranov.

p. 78, *Beauty*, 1993; spotlight, water, nozzles, wood, hose and pump; dimensions variable. Installation view, *Minding the world*, Århus Kunstmuseum, 2004. Image courtesy Studio Olafur Eliasson. Photo: Poul Pedersen.

p. 79 t, *360° room for all colours*, 2002; stainless steel, projection foil, fluorescent lights, wood and control unit; height: 320 cm; diameter: 815 cm. Installation view, San Francisco Museum of Modern Art, 2007. Image courtesy Studio Olafur Eliasson and the San Francisco Museum of Modern Art. Photo: Ian Reeves.

p. 79 b, *360° room for all colours*, 2002; stainless steel, projection foil, fluorescent lights, wood and control unit; height: 320 cm; diameter: 815 cm. Installation view, Musée d'Art Moderne de la Ville de Paris, 2002. Image courtesy Studio Olafur Eliasson. Photo: Bertrand Huet.

pp. 80–1, *Room for one colour*, 1997; monofrequency lights; dimensions variable. Installation view, *The light setup*, Malmö Konsthall, 2005. Image courtesy Studio Olafur Eliasson. Photo: Jens Ziehe.

p. 82, *The weather project*, 2003; monofrequency lights, projection foil, haze machines, mirror foil, aluminium and scaffolding; 26.7 x 22.3 x 155.4 m. Installation view, Turbine Hall, Tate Modern, London. Image courtesy Studio Olafur Eliasson. Photo: Jens Ziehe.

Peter Fischli/David Weiss

p. 83, *Ohne Titel (Fragenprojektion)*, 1981–2001; 1,215 slides, 15 projectors and eight dissolve units; dimensions variable. Image courtesy Sprüth Magers Berlin London, Galerie Eva Presenhuber Zürich, Matthew Marks Gallery New York.

p. 84, *Son et Lumière (Le Rayon Vert)*, 1990; installation with kinetic object: torch, rotating plate, finned plastic mould and tape; approx. 40 x 80 x 50 cm. Image courtesy Sprüth Magers Berlin London, Galerie Eva Presenhuber Zürich, Matthew Marks Gallery New York.

p. 85 (all), *Surrli*, 1986/1998; 162 slides, two slide projectors and two dissolve units; dimensions variable. Image courtesy Sprüth Magers Berlin London, Galerie Eva Presenhuber Zürich, Matthew Marks Gallery New York.

p. 86, *Ohne Titel (Surrli)*, 1989. Production still. Image courtesy Sprüth Magers Berlin London, Galerie Eva Presenhuber Zürich, Matthew Marks Gallery New York.

Dan Flavin

p. 87, *the nominal three (to William of Ockham)*, 1963; daylight fluorescent light; height: 244 cm; CL no. 26. © 2012 Stephen Flavin/Artists Rights Society (ARS), New York and DACS London. Image courtesy of David Zwirner, New York. Photo: Cathy Carver.

p. 89, *untitled (to the "innovator" of Wheeling Peachblow)*, 1966–8; daylight, yellow, and pink fluorescent light; 244 cm square across a corner; CL no 121. © 2012 Stephen Flavin/Artists Rights Society (ARS), New York and DACS London. Image courtesy of David Zwirner, New York. Photo: Billy Jim, New York.

pp. 90–1, *untitled (to S.M. with all the admiration and love which I can sense and summon)*, 1969; red, yellow, pink, and blue fluorescent light; eight modular units, each 244 x 244 cm square, in a corridor measuring 290 x 244 x 1,953 cm; CL no. 236. © 2012 Stephen Flavin/Artists Rights Society (ARS), New York and DACS London. Image courtesy of David Zwirner, New York.

p. 92, *untitled (to Tracy, to celebrate the love of a lifetime)*, 1992; pink, green, blue, yellow, daylight, red and ultraviolet fluorescent light; dimensions variable; CL no. 640. Installation view, Solomon R. Guggenheim Museum, New York. © 2012 Stephen Flavin/Artists Rights Society (ARS), New York and DACS London. Photo: David Heald © SRGF, NY.

Ceal Floyer

p. 93, *Throw*, 1997; profile-spot theatre lamp and commercial-made gobo reference no. 8136 'splodge'; dimensions variable. Courtesy the artist and Lisson Gallery, London & Esther Schipper, Berlin & 303 Gallery, New York. Photo © Carsten Eisfeld, 2008.

pp. 94–5, *Double Act*, 2006; light projection, photographic gobo and theatre lamp; dimensions variable. Installation view, DHC/ART, Montreal, 2011. Courtesy the artist and Lisson Gallery, London & Esther Schipper, Berlin & 303 Gallery, New York. Photo: Richard Max Tremblay.

p. 96, *Door*, 1995; 35mm slide and projector; dimensions variable. Installation view, DHC/ART, Montreal, 2011. Courtesy the artist and Lisson Gallery, London & Esther Schipper, Berlin & 303 Gallery, New York. Photo: Stefan Altenburger.

p. 97 t, *Overhead Projection*, 2006; incandescent lightbulb and overhead projector; dimensions variable. Installation view, VCUarts Anderson Gallery, Richmond, Virginia. Courtesy the artist and Lisson Gallery, London & Esther Schipper, Berlin & 303 Gallery, New York. Photo: Travis Fullerton.

p. 97 b, *Day for Night*, 2001; two desk lamps, two bulbs with filters, wood and metal; dimensions variable. Courtesy the artist and Lisson Gallery, London & Esther Schipper, Berlin & 303 Gallery, New York.

p. 98, *Light Switch*, 1992–9; 35mm slide projection; dimensions variable. Courtesy the artist and Lisson Gallery, London & Esther Schipper, Berlin & 303 Gallery, New York.

Nancy Holt

p. 99, *Holes of Light*, 1973; 650W quartz lights, polyurethane board and pencil; 4.3 x 8.2 x 6.1 m. Installation view, LoGiudice Gallery, New York. Image courtesy Haunch of Venison, London. Photo: Richard Landry. Licensed by DACS, London.

pp. 100–1, *Mirrors of Light I*, 1974; mirrors and spotlight; 3.4 x 8.5 x 6.1 m. Installation view, Bykert Gallery, New York. Image courtesy Haunch of Venison, London. Licensed by DACS, London.

p. 102, *Electrical System II: Bellman Circuit*, 1982; 1.9 cm steel conduit, sockets and lightbulbs; 16.8 x 7.3 x 2.9 m. Installation view, David Bellman Gallery, Toronto. Image courtesy Haunch of Venison, London. Licensed by DACS, London.

p. 103 t + b, *Sun Tunnels*, 1973–6; concrete, steel and earth; 2.8 x 20.9 x 16.2 m. Photographed in 1976. Image courtesy Haunch of Venison, London. Licensed by DACS, London.

p. 104 t to b, *Light and Shadow Photo-Drawing (13)*, 1978 (printed 2012); inkjet print on archival rag paper taken from original 35mm slides; 49.5 x 76.2. Image courtesy Haunch of Venison, London. Licensed by DACS, London.

Light and Shadow Photo-Drawing (18), 1978 (printed 2012); inkjet print on archival rag paper taken from original 35mm slides; 49.5 x 76.2. Image courtesy Haunch of Venison, London. Licensed by DACS, London.

Light and Shadow Photo-Drawing (22), 1978 (printed 2012); inkjet print on archival rag paper taken from original 35mm slides; 49.5 x 76.2. Image courtesy Haunch of Venison, London. Licensed by DACS, London.

Jenny Holzer

p. 105 t, *Xenon for Venice*, 1999 (text: *Blue*, 1998); light projection, Giorgio Cini Foundation, Venice. © ARS, NY and DACS, London 2012. Photo: Attilio Maranzano.

p. 105 b, *Xenon for Paris*, 2001 (text: *War*, 1992; *Truisms*, 1977–9; *Mother and Child*, 1990); light projection, Louvre Pyramid, Napoleon Courtyard, Paris. © ARS, NY and DACS, London 2012. Photo: Attilio Maranzano.

p. 106, *MONUMENT*, 2008 (text: *U.S. government documents*); 18 LED signs with blue, red and white diodes; 402.1 x 146.6 x 73.3 cm. Installation view, *ENDGAME*, Sprüth Magers, Berlin, 2012. © ARS, NY and DACS, London 2012. Photo: Jens Ziehe.

p. 107, *from Survival (1983–5)*, 1985; electronic sign; 6.1 x 12.2 m. Installation view, *Selection from the Survival Series*, Times Square, New York, 1985. © ARS, NY and DACS, London 2012. Photo: John Marchael.

p. 108, *The Venice Installation: The Last Room*, 1990 (detail), (text: *Truisms*, 1977–9; *Inflammatory Essays*, 1979–82; *Living*, 1980–2; *Survival*, 1983–5; *Under a Rock*, 1986; *Laments*, 1989; *Mother and Child*, 1990); Rosso Magnaboschi marble floor and 11 LED signs with green, red and yellow diodes; floor: 991.2 x 645.8 cm, LED signs, each: 24.1 x 447 x 11.4 cm. Installation view, United States Pavilion, 44th Venice Biennale, 1990. © ARS, NY and DACS, London 2012. Photo: Salvatore Licitra.

Ann Veronica Janssens

p. 109, *Rose*, 2007; seven beams of light and artificial haze; 360 x 250 cm. Image © Luciano Romano - Galeria Alfonso Artiaco.

pp. 110–11, *blue, red and yellow*, 2001; volume with transparent coloured sides, filled with artificial mist; 900 x 450 x 340 cm. Image © P. Mercé - EACC.

p. 112, *white yellow green study*, 2006; two projectors and artificial haze; dimensions variable. Installation view, Artspace, Auckland. Image courtesy Artspace, Auckland. Photo © Jennifer French.

p. 113 t, *Skyblue & Yellow*, 2005; halogen lamps and dichroic filters; dimensions variable. Image courtesy Galerie Micheline Szwajcer. Photo © Ph + De Gobert.

p. 113 b, *White yellow study*, 2005; two projectors and artificial haze; dimensions variable. Image courtesy Gallery Esther Schipper.

Brigitte Kowanz

p. 115, *Lux*, 1998; halogen light, mirror, glass and iron; three parts, each: 220 x 50 x 2 cm. Photo: Ulrich Ghezzi.

p. 116 t, *Spatium*, 2006 (left); neon and acrylic glass; 100 x 120 x 100 cm, *Volume*, 2007 (right); neon and acrylic glass; 80 x 140 x 130 cm. Installation view, Kunsthalle Krems, 2007. Photo: Karl Kainz.

p. 116 b, *Luminary Elevation*, 1999; RGB lamps, acrylic glass, iron and electronic control system; whole: 20.1 m; base: 2.4 m. Installation, Lünerseepark Shopping Centre, Bürs. Photo: Ignacio Martinez.

p. 117, *Light Steps*, 1990/2013; fluorescent tube lamps; dimensions variable. Installation view, Galerie Zumtobel, Vienna. Photo: Matthias Hermann.

p. 118 t, *Arise*, 2008; neon and mirror; 70 x 70 x 70 cm. Photo: Wolfgang Woessner.

p. 118 m, *Dedicated*, 2007; neon and mirror; 124 x 183 x 124 cm. Photo: Wolfgang Woessner.

p. 118 b, *Aura*, 2005; neon and acrylic glass; 100 x 100 x 100 cm. Photo: Wolfgang Woessner.

p. 119, *Colourbars*, 2000; fluorescent tube lamps and coloured glass; 270 x 380 x 300 cm. Installation view, foyer, ARD-Hauptstadtstudio, Berlin. Photo: Stefan Müller.

p. 120, *The Endless Fold*, 2007; neon, acrylic glass, wood and foils; 120 x 380 x 290 cm. Installation view, Österreichsche Galerie Belvedere, Vienna. Photo: Wolfgang Woessner.

Anthony McCall

p. 122 t + b, *You and I, Horizontal*, 2005; computer, QuickTime movie file, video projector and haze machine; dimensions variable, one cycle: thirty minutes. Installation view, Institut d'Art Contemporain, Villeurbanne, 2006. Image courtesy the artist and Sprüth Magers Berlin London. Photo: Blaise Adilon.

p. 123, *You and I, Horizontal*, 2005; computer, QuickTime movie file, video projector and haze machine; dimensions variable, one cycle: thirty minutes. Footprints in sequence at 125 second intervals, representing one cycle of six. Image courtesy the artist and Sprüth Magers Berlin London.

p. 124 t to b, *Doubling Back*, 2003; computer, QuickTime movie file, video projector and haze machine; dimensions variable. Installation view, 2004 Whitney Biennial, Whitney Museum of American Art, New York. Photograph taken at 2 minutes 30 seconds, within a thirty minute cycle. Image courtesy the artist and Sprüth Magers Berlin London. Photo: Hank Graber.

Doubling Back, 2003; computer, QuickTime movie file, video projector and haze machine; dimensions variable. Installation view, 2004 Whitney Biennial, Whitney Museum of American Art, New York. Photograph taken at 7 minutes 30 seconds, within a thirty minute cycle. Image courtesy the artist and Sprüth Magers Berlin London. Photo: Hank Graber.

Doubling Back, 2003; computer, QuickTime movie file, video projector and haze machine; dimensions variable. Installation view, 2004 Whitney Biennial, Whitney Museum of American Art, New York. Photograph taken at 11 minutes 30 seconds, within a thirty minute cycle. Image courtesy the artist and Sprüth Magers Berlin London. Photo: Hank Graber.

p.125, Installation view, *Anthony McCall: Five Minutes of Pure Sculpture*, Nationalgalerie im Hamburger Bahnhof, Berlin, 2012. Image courtesy Sean Gallup/Getty Images Entertainment/Getty Images.

p.126, *Landscape for Fire*, 1972; performance; dimensions variable. Performance view, North Weald, London. Image courtesy the artist and Sprüth Magers Berlin London. Photo: Carolee Schneemann.

François Morellet

p.127, *Acrobatie n°1*, 2010; blue and red neon tubes and transformers; 268 x 279 cm.

pp.128–9, *L'Avalanche*, 1996/2006; 36 blue neon tubes and electric cables; 370 x 770 x 660 cm. Installation view, Musée National d'Art Moderne – Le Centre Pompidou, Paris, 2011.

p.130, *Lamentable*, 2006; eight white neon tubes and two transformers; dimensions variable. Installation view, Couvent de la Tourette, Eveux, 2009.

p.132 t + b, *2 trames de tirets 0°–90° avec participation du spectateur*, 1971; white neon tubes and push buttons; dimensions variable. Installation view, Musée National d'Art Moderne – Le Centre Pompidou, Paris, 2011.

Iván Navarro

p.133, *Reality Show (Silver)*, 2010; LED, aluminium door frames, mirrors, one-way mirrors, wood and electric energy; 234 x 114.5 x 114.5 cm. Image courtesy the artist and Paul Kasmin Gallery. Photo: Thelma Garcia.

p.134, *Burden (Lotte World Tower)*, 2011; edition of three, plus one artist's proof; neon, wood, paint, Plexiglas, mirror, one-way mirror and electric energy; 172.1 x 106.7 x 16.5 cm. Image courtesy the artist and Paul Kasmin Gallery. Photo: Thelma Garcia.

p.135 t, *Death Row*, 2006–9; neon, aluminium, mirror, one-way mirror and electrical energy; doors, each 218.4 x 91.4 x 11.4 cm. Installation view, 53rd Venice Biennale, Chilean Pavilion, 2009. Image courtesy the artist and Paul Kasmin Gallery. Photo: Sebastiano Luciano.

p.135 l, *Nowhere Man I*, 2009; edition of three; fluorescent light, fixtures on the wall and electric energy; 226.1 x 195.6 x 8.9 cm. Image courtesy the artist and Paul Kasmin Gallery. Photos: Thelma Garcia and Ivan Navarro.

p.135 r, *Nowhere Man VI*, 2009; edition of three; fluorescent light, fixtures on the wall and electric energy; 226.1 x 195.6 x 8.9 cm. Image courtesy the artist and Paul Kasmin Gallery. Photos: Thelma Garcia and Ivan Navarro.

p.136, *The Border*, 2007; lightbulbs, aluminium door, mirror, one-way mirror and electric energy; 218.4 x 91.4 x 11.4 cm. Image courtesy the artist and Paul Kasmin Gallery. Photos: Bernard Huet.

p.137, *The Armory Fence*, 2011; neon, aluminium and electric energy; dimensions variable, each section: 154.9 x 226.1 x 30.5 cm. Image courtesy the artist and Paul Kasmin Gallery. Photo: David Cendros.

p.138, *Ecco (Brick)*, 2012; edition of two; neon lights, bricks, paint, Plexiglas, mirror, one-way mirror and electric energy; 90.2 x 189.2 cm. Image courtesy the artist and Paul Kasmin Gallery. Photo: Thelma Garcia.

Philippe Parreno

p.139, *L'Article des Lucioles*, 1993; LEDs and electrical system; dimensions variable. Installation view, *Le Principe de réalité*, Villa Arson, Nice.

pp.140–1, an adaptation of *Orange Bay (After Gabriel Tarde's Fragment of Future History)*, 2002, and *Speech Bubbles*, 1997. Installation view, Museum of Modern Art Ireland (IMMA), Dublin, 2009. Image courtesy Esther Schipper, Berlin. Photo © the artist and Irish Museum of Modern Art.

p.142, *Marquee*, 2011; transparent acrylic glass, six neon tubes, 68 lightbulbs (60W), converters, controller and cables; 20 x 165 x 90 cm.

p.143, *Marquee, Guggenheim, NY*, 2008; acrylic, steel, LEDs and incandescent, fluorescent, and neon lights; front section: 503.6 x 489 x 58.4 cm; back section: 479.4 x 364.49 x 40.6 cm. Installation view, Solomon R. Guggenheim Museum, New York. Image courtesy the artist and The Solomon R. Guggenheim Foundation, New York. Photo: Kristopher McKay.

p.144 t, *Skin of Light*, 2001 (with Pierre Huyghe); neon and electrical system; 80 x 58 x 1.4 cm. Installation view, *No Ghost, Just a Shell*, collection Rosa and Carlos de la Cruz, Miami, 2005.

p.144 b, *Happy Ending, Stockholm*, 1995–7; glass, electrical system and lightbulb; glass: 51.5 x 21.5 x 27.5 cm. Installation view, Air de Paris, Paris, 1997.

Katie Paterson

p.145, *Light bulb to Simulate Moonlight*, 2008 (detail); lightbulb with halogen filament and frosted coloured shell (28W, 4,500k); dimensions variable. Installation view, Ingleby Gallery, Edinburgh, 2011. Image courtesy Ingleby Gallery, Edinburgh.

p.146, *Light bulb to Simulate Moonlight*, 2008 (detail); lightbulb with halogen filament and frosted coloured shell (28W, 4,500k); dimensions variable. Installation view, Haunch of Venison, London, 2010. Image courtesy Haunch of Venison, London.

p.147 t + b, *Streetlight Storm*, 2010; lightning detector, electronics and lightbulbs; dimensions variable. Installation view, Deal pier, 2009. Photo © MJC (top) and Ken Lennox (bottom).

pp.148–9, *All the Dead Stars*, 2009; laser-etched anodised aluminium; 200 x 300 cm. Photo © Katie Paterson.

p.150, *100 Billion Suns*, 2011; confetti cannon and 3,216 pieces of paper; dimensions variable. Installation view, 54th Venice Biennale. Photo © MJC

Conrad Shawcross

p.151, *Slow Arc Inside a Cube V*, 2011; edition of three, plus two artist's proofs; mechanical system, steel and light; 120 x 80 x 80 cm. Image courtesy the artist and Victoria Miro Gallery, London.

pp.152–3, *Slow Arc Inside a Cube IV*, 2009; edition of three, plus two artist's proofs; mechanical system, steel and light; 90 x 90 x 180 cm. Image courtesy the artist and Victoria Miro Gallery, London.

p.154 t + b, *Dark Heart*, 2007; stainless steel, aluminium, motors and lights; 700 x 700 cm. Installation view, Sudeley Castle, Gloucestershire. Image courtesy the artist and Victoria Miro Gallery, London.

p.155, *Loop System Quintet*, 2005; mechanical system, oak, steel and light; 17 x 17 x 3 m. Installation view, Victoria Miro Gallery, London. Image courtesy the artist and Victoria Miro Gallery, London.

p.156, *The Blind Aesthetic*, 2011; glass, steel, mechanical system and light; 250 x 220 x 230 cm. Image courtesy the artist and Victoria Miro Gallery, London.

James Turrell

p.157, *Afrum (White)*, 1966; projected light; dimensions variable. Image from Private Collection, courtesy of Michael-Hue Williams.

pp. 158–9, *Wedgework V*, 1974; fluorescent light, fibre optic; dimensions variable. Installation view, *James Turrell, Light Installations*, Yorkshire Sculpture Park, 2006–7. Image courtesy Abstract Select Ltd.

p. 160, *Bindu Shards*, 2010; mixed media; 421 × 653 × 607 cm. Image courtesy Florian Holzherr.

p. 161 t, *Grey Day*, 1997; light installation, a combination of blue and red light at a very low level; 10 × 8 × 3.7 m. Installation view, *JamesTurrell, Light Installations*, Yorkshire Sculpture Park, 2006–7. Image courtesy Abstract Select.

p. 161 b, *Floater 99*, 2001; lighting control system and LEDs; 6.1 × 3 m. Installation view, Zentrum für Internationale Lichtkunst Unna. Image courtesy Zentrum für Internationale Lichtkunst Unna. Photo: Werner Hannappel.

p. 162, *Air Mass*, 1993; skyspace. Installation view, Hayward Gallery, London. Image courtesy Hayward Library and Archive, Southbank Centre, London. Photo: John Riddy.

Leo Villareal

p. 163, *Diamond Sea*, 2007; white LEDs, mirror-finished steel, custom software and electrical hardware; 304.8 × 452.7 × 15.2 cm. Image courtesy the artist and GEHRING & LÓPEZ GALLERY, NY. Photo: James Ewing Photography.

p. 164 t, *Multiverse*, 2008; site-specific installation, LEDs, custom software and eletrical hardware; 61 m long. Image courtesy the artist and GEHRING & LÓPEZ GALLERY, NY. Photo: James Ewing Photography.

p. 164 b, *Cosmos*, 2012; white LEDs, custom software and electrical hardware; 20.6 × 13.5 m. Site-specific installation view, The Johnson Museum of Art, Cornell University, Ithaca. Image courtesy the artist and GEHRING & LÓPEZ GALLERY, NY. Photo: James Ewing Photography.

pp. 166–7, *Cylinder II*, 2012; white LEDs, mirror-finished stainless steel, steel, custom software and electrical hardware; 373.4 × 294.6 × 294.6. Image courtesy the artist and GEHRING & LÓPEZ GALLERY, NY. Photo: James Ewing Photography.

p. 168, *Big Bang*, 2008; LEDs, aluminium, custom software and electrical hardware; 149.9 × 149.9 × 20.3 cm. Image courtesy the artist and GEHRING & LÓPEZ GALLERY, NY. Photo: James Ewing Photography.

Doug Wheeler

p. 169, *RM 669*, 1969; sprayed lacquer on acrylic with white UV neon tubing; 233.7 × 233.7 × 16.5 cm. Installation view, The Museum of Contemporary Art (MOCA), Los Angeles, 1984. Image courtesy David Zwirner, New York.

p. 170, *Untitled*, 1969; sprayed lacquer on acrylic with argon neon tubing; 232.4 × 232.4 × 19.1 cm. Image courtesy David Zwirner, New York. Photo: Jens Frederiksen.

p. 171 t, *Untitled*, 1966; sprayed lacquer on Plexiglas with daylight neon tubing; 225.1 × 212.4 cm. Installation view, Pasadena Museum, 1968. Image courtesy David Zwirner, New York. Photo: Frank J. Thomas; courtesy of the Frank J. Thomas Archives.

p. 171 b, *49 Nord 6 Est 68 Ven 12 FL*, 2011–2; acrylic and epoxy paint, nylon scrim, white UV and Grolux neon tubing, and electronic dimming system; 478.7 × 881 × 1,392.6 cm. Installation view, Frac Lorraine, Metz, 2012. Image courtesy David Zwirner, New York. Photo: Didier Boy de la tour.

pp. 172–3, *SA MI 75 DZ NY 12*, 1975/2012; reinforced fibreglass, LED lights, high-intensity fluorescent lights, UV fluorescent lights, quartz halogen lights and DMX control; architecturally modified space, composed of two parts: room 1: 609.6 × 914.4 × 365.8 cm; room 2: 1,432.6 × 1,463 × 487.7 cm (total: 1,432.6 × 1,783.1 cm). Image courtesy David Zwirner, New York. Photo: Tim Nighswander/ IMAGING4ART.

p. 174, *49 Nord 6 Est POV Luminiferous Light Volume*, 2011–2; phosphorescent paint applied to existing architecture, and metal halide projectors; 370 × 610 × 915.6 cm. Installation view, Frac Lorraine, Metz, 2012. Image courtesy David Zwirner, New York. Photo: Didier Boy de la tour.

Cerith Wyn Evans

p. 175 l to r, (Left) Cerith Wyn Evans, *"Diary: How to improve the world (you will only make matters worse)" continued 1968, from 'M' writings '67–'72 by John Cage*, 2003; chandelier (Venini Quadratti), flat screen monitor, Morse code unit and computer; dimensions variable. (Middle) *'Things that Speak – The Glass Flowers' by Lorraine Daston*, 2007; chandelier (Luce Italia), flat screen monitor, Morse code unit and computer; dimensions variable, chandelier: 140 × 100 cm. (Right) *"Paranoid reading and reparative reading, or, you're so paranoid, you probably think this essay is about you", from 'Touching Feeling' by Eve Kosofsky Sedgwick*, 2003; chandelier (Galliano Ferro), flat screen monitor, Morse code unit and computer; dimensions variable, chandelier: 140 × 70 cm. Image courtesy White Cube. Photos: Stephen White (left and right); Todd-White Art Photography (centre).

p. 176–7, *S=U=P=E=R=S=T=R=U=C=T=U=R=E ('Trace me back to some loud, shallow, chill, underlying motive's overspill...')*, 2010; mixed media; dimensions variable. Installation view, *Cerith Wyn Evans: "Everyone's gone to the movies, now we're alone at last..."*, White Cube Mason's Yard, London, 2010. Image courtesy White Cube. Photo: Todd-White Art Photography.

p. 178 t, *'Talvinder, you'll never guess, It's the Pacific Ocean, again.'*, 2007; neon; 440 × 420 × 250 cm. Image courtesy White Cube. Photo: Stephen White.

p. 178 b, *Each body distributes...*, 2007; neon; 116 × 397 cm. Image courtesy White Cube. Photo: Stephen White.

p. 179, installation view, *Visibleinvisible*, Museo de Arte Contemporáneo de Castilla y León (MUSAC), 2008. Image courtesy MUSAC.

p. 180, *Cleave 03 (Transmission: Visions of the Sleeping Poet)*, 2003 (text by Ellis Wynne); World War II search light, shutter, computer and Morse code controlling device; dimensions variable. Image courtesy White Cube. Photo: Polly Braden.

Endpapers

p. 1, Dan Flavin, *the diagonal of May 25, 1963 (to Constantin Brancusi)*, 1963; yellow fluorescent light; 244 cm long on the diagonal; CL no 13. © 2012 Stephen Flavin/Artists Rights Society (ARS), New York and DACS London. Image courtesy of David Zwirner, New York. Photo: Billy Jim, New York.

pp. 2–3, Carlos Cruz-Diez, *Chromosaturation*, 2011. Installation view, *Carlos Cruz-Diez: Color in Space and Time*, The Museum of Fine Arts (MFAH), Houston. Image courtesy Atelier Cruz-Diez Paris.

pp. 4–5, Jenny Holzer, *For Chicago*, 2007 (Text: *Arno*, 1996); 11 LED signs with amber diodes; 6 × 830.7 × 1,467.3 cm. Installation view, *Protect Protect*, Museum of Contemporary Art, Chicago, 2008. © ARS, NY and DACS, London 2012. Photo: Attilio Maranzano.

pp. 6–7, Brigitte Kowanz, *Lux*, 1998; halogen light, mirror, glass and iron; three parts, each 220 × 50 × 2 cm. Photo: Ulrich Ghezzi.

pp. 204–5, Leo Villareal, *Threshold* (1801K), 2008; LEDs, glass, custom software and electrical hardware; 2.4 × 54.9 m. Site-specific installation view, 1801 K street, Washington, DC. Image courtesy the artist and GEHRING & LÓPEZ GALLERY, NY. Photo: James Ewing Photography.

pp. 206–7, Cerith Wyn Evans, *'Talvinder, you'll never guess, It's the Pacific Ocean, again.'*, 2007 (detail); neon; 440 × 420 × 250 cm. Image courtesy White Cube. Photo: Stephen White.

p. 208, Nancy Holt, *Sun Tunnels*, 1973–6 (detail); concrete, steel and earth; 2.8 × 20.9 × 16.2 m. Photographed in 1976. Image courtesy Haunch of Venison, London. Licensed by DACS, London.

Hayward Gallery is immensely grateful for all the help we have received in organising this exhibition and would like to thank the following individuals and organisations for their invaluable guidance and assistance.

Alfonso Artiaco
Kristine Bell
Kerrie Bevis
Emily Blanchard
Guillaume Bleret
Greta Casacci
Serena Cattaneo Adorno
Russell Calabrese
Eléanore Jacquiau Chamska
Olly Coates
Adriana Cruz
Esther Dörring
Caroline Eggel
Andreas Gegner
Gering & López Gallery, NY
Hannah Gruy
Haunch of Venison
Alois Herrmann
Kay Heymer
Heide Häusler
Eiko Honda
Bridget Johnson
Florian Lüdde
Erin Manns
Steve Morse
Nick Olney
Niall Persaud
Ryan Pike
Kelly Reynolds
Anne Rodler
Matthew Schreiber
Silvia Sgualdini
Andrew Silewicz
Sprüth Magers Berlin London
Stiftung Museum Kunstpalast, Dusseldorf
Studio Olafur Eliasson
Kerin Sulock
Caspar Teichgraeber
Ben Tuffnel
Nicole Wittenberg
Zumtobel Lighting

Southbank Centre is grateful to its Patrons for their generous support of the exhibition:

Abstract Select Ltd
Ulf G. Brunnstrom and Jiwon Lee
Paul Kasmin Gallery
Victoria Miro Gallery

At Hayward Gallery and Southbank Centre, for their contributions to the realisation of *Light Show*, thanks are given to:

Bode Akanbi, Health and Safety Advisor; Marcia Ceppo, Operations Co-ordinator; Bea Colley, Participation Producer (Literature); James Cowdery, Head of Digital Engagement; Hannah Cox, Participation Assistant; Davina Drummond, Learning and Participation Project Manager; Helen Faulkner, Marketing Manager; Roger Hennigan, Technical Manager, Southbank Centre Production; Alison Maun, Bookings and Transport Administrator; Oliver Krug, Press Manager; Urszula Kossakowska, General Manager, Hayward Gallery (maternity cover); Rohini Malik Okon, Participation Producer (Visual Arts); Laura Mayo, Artistic Rentals Manager; Rebecca Millward, Event Manager; Sarah O'Reilly, General Manager, Hayward Gallery; Deborah Power, Sales Manager; Faye Robson, Staff Editor; Stephanie Rosenthal, Chief Curator; James Runcie, Head of Literature; Adam Thow, Head of Retail and Buying; Kabir Thukral, Curatorial Volunteer; Afia Yeboah, Programming Assistant, Artistic Programming; Daniel Wallis, Learning and Participation Project Manager; Daniel Webb, Marketing Officer; Hilton Wells, Head of Technical Services (Estates and Facilities); Ciaran Begley, Jeremy Clapham, James Coney, Philip Gardner, Mark King, Dave Wood, Art Handling Team, Hayward Gallery; Ali Brikci-Nigassa, Janet DeLuca, Alan Pinkney, Security Team.

Lenders

Abstract Select Ltd
Annely Juda Fine Art
Bryce Wolkowitz Gallery, NY
Catherine and Jean Madar Collection
Cruz-Diez Foundation
Stephen Flavin
Galerie Daniel Templon, Paris
Galeria Leme, São Paulo
Gering & López Gallery, NY
Laurent Delaye Gallery
Lisson Gallery, London
Paul Kasmin Gallery
PinchukArtCentre Collection
Scottish National Gallery of Modern Art, Edinburgh
Stiftung Museum Kunstpalast, Düsseldorf
Sprüth Magers Berlin London
Victoria Miro Gallery, London
White Cube

Together with those lenders who wish to remain anonymous

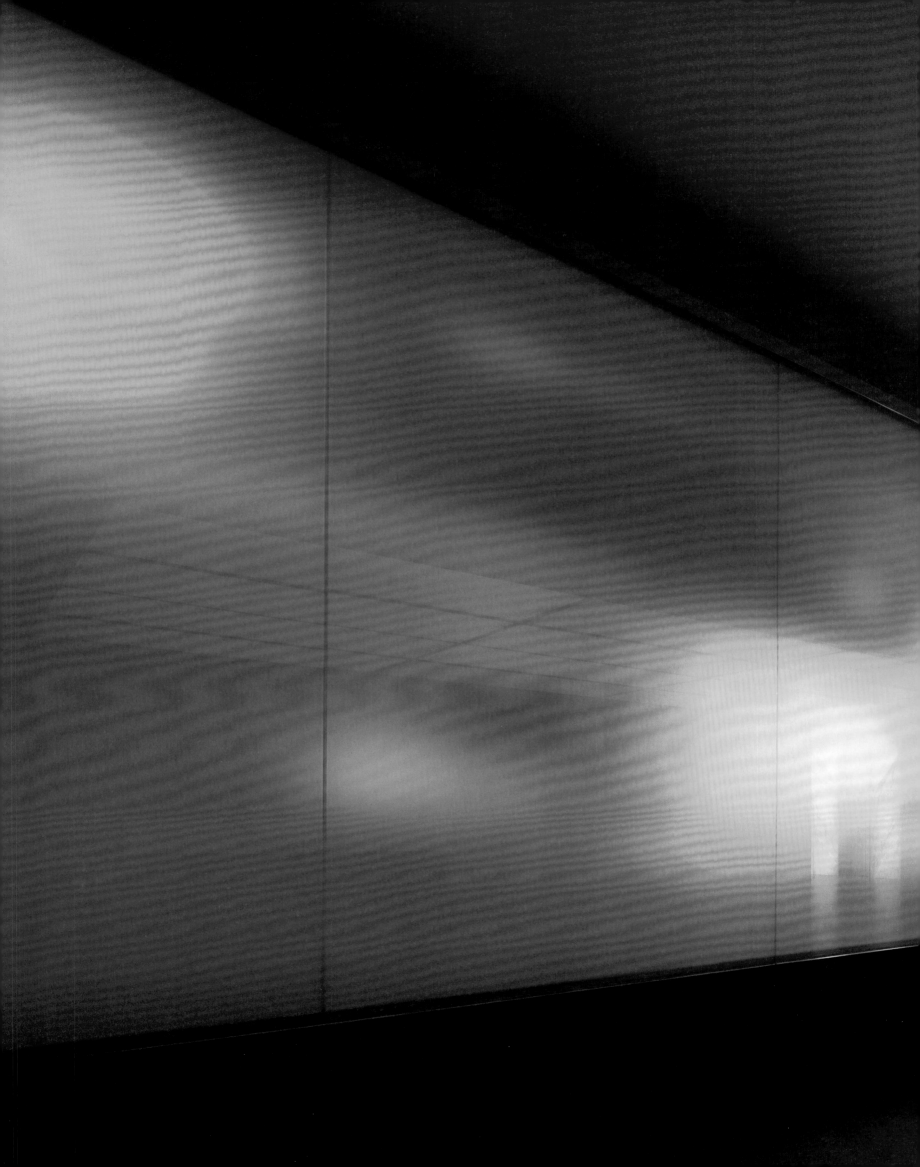

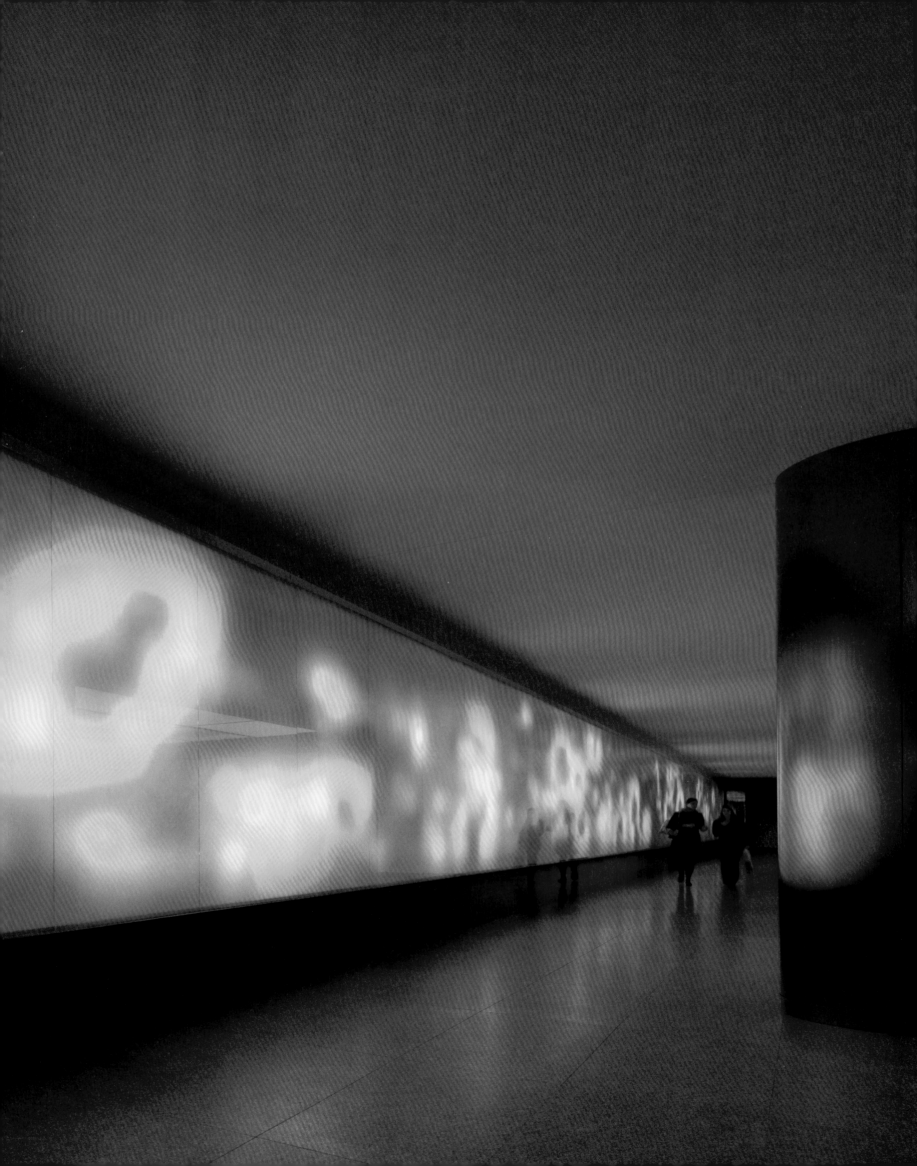

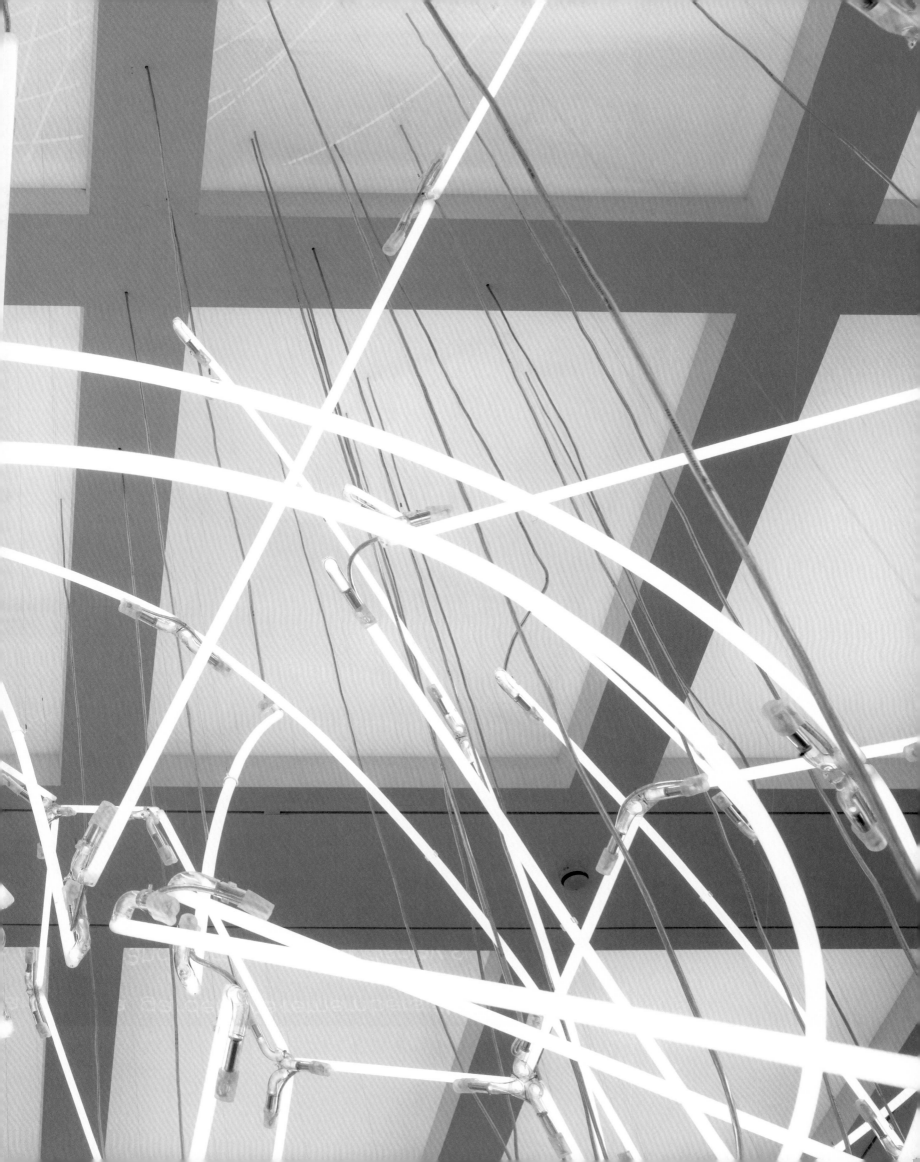

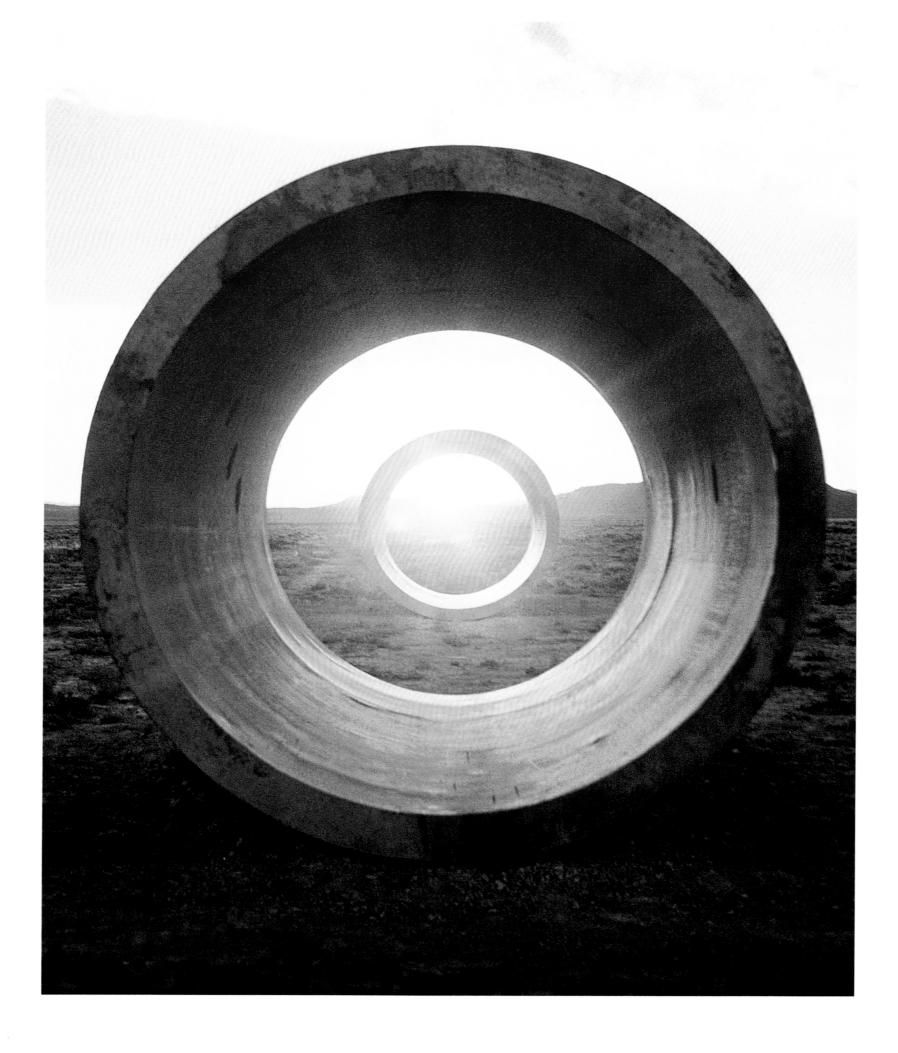